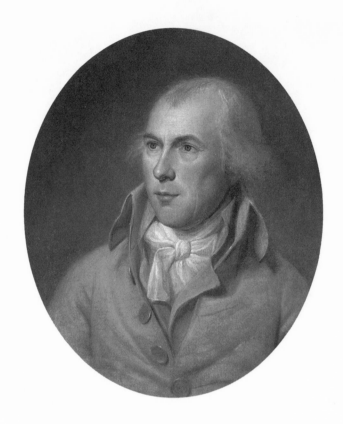

If we advert to the nature of republican Government, we shall find that the censorial power is in the people over the Government, and not in the Government over the people.

—James Madison, 4 *Annals of Congress* 934

A popular Government, without popular information, or the means of acquiring it, is but a Prologue to a Farce or a Tragedy; or, perhaps both. Knowledge will forever govern ignorance; And a people who mean to be their own Governors, must arm themselves with the power which knowledge gives.

—James Madison, letter to W. T. Barry, August 4, 1822.
9 *Writings of James Madison* 103

FREE SPEECH YEARBOOK

The Meaning of the First Amendment:
1791–1991

VOLUME 29
1991

EDITOR
Raymond S. Rodgers
Department of Communication
North Carolina State University
Raleigh, NC 27695

Published for
The Speech Communication Association

Southern Illinois University Press
Carbondale and Edwardsville

ISSN 0899-7225
ISBN 0-8093-1782-6
ISBN 0-8093-1783-4 pbk.

FREE SPEECH YEARBOOK is an annual publication of the Commission on Freedom of Speech, the Speech Communication Association, and Southern Illinois University Press. Manuscripts for volumes 30–33 should be prepared according to the MLA HANDBOOK or A UNIFORM SYSTEM OF CITATION and submitted in triplicate to the Editor, Dale A. Herbeck, Department of Speech Communication and Theater, Lyons Hall 215, Boston College, Chestnut Hill, MA 02167–3804.

Requests for back issues of volumes 1–25 should be addressed to the Speech Communication Association, 5105 Backlick Road, #E, Annandale, VA 22003. Requests for subscriptions and back issues of volumes 26–current should be addressed to Southern Illinois University Press, P.O. Box 3697, Carbondale, IL 62902–3697.

Frontispiece: James Madison portrait by Charles Willson Peale reproduced with permission of The Thomas Gilcrease Institute of American History and Art, Tulsa, Oklahoma.

Dedication: Photograph of William Brennan, Jr., reproduced with permission of AP/World Wide Photos.

The paper in this publication meets the minimum requirements of American National Standard for Information Sciences—Permanence of Paper for Printed Library Materials, ANSI Z39.48-1984. ∞

This special bicentennial edition
of the FREE SPEECH YEARBOOK
is dedicated to

WILLIAM J. BRENNAN, JR.
Associate Justice,
United States Supreme Court,
1956–1990

Some twenty years ago, I had the pleasure of serving as a delegate to the Seventh Arkansas Constitutional Convention. (Surely a lawyer's greatest pleasure must be to write a constitution—even if the voters soundly reject it, as they did in 1970.) The President of that convention was Robert A. Leflar, a distinguished professor of law at the University of Arkansas and New York University and today still a leading scholar of the conflict of laws. Dr. Leflar reminded us constantly that constitutions should be simple and brief. He went so far as to say that all a constitution really needs is a legislative article and a bill of rights.

This is hyperbole, of course. (For one thing, it leaves out courts!) But there's a lot of truth here, too. The legislative power is perhaps the core of government, and a bill of rights is essential to keep that power under control.

I would go farther than Dr. Leflar (again using exaggeration to make a point). All a constitution *really* needs is a First Amendment. In fact, all a constitution really needs is a Free Speech Clause. If the people are truly free to speak on political subjects (and "speak" here would include "write"), they can create whatever kind of government they wish. The whole structure of government will be the child of free expression.

It follows that those who cultivate the garden of free speech have a special place in American history. Although there is, in fact, much more to the Federal Constitution than the Free Speech Clause, the right of free speech is the source and matrix of all other rights.

The list of those—judges and others—who have guarded and enhanced this right is a long one, but no name deserves to be higher on the list than William J. Brennan, Jr. Holmes and Brandeis were great dissenters. Their inspiring phrases are still quoted and deservedly so. But Justice Brennan is more than that. He has been a great affirmer, defending and expanding the right of free expression in all its forms in opinions for the Court, opinions that do not merely point the way for the future but make law for the present.

New York Times Co. v. Sullivan, 376 U.S. 254 (1964), is a good example. Justice Brennan delivered the opinion of the Court. It has two great qualities, seldom seen in combination: boldness and moderation. In breaking new ground, in subjecting private actions for defamation to First Amendment scrutiny for the first time, the opinion is bold. In not embracing an absolutist position, a position protecting the media even when they act with malice, the opinion is moderate. This combination of qualities, typical of Justice Brennan, produced a great advance in the law, but it did not lose its effectiveness by going beyond the point to which a majority of the Court was willing to go. Justice Brennan had an unerring sense of what it takes to get and keep "a Court"—those five votes without which a case cannot be decided.

For these and many other contributions to the liberty of the individual, this volume is dedicated with respect and affection to Justice William J. Brennan, Jr.

RICHARD S. ARNOLD
United States Circuit Judge for the Eighth Circuit
Law Clerk to Mr. Justice Brennan, October Term 1960

Contents

Foreword

Anthony Lewis

"We consider this case against the background of a profound national commitment to the principle that debate on public issues should be uninhibited, robust and wide-open, and that it may well include vehement, caustic and sometimes unpleasantly sharp attacks on government and public officials."

These words are from Justice Brennan's Opinion of the Court in *New York Times v. Sullivan*, the great libel case decided in 1964. They are familiar words, but I wonder how many of us understand a simple truth about the "profound national commitment" that Justice Brennan described. More than any other judge in this century, Justice Brennan made that commitment a reality. He drew together threads in history and in past judicial opinions—many of them dissenting opinions—to define the modern view of free speech in the United States. He convinced the Supreme Court and he convinced the country that America is committed to protect uninhibited, unpleasant, unpopular speech.

When Justice Brennan joined the Supreme Court in 1956, the dominant landmark on the free speech scene was a denial of that freedom: *Dennis v. United States*, the 1951 Supreme Court decision affirming the conviction of Communist Party leaders for conspiring to teach the duty of overthrowing the government by force. The Court found a "clear and present danger" in the tiny, powerless band of American Communists, justifying suppression of their speech. As a speech-protective device, Justice Holmes' clear-and-present-danger formula was reduced to meaninglessness.

A year after *Dennis*, in *Beauharnais v. Illinois*, the Court upheld an Illinois group libel law criminalizing speech that held any racial or religious group to "contempt, derision or obloquy." The majority opinion said libelous utterances against either individuals or groups were not "within the area of constitutionally protected speech."

That was the legal setting when *New York Times v. Sullivan* came to the Court. The *Times* had run an advertisement, on behalf of Dr. Martin Luther King, Jr., and the civil rights movement, that criticized what it called "Southern violators" of the Constitution. L. B. Sullivan, a city commissioner of Montgomery, Alabama, sued for libel although he was not mentioned in the ad, claiming that he would be associated with its critical depiction of police activities against blacks because his duties included supervision of the police. A local jury awarded him $500,000, the largest libel judgment in Alabama history.

The Alabama judgment menaced the *Times* and other national news organizations, threatening them with heavy damages if they printed forthright material on the civil rights struggle. (Various other Southern libel suits against national media were pending by the time the *Sullivan* case reached the Supreme Court.) First Amendment values were therefore engaged. But the Court had said repeatedly, as in *Beauharnais*, that libel was outside the Constitution.

Justice Brennan dealt with the problem by going back to first principles. He gave freedom of speech the comprehensive meaning that Professor Smith, in his essay in this

volume, so compellingly argues it had for Americans from the beginning. Justice Brennan saw as the decisive early test the great struggle over the Sedition Act of 1798, which made it a crime to publish false derogatory statements about the President or Congress. The act evoked from James Madison a classic statement of the purpose of free speech in a democratic society—to enable the sovereign people to judge, criticize, and change the policies of those who temporarily governed. Justice Brennan embraced the Madisonian vision. He declared retrospectively that the Sedition Act—never tested in the Supreme Court before it expired in 1801—was unconstitutional. He cited the eloquent dissents of Holmes and Brandeis from repressive speech decisions. He brushed aside the various statements that the First Amendment did not apply to libel, saying that "mere labels" could not foreclose constitutional rights. He concluded that civil libel actions could not be used, any more than the criminal approach of the Sedition Act, to suppress criticism of public officials.

It was a bold opinion, perhaps a unique example in recent decades of a Supreme Court opinion in the grand style. But as Judge Arnold points out in his dedication to this volume, Justice Brennan did not take an absolute view. He left room for protection of reputation by saying that an official could still recover libel damages if he showed that a published statement about him or her was knowingly or recklessly false. By doing so, he made it possible to speak for a majority of the Court.

New York Times v. Sullivan was, of course, not Justice Brennan's only contribution to freedom of speech. He did much to liberate this country from an artistically constricting Puritanism when he said in *Roth v. United States* in 1957 that works could be punished as obscene only if they were "utterly without redeeming social importance." (In dissent 16 years later, he concluded that even that line was too restrictive, because it could not be clearly understood.) He gave freedom of speech vital procedural protection when he wrote in *Speiser v. Randall* in 1958 that a California law conditioning property tax exemptions for veterans on their executing a loyalty oath denied them due process by putting on them the burden of showing that their speech or associational activities were constitutionally protected. And much more.

But the *Sullivan* case has special import for the theme of this *Free Speech Yearbook*, which is the meaning of the First Amendment, 1791–1991. More than any other modern decision, it refocused our vision of free speech, restoring the courageous optimism that prevailed in the early years of the First Amendment. The decision revolutionized the law of libel, imposing Federal constitutional standards on what had been entirely a matter of state law. But more than that, it had a radiating influence on our attitude toward thoughts that we hate. Professor A. E. Dick Howard of the University of Virginia Law School put it: "I can think of no case that in practical terms matters more to the exchange of ideas in this country."

Two years after *Sullivan*, the Court held that the Georgia House of Representatives had violated the First Amendment when it refused to seat Julian Bond as a member because of his opposition to the Vietnam War. Chief Justice Warren, writing for the Court, said the amendment's "central commitment," defined by *New York Times v. Sullivan*, was that "debate on public issues should be uninhibited, robust and wide-open." Three years later, in *Brandenburg v. Ohio*, the Court substituted for the-clear-and-present danger test in cases of subversive advocacy the requirement that the speech be "directed to inciting or producing imminent lawless action" and was "likely to incite or produce such action." Again, I believe, the way had been opened by Justice Brennan's teaching that American principle requires us to tolerate abrasive speech.

The breadth of the First Amendment in our day was demonstrated amusingly but also significantly when the Supreme Court weighed the balance between the Reverend Jerry Falwell and the publisher of *Hustler* magazine, Larry Flynt. *Hustler* had published a scabrous advertising parody suggesting that Falwell had had, as the Court put it, "a drunken incestuous rendezvous with his mother in an outhouse." Falwell sued, and a jury awarded him damages for intentional infliction of emotional distress. The Court's opinion was by Chief Justice Rehnquist, who was hardly regarded as a pillar of the First Amendment. But the Chief Justice said the guarantee of free speech did not allow punishment of publications because they were "outrageous." Larry Flynt may have been out to get the Reverend Mr. Falwell, "but in the world of debate about public affairs many things done with motives that are less than admirable are protected by the First Amendment." Relying on *Times v. Sullivan*, he said the victim of such a publication could recover damages only if he proved that it contained a knowingly or recklessly false statement of fact about him or her. Since the *Hustler* parody would not be taken by readers as fact, Falwell lost.

Professor Strossen, in her contribution to this volume, argues that "the tide has begun to turn" against free speech in the Rehnquist era. I am glad that she and her colleagues in the A.C.L.U. are on guard, but I am not persuaded that the cases she cites amount to a tide. A Court that decided *Hustler v. Falwell* as it did is quite sympathetic to freedom of speech.

There are real dangers facing the First Amendment today, and they should not be ignored. Professor Haiman, in his contribution, identifies two of them as "the imperial Presidency" and "the imperial majority." The growth of Presidential power and the secrecy that accompanies it threatens the Madisonian premise of an informed sovereign public. What Professor Haiman calls "the imperial majority" would substitute a new communitarianism for the American principle of individual rights, limiting free speech when it might upset the community by offending some sensibilities.

But, on the whole, the United States is committed today to freedom of speech and press. I think it is as free in that regard as it has ever been in history, and freer than any other country on earth. The American public and its representatives were even able to resist the siren call for a constitutional amendment to overrule the Supreme Court's decision that burning the flag as a protest was a form of expression protected by the First Amendment. Enough of us came to understand what Justice Brennan said in the last sentence of the last opinion he wrote for the Court, in the second flag case: "Punishing desecration of the flag dilutes the very freedom that makes this emblem so revered, and worth revering."

Editor's Preface

As this volume goes to press, the United States and its allies are celebrating the most unequivocal military victory since World War II and are anticipating the return of over a half million service men and women. George Bush has announced that, in addition to the total defeat of Saddam Hussein, we have finally kicked "Viet Nam Syndrome." While most Americans will agree that this war was justified (President Bush currently enjoys a 91% approval rating, the highest in American history), students of communication law and policy may point to a new and troubling irony posed by this war that is different from any previous ones.

The irony of this war is that it was our first one to be conducted under a regime of total press management by the military, while at the same time, the news media now had available to them the most sophisticated communications technology ever envisioned. This paradox raises legitimate questions of communication policy.

Commenting on CNN's live coverage of SCUD missile attacks by Iraq on Tel Aviv, and the usually successful interception of those missiles by our own Patriot defense systems, Walter Cronkite observed that one might characterize this as brilliant news coverage and one might also characterize it as artillery spotting. It has long been a commonplace that the government may properly keep secret such information as "the sailing times of troop ships," and no serious free speech scholar disputes that general principle. Indeed, such thoughtful scholars as Morton Halperin and Daniel Hoffman, in their 1977 work, *Top Secret: National Security and the Right to Know*, identify "details of plans for military operations" as one example in their category of "presumptively secret" information. In the context of our present war and the capability of the news media to instantaneously transmit potentially sensitive military information around the world, we are confronted with old questions rendered newly difficult. The crux of the problem seems to be: under what circumstances would certain military information lose its presumption of secrecy, and how is that equation affected by the contemporary media of communication?

But Halperin and Hoffman also proposed a category of government held information which ought to be "automatically released," and seven out of eight examples they provided relate to military actions, weapons systems, the financing of war efforts, and the like. The principle which they articulated for including information in this category was that it be "necessary to congressional exercise of its constitutional powers to declare war, to raise armies, [and] to regulate the armed forces. . . ." Such information, they argued, "must be made available not only to Congress but to the public."

Most free speech scholars would probably agree with these two assertions: On the one hand, there is certain information held by the government which is protected by the presumption of secrecy, but that presumption is capable of being overcome. On the other hand, there is certain information which presumptively belongs to the public and that presumption is likely to be insurmountable. This is not a new debate, but as the First Amendment enters its third century of application and interpretation, the debate has new and difficult wrinkles. Our challenge as scholars of the system of freedom of expression

is to discover which of our old arguments still work, which don't, and what new arguments are needed in the age of satellites and laser optics.

Sadly, another old debate about freedom of speech has accompanied the opening volleys of this war. This is also one about which few free speech scholars will disagree. Very early, we heard the accusations of lack of patriotism and worse being heaped upon those who opposed by expression our involvement in this war. A new, and by the standard of one who formed his political world view in the late 1960s, bizarre, event, the "Pro-War Rally," emerged on college campuses in the 1990s. Rhetorically, these events appeared more like pre-game pep rallies than political demonstrations. Ideologically, they were deeply intolerant of opposing views. And while this crabbed view of what constitutes patriotism may not be new (does anyone still remember those "nattering nabobs of negativism" that Mr. Agnew taunted?), it somehow seems sadder than it did 25 years ago.

It is saddening because just 29 years ago, this journal came into existence. Born out of a concern for the protection of dissent and a desire to insure the integrity of rational discourse in a decade of violent social and political turmoil, this journal, and the Commission on Freedom of Expression which sponsors it, have attempted assiduously to teach, investigate, and promote the values of freedom of expression. When the Speech Communication Association articulated its Credo for Free and Responsible Communication in a Democratic Society in 1972, the document included the statement that "We encourage our students to accept the role of well-informed and articulate citizens, to defend the communication rights of those with whom they may disagree, and to expose abuses of the communication process." The level of intolerance for dissent on America's college campuses in the early 1990s causes me to wonder how well we have done our jobs over the past quarter century.

While many of us will have honest differences of opinion about whether this war was justified, there can be little doubt that it made clear for us again that our task as scholars and teachers of freedom of expression continually challenges us to inculcate in our students the necessity of open debate in democratic societies, particularly in wartime. We must again share with our various publics the arguments of Senator Robert LaFollette. In his famous address, "Free Speech in Wartime," delivered in the United States Senate on October 6, 1917, LaFollette observed that "The mandate seems to have gone forth to the sovereign people of this country that they must be silent while those things are being done by their Government which most vitally concern their well-being, their happiness, and their lives." But rather than remaining silent in order to create the impression of public unanimity toward America's involvement in World War I, LaFollette argued forcefully that, on the contrary,

The citizen and his representative in Congress in time of war must maintain his right of free speech. More than in times of peace, it is necessary that the channels for free public discussion of government policies shall be open and unclogged. I believe, Mr. President, that I am now touching upon the most important question in this country today, and that is the right of the citizens of this country and their representatives in Congress to discuss in an orderly way, frankly and publicly and without fear, from the platform and through the press every important phase of this war: its causes and manner in which it should be conducted and the terms upon which peace should be made.

Because Desert Storm reminded us again of Senator Hiram Johnson's maxim that "The first casualty when war comes is truth," we must again dedicate ourselves to the proposition that the fragile and dialectic nature of truth compels us to believe that the only way we can pursue it properly is within a viable system of freedom of expression. We must

remember that the traditional, necessary, and vital role of the media in this republic is that of watchdog, not lapdog. It was Thomas Carlyle who told us in 1841 that "Burke said there were Three Estates in Parliament; but, in the Reporter's Gallery yonder, there sat a Fourth Estate more important far than they all. It is not a figure of speech or witty saying; it is a literal fact—very momentous to us in these times." To understand and value the adversarial role of the media is critical to the health of our system of freedom of expression. Sadly, when one former senior correspondent for the *New York Times* recently took the temperature of media coverage of the Gulf War, he suggested that CNN should change its name to PNN: the Pentagon News Network. Franklyn Haiman, in his essay in this volume, warns us against succumbing to the pressures of the "imperial majority." John Stuart Mill called it "the tyranny of prevailing opinion" and posted the same warning in 1859. Perhaps one of the keys to guarding against such pressures is to help our students understand that in the United States in 1991, just as in England in 1841, the adversarial role of the Fourth Estate remains "very momentous to us in these times."

As we celebrate two hundred years of successful democracy under the regime of the First Amendment, and as we enter its third century grappling with old problems under the clouds of a new war, we would do well to read with renewed urgency the words of Justice William O. Douglas' dissenting opinion in *Dennis v. U.S.* (1951):

Free Speech has occupied an exalted position because of the high service it has given our society. Its protection is essential to the very existence of a democracy. The airing of ideas releases pressures which otherwise might become destructive. When ideas compete in the market for acceptance, full and free discussion even of ideas we hate encourages the testing of our own prejudices and preconceptions. Full and free discussion keeps a society from becoming stagnant and unprepared for the stresses and strains that work to tear all civilizations apart.

Full and free discussion has indeed been the first article of our faith. We have founded our political system on it. It has been the safeguard of every religious, political, philosophical, economic, and racial group amongst us. We have counted on it to keep us from embracing what is cheap and false; we have trusted the common senses of our people to choose the doctrine true to our genius and to reject the rest. This has been the one single outstanding tenet that has made our institutions the symbol of freedom and equality. We have deemed it more costly to liberty to suppress a despised minority than to let them vent their spleen. We have above all else feared the political censor. We have wanted a land where our people can be exposed to all the diverse creeds and cultures of the world.

Such wise words will serve us well as we chart our course into the First Amendment's third century. It has been said that ships are safest when in port, but that is not what ships are for. We must take care amid both justified jubilation and alarming post-war jingoism that we do not succumb to the temptation, on the eve of a new century of First Amendment application and interpretation, to shirk from our commitment to sound thinking about our republic's genius. With historically grounded and well-reasoned understanding of the First Amendment's mandate as our compass, we will be on a safer course.

RAYMOND S. RODGERS
Raleigh, North Carolina
March 1, 1991

Acknowledgments

The publication of this volume closes my tenure as Editor of the *Free Speech Yearbook*. To have been given the responsibility of stewardship over this outstanding journal has been the high point of my professional career. There are people in whose debt I shall always remain, and some of them must be mentioned here. The men who founded the SCA Commission on Freedom of Speech in 1961, Alvin A. Goldberg, Mark Klyn, Franklyn Haiman, Robert M. O'Neil, and George P. Rice, and who directed that Commission to publish this journal, are first. Without their vision, our discipline would be poorer. It is wonderfully appropriate that two of those founders have articles in this volume. It is particularly noteworthy that Professor Frank Haiman concludes his long and distinguished career in the same year this volume appears. His example of impeccable scholarship, informed activism, and personal warmth have been an inspiration to generations of graduate students, and he always will remain the model to which serious communication scholars of freedom of expression must aspire. To the members of the SCA Commission on Freedom of Expression who gave me the opportunity to serve as Editor of this journal, and specifically the authority to prepare this volume, I am humbly grateful. I hope that I have lived up to your expectations. My undergraduate debate coach, mentor, and friend, Chick Graham Williams, now of Longwood College, not only taught me how to debate but taught me that there are always two sides. Acceptance of that principle is the *sine qua non* of a commitment to freedom of expression and a tolerance for dissent. My graduate advisor, mentor, and friend, Jimmie Rogers of the University of Arkansas, showed us all how it is done. My graduate advisor, mentor, and friend, Paul A. Barefield, then of the University of Oklahoma, taught me my first course in freedom of expression and saw to it that I would have an environment in which to pursue to completion my research in this area. I can never repay my best friend in the discipline, Steve Smith for his support, advice, and example. He is responsible for the modern "look" and quality of the *Free Speech Yearbook*, and his own scholarship, as evidenced by his article in this volume, sets the template for historical research in freedom of expression. Kenney Withers, Director of Southern Illinois University Press, and his staff have always provided cheerful, professional, and enthusiastic support of the *Free Speech Yearbook* and its editors. They all are to be commended. My Department Head, Bill Jordan, and my Dean, Bill Toole, have generously provided me with the institutional and personal support without which this journal cannot be prepared. I remain deeply grateful for that support. Likewise, my various manuscript typists over the years, particularly Beth Kascenska, Anne Warren, Debbie Pell, and Charlotte Jones, have demonstrated rare combinations of skill in the art and long patience with the Editor. I could not have done it without them. The selfless and dedicated scholars, attorneys, and jurists who served so generously and well as Associate Editors on Volumes 27 and 28 of the *Free Speech Yearbook* are truly what makes an academic journal respectable, and they have made this one very much so. To all the authors who contributed so admirably to this volume, my personal gratitude pales alongside that of your future readers. You have all, by your scholarship and your personal example,

helped insure a sound beginning of the First Amendment's third century. Like most of us, I continue to turn to my students for challenge, inspiration, and occasional battery charges. To all the students in over twelve years of classes in COM 421, thanks guys, for keeping me on my toes. And finally, to my wife and best friend, Peggy Beasley-Rodgers, and my daughter, Austin, thanks for everything else.

The First Amendment in Its Third Century: The Majoritarian Challenge

Franklyn S. Haiman

For knowledgeable students of the First Amendment, there is nothing new to the idea that freedom of expression, like many of the guarantees of the Bill of Rights to the U.S. Constitution, is a counter-majoritarian concept. It defines democracy as a system in which majority rule is balanced by minority rights, not only because minorities are entitled to equal treatment as human beings, but because the free expression of their views may be a source of leadership, innovation, the prevention of error, or the correction of prejudice for those in the majority. The rights protected by the first ten amendments to the Constitution were not mere afterthoughts or appendages to democracy. On the contrary, they were so much taken for granted as premises of a democratic system of government, that it was at first not even thought necessary to commit them to writing. It was only to reassure those who were wary about the potential for majoritarian abuse by the new Federal government that promises were made to the would-be ratifiers of the Constitution that a written Bill of Rights would immediately be attached.

That wariness was well founded. It recognized the social-psychological reality that political theorists may too easily forget—that respect for minority rights does not come naturally to most people and that, in fact, there are powerful herd instincts constantly impelling majorities to suppress the deviants in their midst. The protection of those dissenters is provided, if at all, by rational leaders (elites, if you will) who see beyond the emotional impulses of the moment and are able to act on behalf of the wiser long-range interests of their society. In the United States, that task has been facilitated by the existence of a Bill of Rights; by a Federal judiciary, appointed for life, with the authority to enforce that document; and by watchdog groups, like the American Civil Liberties Union, who provide the legal and financial resources to invoke that judicial power.

Throughout the 200-year history of the United States, there have been a variety of threats to the vitality and even survival of our democracy. A few have come from aggressive foreign powers, one from a bloody Civil War, but most from incipient disruptions of the system of checks and balances that our Founding Fathers carefully erected among the three branches of the Federal government; among the Federal government, the states, and the people; and between majority rule and minority rights. During the last half of the twentieth century, for example, a well-placed concern has arisen over the development of a so-called "imperial presidency"—a peril to democracy that is likely to remain with us because the phenomena which have contributed to it, such as nuclear weapons, the war and foreign policy powers of the executive, bureaucratic secrecy, and the cumbersomeness of the legislative process, are not going to disappear. But another serious danger faces us as we embark upon the third century of our national existence—that of an imperial majority.

1

As already suggested, this is not an entirely new threat, for it is always present in the dynamics of any group or society. What is new as we celebrate the 200th anniversary of the Bill of Rights is the increased intellectual respectability and political force that the majoritarian strain in our culture seems to be attaining. And the more that the herd instinct shifts in its leadership from crude know-nothingism to sophisticated, articulate, ostensibly mainstream, and politically well-placed advocates, the more dangerous it becomes. It is not so much the politically cynical drive for a constitutional amendment to prohibit flag burning nor the obscenity prosecutions of the Mapplethorpe exhibit and 2 Live Crew's "As Nasty As They Wanna Be" that should concern us—worrisome as those events have been—but the more fundamental, theoretical challenges to a liberal philosophy of government that are being advanced by spokespersons for what is now being labelled a "communitarian" point of view. As articulated in a 1988 *Harvard Law Review* note:

> Communitarian thinkers reject liberalism as reflecting an impoverished vision of the self, one that discounts our participation in common traditions and practices and ignores the fulfillment that individuals can achieve through citizenship. In contrast to liberalism's individualistic portrayal of politics, communitarianism emphasizes the classical conception of a political community animated by a shared conception of the good.[1]

One can only speculate about the causes of this new trend, but surely important among them is the perception in many quarters that individualism in America has run amok, threatening us with both physical and moral anarchy. This view has perhaps been buttressed by an increased cross-cultural awareness that there are other societies in the world which seem to function successfully while placing far greater value on group conformity than we do.

These critiques must be understood and taken seriously if one wishes to defend success-fully against them. They arise in the context of particular First Amendment disputes, such as that of obscenity or racist speech, as well as at a higher level of abstraction involving arguments about constitutional interpretation and the proper role of the U.S. Supreme Court. It is the purpose of this essay to examine a small sampling of those arguments and to suggests some antidotes to them. We will begin with the more general issues and proceed to the more specific.

The Generic Challenge

The most forceful and intellectually skillful recent challenge to the liberal perspective has come from one who suffered a stinging personal defeat at the hands of its adherents, former law professor and Federal Judge Robert H. Bork. Still smarting from his defeat as a candidate for the U.S. Supreme Court, Bork has written a self-justificatory volume, *The Tempting of America*,[2] in which he takes on the twin evils he sees destroying his country—a disregard for the moral sensibilities of the majority, aided and abetted by a group of elitist Supreme Court justices who feel free to interpret the Constitution according to their personal predilections rather than its original intent. "It is difficult to know," he says, "the origin of the peculiar notion that what the community thinks to be moral harm may not be legislated against. The notion has been given powerful impetus in our culture . . . by John Stuart Mill's book, *On Liberty* . . . It is, in any event, an idea that tends to dissolve social bonds . . . These are not negligible matters. Any healthy society needs a view of itself as a political and moral community."[3]

As to the Supreme Court's role in advancing this "peculiar notion," Bork opines:

When a court strikes down a statute, it always denies the freedom of the people who voted for the representatives who enacted the law. We accept that more readily when the decision is based upon a fair reading of a constitutional provision . . . But when the Court, without warrant in the Constitution, strikes down a democratically produced statute, that act substitutes the will of a majority of nine lawyers for the will of the people. That is what is always involved when constitutional adjudication proceeds by a concern for results rather than by concern for reasoning from original understanding.[4]

To Bork, a "fair reading" of the Constitution's "original understanding" is much more self-evident and far more cramped than to most constitutional scholars, and his self-righteous condemnation of results-oriented adjudication seems oblivious to the fact that, under the guise of "neutral principles," he is simply seeking different results.

An earlier advocate of the kind of philosophy espoused by Bork, political scientist Walter Berns, was more honest about that truth. In urging that the Supreme Court make avowedly moral decisions in its First Amendment adjudication, Berns said:

There is always the danger that the abridgement of vicious speech will be followed by the abridgement of good, or virtuous speech, but the Court would be in a position to permit the former and prohibit the latter if it developed principles that recognize the difference between vice and virtue. Supreme Court opinions may deny that such distinctions may properly be made by any official of a democratic government, but this is to deny what the Court is doing all the time—even when it fails to act—when it separates the legal from the illegal. Whether bad speech is denominated 'fighting words,' obscenity, or incitations to breaches of the peace, it constitutes an authoritative definition of what is not to be permitted. . . . When the Court ruled that the practice of polygamy was not the sort of religious freedom the First Amendment protects, it to some extent defined good religion. . . . [A]s long as some members of the Court persist in holding to the principle that the best speech is the freest speech . . . there is the danger of . . . decisions which cannot long stand because they offend the conceptions of right and wrong held by the community. . . . The law of the First Amendment is in a condition of confusion . . . The basic reason for this has been the attempt to identify freedom as the hallmark of life under the American government, or as the greatest of all goods. . . . Thus, the justices refuse to distinguish between the inherent worth of the ideas expressed. . . . Nevertheless, they are inevitably forced to make the choice on these grounds, though they may disguise what they are doing; the only escape from this choice is to insist that nothing is superior to freedom. However often this is asserted from the bench, no justice has carried out this proposition in practice.[5]

We need not rely on theoretical speculation to learn how the Borkian and Bernsian world view, if widely accepted, would play out in actuality, for Justice Antonin Scalia obligingly provided us with two living examples during the U.S. Supreme Court term of 1989–90. Speaking for an astonishing number of his colleagues in explaining the Court's refusal to extend to Native Americans the right to ingest peyote as part of their religious sacrament, Justice Scalia wrote:

Values that are protected against government interference through enshrinement in the Bill of Rights are not thereby banished from the political process. . . . It may fairly be said that leaving accommodation to the political process will place at a relative disadvantage those religious practices that are not widely engaged in; but that unavoidable consequence of democratic government must be preferred to a system in which each conscience is a law unto itself or in which judges weigh the social importance of all laws against the centrality of all religious beliefs.[6]

For Justice Sandra Day O'Connor, who agreed that *in this particular instance* the state's "compelling interest" in enforcement of a criminal law against the use of drugs outweighed the granting of an exception on the grounds of religious freedom, the rationale of Justice Scalia's five-person majority opinion was totally unacceptable. Her concurrence in only the final judgment reads more like a dissent:

In my view, today's holding dramatically departs from well-settled First Amendment jurisprudence, appears unnecessary to resolve the question presented, and is incompatible with our Nation's fundamental commitment to individual religious liberty. . . . [T]he Court today suggests that the disfavoring of minority religions is an 'unavoidable consequence' under our system of government and that accommodation of such religions must be left to the political process. . . . In my view, however, the First Amendment was enacted precisely to protect the rights of those whose religious practices are not shared by the majority and may be viewed with hostility. The history of our free exercise doctrine amply demonstrates the harsh impact majoritarian rule has had on unpopular or emerging religious groups such as the Jehovah's Witnesses and the Amish. . . . The compelling interest test reflects the First Amendment's mandate of preserving religious liberty to the fullest extent possible in a pluralistic society. For the Court to deem this command a "luxury" . . . is to denigrate "the very purpose of a Bill of Rights."[7]

But Justice Scalia is not easily deterred. Two months later, joining with a majority of the Court in denying to the parents of Nancy Cruzan the right to disconnect the tubes that had been keeping her alive in a comatose state for seven years, he felt impelled to write a separate concurring opinion with which, this time, not one of his colleagues could agree:

Are there, then, no reasonable and humane limits that ought not to be exceeded in requiring an individual to preserve his own life? There obviously are, but they are not set forth in the Due Process Clause. What assures us that those limits will not be exceeded is the same constitutional guarantee that is the source of most of our protection—what protects us, for example, from being assessed a tax of 100 percent of our income above the subsistence level, from being forbidden to drive cars, or from being required to send our children to school for 10 hours a day, none of which horribles is categorically prohibited by the Constitution. Our salvation is the Equal Protection Clause, which requires the democratic majority to accept for themselves and their loved ones what they impose on you and me. This Court need not, and has no authority to, inject itself into every field of activity where irrationality and oppression may theoretically occur, and if it tries to do so it will destroy itself.[8]

The Moral Majority may be dead as an organization but its spirit lives on in the person of Antonin Scalia!

The modernized majoritarianism has addressed itself in recent times to two specific and enduring free speech issues for which there has always been an audience receptive to proposed restrictions—obscenity and racist speech. But now the arguments are more sophisticated and are often propounded by advocates who claim, with some legitimacy, to be friends of the First Amendment.

The Obscenity Challenge

One such proponent is political scientist Richard Randall, whose 1989 volume, *Freedom and Taboo: Pornography and the Politics of a Self Divided*, makes the case for a new and different basis on which the U.S. Supreme Court should rest its prohibitions against obscenity.[9] Randall starts from a psychoanalytical premise that we human beings all have bizarre sexual fantasies springing from our childhoods that are too horrifying to admit to

consciousness and are thus expressed or satisfied in the "pornographic imagination" of erotic art, magazines, films, etc. But, he continues, just as there is an inexorable need for outlets for these fantasies, so there is a psychological imperative to keep them in check, inevitably resulting in the development of social taboos and legal controls. These controls, he argues, should not depend on unreliable and unmeasurable criteria used by the Supreme Court such as appeal to the prurient interest, lack of serious value, or potential for social harm, but solely on the material's patent offensiveness to a community's standards.

Although a sense of being offended is obviously subjective, "patent offensiveness"—which the Court has described as going beyond the *customary* limits of candor—is objectively measurable. . . . Almost any community can supply evidence of what is patently offensive. We are not speaking here of public opinion polls. . . . More to the point are actual communications. The chief evidence of existing community standards on any matter is what has actually been done or practiced and what the community's response has been to departures from the customary. What sorts of sexual material have been openly available? . . . was there protest or complaint, indifference, or approval? If so, by whom and in what numbers. These are factual questions on which factual evidence can be presented.[10]

And why should patent offensiveness to community standards be considered an acceptable, even preferred, basis for legal restraints? For Randall, the answer seems to be primarily a pragmatic one:

. . . liberty as an absolute value negates the legitimacy and prudence of all opposing interests and obscures the actual probabilities and necessities of liberal democracy. . . . Liberal democracy rests on the uneasy union of a free speech society with a mass democratic one. Individual liberties must co-exist with the equality principle and its operating agent, majority rule. . . . In theory, a free speech society works because its members are wise enough, mature enough, or simply self-controlled enough to check their natural inclination to silence troubling views and disagreeable expression. . . . Yet few members of any society can consistently reach such heights of political wisdom and temperance. . . . Thoughtful libertarians may recognize the implicit danger in calling reflexively for greater liberty without regard to the consequences of such absolutism for other values. The question is not whether freedom of speech should submit to popular preferences and majority will . . . but whether the inevitable and continuing conflict between these two vital elements of liberal democracy has been managed as well as it might be . . . protecting necessary freedom and preventing unnecessary reaction.[11]

The Racist Speech Challenge

Anyone who has been involved in the recent debates on college campuses across the country over the adoption of rules restricting racists speech knows the intensity of feeling that issue has generated, particularly among the members of minority groups who have been the victims of such speech. But, in addition, it has produced an outpouring of legal scholarship, much of it also from members of target groups, offering intellectual justifications for restrictions on group libel—some of it recycled from the Nazi-in-Skokie debate, some of it borrowed from our sister democracies of Western Europe who outlaw racist speech, and some of it with a new twist. Professor Mari J. Matsuda's 1989 *Michigan Law Review* article, "Public Response to Racist Speech: Considering the Victim's Story," is a prominent example: "What is argued here . . . is that we accept certain principles as the shared historical legacy of the world community. Racial supremacy is one of the ideas we have collectively and internationally considered and rejected."[12]

The alternative political vision which runs through all of these justifications is concisely summarized by the *Harvard Law Review* note cited earlier:

The purpose of the state, under the liberal view, is to secure the widest possible scope for individual autonomy. Restricting speech that imperils the physical security of others, then, is legitimate, because such expression represents an exercise of liberty incompatible with a similar degree of liberty for all. However, from this perspective, individual preferences concerning the content of other persons' conceptions of the good are suspect. . . . From the communitarian perspective, permitting group vilification causes significant harms both to individuals and to the political community as a whole. Toleration of group vilification injures individuals because it fails to respect fully the personhood of its targets. Religious and racial affiliations are central to the identities of many individuals. . . . Thus, the offense that the members of these groups take at group vilification reflects a constitutive component of their identities. It is not possible, then, as liberalism supposes, to disregard such sensibilities while still respecting the personhood of the individuals who experience them. . . . Permitting group vilification harms the political community as a whole because it denigrates the idea of equality. Equality is inherent in the concept of community. . . . The toleration of group vilification . . . denies the targets of such expression equal membership in the political community.[13]

The Liberal Response

This communitarian/majoritarian critique of liberal philosophy almost answers itself. It quite accurately describes the point at which a liberal state feels justified in restricting freedom of expression—when it "imperils the physical security of others." Or as Thomas Jefferson put it, ". . . when principles break out into overt acts against peace and good order."[14] Or as the Supreme Court has phrased it, when "advocacy is directed to inciting or producing imminent lawless action and is likely to incite or produce such action."[15]

Majoritarians would substitute for that boundary line a criterion of offense or injury to the sensibilities of others, either individually or collectively, which they assert cannot be disregarded without denying to those others their personhood and their equality as members of the community.

There are at least two serious problems with this line of argument. The first is the assumption, made explicit by Richard Randall but implied by all other so-called communitarians, that offensiveness and psychological injury are phenomena not simply in the eye of the beholder but sufficiently identifiable and measurable by courts of law to allow for fair and objective decision-making.

That is a premise which the U.S. Supreme Court found wanting when the speech in question was "Fuck the Draft" and the Court said: "How is one to distinguish this from any other offensive word? . . . [I]t is largely because government officials cannot make principled distinctions in this area that the Constitution leaves matters of taste and style so largely to the individual."[16]

That premise was found wanting again in Jerry Falwell's lawsuit against *Hustler* magazine for the intentional infliction of emotional distress when the Court declared:

"Outrageousness" in the area of political and social discourse has an inherent subjectiveness about it which would allow a jury to impose liability on the basis of the juror's tastes or views, or perhaps on the basis of their dislike of a particular expression. An "outrageousness" standard thus runs afoul of our longstanding refusal to allow damages to be awarded because the speech in question may have an adverse emotional impact on the audience.[17]

It is a premise that is flawed because what injures the feelings of one person does not necessarily do so with another or with the same person all of the time, whereas a punch

in the nose is not only clearly observable but invariably hurts. As for Randall's claim that a community's standard of offensiveness is more measurable than that of its individual citizens, it should be noted that what he is proposing to be added together in an objective way are subjective judgments to begin with. Adding zero to zero still makes zero.

This is not to say that real emotional pain may not be suffered by a Holocaust survivor seeing neo-Nazis march in Skokie, or by a Black student confronted with a poster that reads "Nigger Go Home," or by a woman exposed to the lyrics of "As Nasty As They Wanna Be." It is to say that, while such experiences may warrant our personal sympathy for the victims and moral condemnation of the perpetrators, they cannot be remedied by the law without imperiling the very essence of the First Amendment.

A second fundamental problem with the majoritarian perspective is its premise that disregard for the sensibilities and personal morality of the members of a community is the same as denying them their personhood and depriving them of equal rights. This proposition again conflates and confuses the questions of morality and law, speech and action.

We can have deep respect for the personhood, identity, morality and feelings of others without believing that it is or can successfully be the role of the law to protect those interests. While the law can attempt to insure equality of *treatment*, like the right to vote or to be free from discrimination in housing, jobs, and public accommodations, it cannot assure equality of respect. Nor is the absence of attitudinal respect equivalent to the denial of material rights. When some feminists and minorities argue, for example, that "their voices have been silenced" by the discriminatory treatment they have long suffered, they are using a loose and somewhat misleading metaphor, for the fact that they are *voicing* their objections contradicts, to some extent, their own assertion.

Moreover, it is not unthinkable that true respect for the personhood of others includes a recognition of their ability to handle offenses to their morality and injuries to their feelings with the vigorous counter-assertion of their own values in a free marketplace of ideas rather than the suppression of that which offends them. Nor is it implausible that true equality of membership in a community is achieved when barriers to equal *treatment* are removed—that it does not require everyone's *feelings* to be equally respected. Indeed, those who would by law impose the morality of the majority on others in the name of equality and so-called community values are themselves failing to accord equal *treatment* to the members of that community who do not share those values and are not permitted to *express their* feelings.

In short, the substitution in recent discourse of the word "communitarianism" for "majoritarianism" may be a subtle verbal stratagem, intentional or not, which masks the fact that a community and a majority are not identical. A community includes everyone; a majority does not. Perhaps the strongest antidote that can be provided for the majoritarian challenge to the First Amendment in its third century is to uncouple those terms.

Notes

1. Note, "A Communitarian Defense of Group Libel Laws," 101 *Harvard Law Review* (January 1988) 682.
2. New York: The Free Press, 1990.
3. Id. 249.
4. Id. 264.
5. *Freedom, Virtue and the First Amendment* (Baton Rouge: Louisiana State University Press, 1957) 126–28.

Franklyn S. Haiman

6. *Employment Division, Department of Human Resources of Oregon v. Smith*, 58 U.S. Law Week 4433 (1990) 4438.

7. Id. 4438–42.

8. *Cruzan v. Director, Missouri Department of Health*, 58 U.S. Law Week 4916 (1990) 4926.

9. Berkeley: University of California Press, 1989.

10. Id. 248.

11. Id. 179,256,258.

12. 87 *Michigan Law Review* (August 1989) 2360.

13. Note, *Harvard Law Review*, *op. cit.* 688, 690–91.

14. Virginia Statute Establishing Religious Freedom

15. *Brandenburg v. Ohio*, 395 U.S. 444 (1969).

16. *Cohen v. California*, 403 U.S. 15 (1971).

17. *Hustler v. Falwell*, 458 U.S. 46 (1988).

Mr. Jefferson's Wall
and "Christian" America

W. W. Finlator

Let me begin with myself. I am a minister in the Southern Baptist Convention, and I am identified as a "moderate" Baptist to distinguish me from "conservative" and "fundamentalist" Baptists who in the past decade have taken over the Convention. I would prefer the title of "immoderate" since I belong to that all too small fellowship among us that might be called "Baptists with a Memory."

To live and move and have one's being in our institutionalized and bureaucratized church today and, at the same time, to recall the faith of the fathers, and to insist that it shall be "living still," is to invite not only the nomenclature of immoderate but also radical. And deservedly so, for that is just what our English forebears in the late 16th and early 17th centuries were: radicals, and dangerous to boot. But, alas, amnesia has long ago taken possession of a people who have little regard for their roots.

England at the time of the appearance of the early Baptists wanted, above all, a unified country and could tolerate no departure from a nation state allied with an established church. Nonetheless, Baptists and other dissenters, ready to defy the elements and face dungeon, fire and sword, appeared on the scene. Black civil rights leaders testified in the sixties that, though in school, they were taught that law and the police were to be respected as their friends. They regarded, on the contrary, law and law enforcement officers allied with the white power structure, as their enemies! The early Baptists were just as sure that the state in alliance with the Church of England was the Enemy!

If they wanted to preach their faith, they were denied free speech. If they wanted to disseminate their doctrine, they were forbidden a free press. If they wanted to congregate for worship, they were not allowed peaceable assembly. And in an environment where thought was controlled and conscience coerced, they were at great risk to open their hearts to one another. This suppression came from a government which, far from honoring and respecting, they came to fear as their foe. It is small wonder that many of these Baptists refused to serve in the armed forces and declined positions as civil servants.

So today, if you see a Baptist who supports prayer and equal access for religion in public schools, or advocates tuition credits and other hidden government subsidies for Christian Academies, or attends prayer breakfasts in the White House, or would suffer cardiac arrest at the suggestion that "In God We Trust" might be removed from our coins, or "under God" from the Pledge of Allegiance, or that swearing over the Bible shall no longer be required, or one who calls for an amendment to the Constitution declaring that the United States of America is a "Christian Nation," be well advised that you are looking at a Baptist who has no sense of or gratitude for history, no reverence for heritage, no regard for the rock from which Baptists were hewn, in short, an unauthentic Baptist whether moderate, conservative or fundamentalist. He will be incredulous if you tell him

that two centuries before the adoption of the Bill of Rights of our Constitution, English Baptists, for the sake of sheer survival, were struggling for the soul and substance of the First Amendment. And he will be shocked to be reminded that his forebears, having learned that freedom is an indivisible thing, fought just as valiantly for the same freedoms for Jews, skeptics, atheists, Catholics and Quakers as for themselves and would no doubt have supported, had there been a British chapter, the Civil Liberties Union!

Today it is estimated that some fifty to sixty million Americans are of evangelical-conservative-fundamentalist persuasion. They are advocates for an amendment to the Constitution declaring that the United States is a "Christian Nation." I have often wondered why this declaration has such appeal and is pursued with such vigor. Perhaps it represents a yearning for the simplicity of colonial years when the population was Protestant, Anglo-Saxon and male dominated. This was the period before the mass immigration of non-Protestant newcomers, when Indians were either converted or decimated, when secular humanism or unbelief dare not lift its head, and when the word of the clergy was law. A "Christian Nation" represents a kind of nativist nostalgia in a pluralist America.

Perhaps another reason for the appeal of the declaration is the fact that the fundamentalist and evangelical segment of the Christian faith has a distinct agenda that needs it. In addition to such clear-cut theological concepts as biblical literalism, blood atonement and Second Coming, they have defined the Christian faith in terms of censorship, sexual orientation, behavior codes, abortion, alcohol and drug use, and a vague something called "traditional values" which, like the Roman Catholic "faith and morals," covers much. The reduction of the Christian faith to such a definition is not new. Neither is the commitment to propagate it from sea to shining sea. What *is* novel is the decision in these latter days to go political and to enter into coalitions and elect "Christian" politicians and appoint justices who will enact and interpret legislation that reflects their "Christian" principles and tenets. If you can once get the country declared "Christian" after their beliefs and commitments, the going for funda-mentalist ideology to prevail in America will be much easier.

Yet another appeal of the declaration that ours is a "Christian Nation" involves a wider segment of Americans and presents a picture that is truly ominous: the religious sanction of our economic, political and military pursuits. We are an innocent people and we revel in our innocence. Unbeknownst to the vast majority of Americans, our foreign policy has always been imperialistic. One has only to read what the young Lincoln said about the Mexican War or what Mark Twain wrote about our conquest of the Philippines to see what the U.S. has always been up to without the challenge of self-discovery. We have persuaded ourselves all along that the goal of our military policies has been the extension of freedom and democracy throughout the world. Who would accuse us of self-interest and economic exploitation? If we devastate the American Indian, it is our Manifest Destiny. If we impoverish our workers and despoil our natural resources, it is in obedience to the inexorable laws of the market and under the guidance of an Invisible Hand that will one day prove a blessing to all. And if the Giant from the North invades the Isthmus of Panama, we vindicate ourselves by calling it "Just Cause." How clever of our phrase-makers to discover this ready-made slogan in our National Anthem:

> Then conquer we must, when our cause it is just.
> And this be our motto, "In God is our trust."

And how comforting and reassuring to know that, since we are a Christian Nation, whatever the Pentagon, the CIA or the State Department do must therefore have heaven's

blessing and that our economic system, whatever its failures, is ordained from above for us. I used to read a publication called *Christian Economics*, and I know people who insist that without capitalism Christianity cannot survive.

It is a spiritual tragedy that our churches have let us get away with this theology. The churches have defaulted from their obligation to serve as conscience of the nation and have become partners in the mesmerism and self-illusion they should deplore. In a land where we profess to believe in church-state separation, the churches for the most part have participated in a kind of self-establishment. They have forfeited their prophetic mandate to distinguish between Caesar and God. It is pointless to preach the evils of alcohol to a congregation of teetotalers or lecture on the toxicity of nicotine to people who have resolutely kicked the habit. It is just as pointless to call upon a nation to do justice and love mercy and walk humbly that recites in its pledge of allegiance that it is already "under God," sings in its national anthem that its cause is just and inscribes on its coins that "In God We Trust." We pay a big price for this breaching of Jefferson's Wall of Separation.

Nevertheless, millions believe strongly that our government is founded solidly on the Christian faith and that the underlying purpose of the Constitution is the establishment of the New Jerusalem in this Promised Land. Having bid farewell to the lands of bondage and persecution, they are convinced that our forebears crossed safely the Great Waters under Divine Guidance and, entering the land flowing with milk and honey, made a covenant with the Almighty and became thereby his chosen people with a special destiny. Hence our laws, our institutions and our customs must always reflect our Christian beginning.

This is a myth that must be challenged and refuted. To do so is becoming increasingly difficult. It is a rewrite of history heard in the churches across the continent and found in the curricula of the schools which they are proliferating and for which they are demanding tax subsidies. Let's look at the facts: The document under which we govern ourselves is not the Mayflower Compact or the Declaration of Independence. It is the Constitution and its Amendments. Nowhere in this document is there a mention of God or Jesus Christ or heaven or hell or church or Bible or sin or forgiveness or prayer. There *are* two references to religion in it and both are NO NO's. The first forbids any religious oath as a requisite for public office; and the second, containing the no-establishment and free-exercise clauses, declares that the government is strictly forbidden from either helping or hindering, advancing or impeding religion, that is, strictly hands off. The Constitution of the United States is as religiously neutral as a scientific treatise or a lecture on genetics. It recognizes no such entity as "Christian Economics." In short, it is a completely secular document and, as a Baptist minister, I love it.

This is all the more remarkable when you recall that it was not written by men who could be called "secular humanists." With the exception of here a deist or there an agnostic, the authors were men of Christian persuasion and church membership. Furthermore, they came from areas where institutional religion was deeply embedded in the structures of government. They knew what an established church meant, paid taxes to pay clergy salaries, and lived under harsh codes enacted at the behest of the church. They were aware of the persecution of Quakers in New England, familiar with the expulsion of Roger Williams in dead winter, and remembered that Patrick Henry in Virginia defended Baptist preachers who were jailed for the crime of preaching the gospel. And being men of learning, they never forgot those "holy wars" that devastated the old countries across the Atlantic. So, meeting in Philadelphia to form a more perfect union, they said, "Never again," "Not in this land," will there be an established church. Christians gave us a document that atheists might well have written.

Benjamin Franklin's call for a pause in prayer for help from divine Providence at a critical moment during the deliberations is often quoted. What has largely passed unnoticed is the response of one of the Founders, when the subject of paid chaplains for the Congress came up, that surely the elected leaders were competent to guide the destiny of the nation without benefit of foreign intervention!

Another disturbing factor about a "Christian Nation" is the slender understanding of its advocates of both the Christian faith and the U.S. Constitution. Christians are required to feed their enemies and do good to those who do evil to them. Who would dare ask the U.S. to go and do likewise? Christians are commanded to live in a condition of mutual trust and forebearance. The Constitution is built around the idea that we dare not put blind trust in our government and hence its balance of powers, its provisions for removal from office, and its first Ten Amendments to guarantee protection of individuals from the infringements of their own government. Religious institutions receive their support from the free will and volition of their members. A government that depends on revenue enhancements that do not have the force of law is doomed to bankruptcy. "East is East and West is West and never the twain shall meet," wrote Kipling. Still there are those who persist in their fantasy that the Faith of the Fathers and the vision of the Founding fathers shall be one—something that bodes untold mischief to both church and state.

This mischief should be obvious when religious symbols are placed on public properties. A huge cross erected on the hilltop of a national park can stir controversy and quite likely be removed by the courts. A Christmas creche included in the paraphernalia of elves and Santa Claus and Rudolph the Red-Nosed Reindeer, etc. and exhibited on city property on a crowded street is more complex. Its presence is ingloriously defended on the ground that the creche, like the other objects, has in fact become a sort of national folklore and is therefore not to be regarded as a distinctly religious symbol. Thus, no state-church violation.

I marvel at the restraint of theologically sensitive people at this outrage and effrontery. The birth of that baby in the creche is the central tenet of the Christian faith, the Incarnation. It represents the belief that Almighty God has through his Son entered into human flesh to bring salvation to the world. And here on city property is a representation of this wondrous mystery that is constitutionally permissible only because the whole thing is just part of the national folklore!

The vast majority of the people pushing for the amendment are evangelical-fundamentalist Christians who have been on the scene since colonial days, and their number is legion. As Lincoln said of the common people, God must love them since He made so many of them. But until recent years, they have not been in the political limelight, out of their own preference. Their traditional ruling passion having been the salvation of souls and preparation for entrance into the true life that lies beyond the grave, they turned aside from mundane matters and political involvement, leaving the outcome in the hands of the Almighty. But in recent years, all this has changed. They have made a compete 180-degree reversal. Aware of their strength in numbers and potential, they have parlayed it into political clout. Furthermore, they have formed a coalition with the political right, which has its own agenda, and have thereby become formidable. In short, we have witnessed in the past decade the politicizing of evangelical and fundamentalist America, and welcome as this may be to millions, it is bad news for the First Amendment.

It is no surprise that the most clamorous opposition to flag burning comes from this quarter. For these people, this is sacrilege and desecration. The flag, being the symbol of

a Christian Nation, is for them therefore something sacred, and to burn it is to desacralize it. It is unthinkable and abhorrent to them that such a practice could come under the protection of free speech. To respect the flag, to honor it for what it represents, is not enough. It must be an object of worship. And so again, when the Constitution and particularly the First Amendment conflict with religious ideology, it's the Constitution that suffers.

Up to now, they have not succeeded either with the amendment or with sacralizing the flag, but they have scored some notable victories under recently friendly courts. A most disturbing example was the determination that "equal access" is constitutional. The argument prevailed that a school that permitted dramatic clubs, foreign affairs clubs, literary clubs, etc. would in effect discriminate and exclude if it denied students the right to have religious clubs, in spite of the fact that the one thing the Constitution itself specifically excludes is religion.

It requires little perspicacity to predict Pandora's Box: The students forgathering in the "club" will be of evangelical-fundamentalist persuasion. They will not long confine their activities to the discussion of the Bible and religion. Soon they will be singing, praying and witnessing. Next they will yearn to share their faith with other students. Finally they will invite adult "advisors" to meet with them and anon there will be replicas of Jerry Falwells on the campus. A scenario for mischief, indeed, when it is discovered that by this ruling of the court, the divisions that tear at the fabric of the religious communions of America are now transported body and soul into the public schools.

The fable of the goose that laid the golden eggs comes to mind. As there are people who, according to Wordsworth, will "peep and botanize over their mother's grave," so the owner of this wonderful bird, driven by the impulse for anatomy, forfeited forever those golden returns. Only in America, in the long history of nations, was the principle enshrined by statute that complete religious freedom shall be guaranteed by church-state separation. And under this principle among a pluralistic people, the religious communions have flourished and prospered as nowhere else in the world. While in the old countries, with their established and state-supported churches, religious institutions have diminished and stagnated, the churches and synagogues in the U.S. have enjoyed phenomenal success in numbers and expansion.

There may be several ways to account for this, but the central and decisive factor is the commitment to the belief that the church must pick up its own ticket without help or hindrance from the state, that each must live and let live, and that Mr. Jefferson's Wall of Separation has been the fence that makes good neighbors. Alas, with the breaching of this wall in our day, we begin the killing of the goose.

While it may be difficult to pinpoint just when the breaching began, the resurgence of the fundamentalists within the past 12–15 years and their entrance upon the political arena has been the prime factor. Today in their growing churches and schools, they are herding a once politically indifferent people into voter registration and electing to public office "Christian" candidates with "Christian" agendas, often replacing stalwart defenders of the First Amendment. Their agenda includes, among other matters, censorship of what we may read or see or hear or sing. It includes the criminalization of abortion and the denial of rights to people of differing gender orientation. It includes the progressive weakening of public schools through the diverting of public monies, direct and indirect, to subsidize their religious schools. And it includes the call for a "Christian Nation" Amendment under which their family-traditional "values" may have a much better chance of enactment into

law. The circle comes full. After setting up a government that, for the first time in history, rejected church-state alignment, we now have what could in fact amount to a more established religion in America than in the nations of Europe!

A frightening scenario but please don't think it unthinkable. It's actually happening. All of us are aware of the steady and relentless conversion of the Supreme Court to one not unfavorable to these aspirations. How many of us are aware that fifty percent of all Federal judges now serving were appointed by Ronald Reagan, the patron saint of the fundamentalists, that these judges are in their early and middle maturity and will be around a long time, and that George Bush is appointing more of the same?

The founders of our nation said some specific things about the preservation of our freedoms. They said that we were a government of laws and not men, thereby warning us against the sway of charismatic and persuasive leaders who come to feel themselves above the law. They told us that since eternal vigilance is the price of our liberties, we must take alarm at the first infringement of any of them. And they reminded us that we neither deserve nor shall we long keep our freedoms if we are unwilling to defend them.

I am profoundly grateful for every ally I have out there defending and upholding the First Amendment and particularly its provision for church-state separation. If they will permit, I thank heaven for the American Civil Liberties Union, for the NAACP, for every Jewish organization for freedom, for Americans United, for People for the American Way, for every secular humanist, for every skeptic, agnostic and atheist, for the AAUP, and for all others who believe in and are struggling to preserve a religiously neutral government with liberty and justice for all. Each group, each individual, has its own very special and all-important contribution to make.

But in the final analysis, the heaviest responsibility for the defense falls upon mainline, Protestant, church-attending America. Mainline Protestant Christians wrote the Constitution providing for strict church-state separation, and mainline Protestant Christians must protect and defend it today. No one can accuse this sector of being anti-Bible or anti-family as they do the ACLU. No one can charge that they are a godless religion as they do the secular humanists. No one can say that they are denying the faith as is said of the agnostics and the atheists. No one can blame them for undermining the moral fiber of the young as they do some of the professors. In short, in spite of all their failures, they are not susceptible to this kind of arraignment. They are Teflon, they are invulnerable, and they are mandated for this engagement.

One thing, however, gives pause. They are the one group to take on the fundamentalists and evangelicals. And the battle will never be joined without this confrontation. And here their faith will be put to its severest test, for many of their members belong to the political right that has made common cause with the religious right. Their political and economic success has depended largely upon this coalition, and, being human, it may be an all but impossible task to win their hearts and minds from gain to principle. They must cease and desist the unholy trade-off of school prayers, public subsidies for religious academies, abortion criminalization, censorship, "Christian America" for anti-labor, anti-welfare, anti-environment, anti-tax reform, and pro-Pentagon support wherein the First Amendment is sacrificed.

But win them or not, mainline Protestant America must join hand and heart with the secular humanist and the ACLU and all other Americans who are dedicated and prepared to defend the mandate that "Congress shall make no law respecting an establishment of religion or prohibiting the free exercise thereof."

Freedom of Speech Without a Constitutional Guarantee: A State Case History

Harry C. Martin and Donna B. Slawson

For a period of at least two hundred sixty-two years prior to 1925, the people of what is currently known as the State of North Carolina lived without a constitutional guarantee of the right of freedom of speech. This article will briefly examine the manner in which cases involving what we today identify as freedom of speech issues were disposed of by the courts of North Carolina during that period.

Historic Background

After attempts by Sir Walter Raleigh in the 1580's to colonize territory now including the State of North Carolina, this area was granted by King Charles II to eight lords proprietors in 1663 and 1665.[1] The charters so issued did not directly contain any grant of freedom of speech to the inhabitants of the territory.[2] The charters did contain, however, provisions providing that such colonists would be entitled to the rights of Englishmen as they then existed.[3] However, freedom of speech was not one of the fundamental rights of Englishmen as enunciated in the Magna Carta obtained from King John in 1215,[4] the Petition of Right, the Habeas Corpus Act passed under Charles II, the Bill of Rights enacted in Parliament, and the Act of Settlement.[5] These rights were viewed by Blackstone as natural rights and consisted of three primary articles: the right of personal security in one's life, limbs, body, health, and reputation; the personal liberty of locomotion and freedom from imprisonment, except by due course of law; and the right to the free use, enjoyment and disposal of property, without control, except by the law of the land.[6] Neither the Petition of Right, the Bill of Rights (two of the great constitutional documents of England which provide the fountainhead of our Federal Bill of Rights), nor the North Carolina Declaration of Rights of 1776 contain a reference to freedom of speech.[7]

On 21 July 1669, the lords proprietors proclaimed the Fundamental Constitutions for the government of Carolina.[8] Certain safeguards for the benefit of the people were contained in the Constitutions, including a prohibition against double jeopardy in criminal prosecutions, the right to a trial by jury of twelve, a right of freeholders to vote for representation in the Parliament, and, to some extent, freedom of religion.[9] The Constitutions contained no reference to a guarantee of freedom of speech. Thereafter, Carolina became a Crown Colony and remained so from 1729 until the Revolution of 1776.[10] During this period, freedom of speech was not recognized by the royal government.

On 12 April 1776, in the midst of the American Revolution, the Halifax Resolution was adopted by the Provincial Congress of North Carolina.[11] It made no reference to freedom of speech, nor, again, did the Declaration of Rights of North Carolina, which was ratified

on 17 December 1776.[12] The 1776 Constitution containing the Declaration of Rights was promulgated on 18 December by the Fifth Provincial Congress[13] and became effective upon promulgation; it was not adopted by a vote of the people. North Carolina was not alone in failing to recognize freedom of speech, as witnessed by the early constitutions of Rhode Island, Delaware and New Jersey, none of which contained such a guarantee.[14]

Although the North Carolina Legislature had ample opportunity to amend the North Carolina Constitution to include a guarantee of freedom of speech, it did not do so until 1971. The 1776 Constitution was substantially amended in 1835, and the Constitution of 1868, ratified by the people, contained no freedom of speech guarantee.[15] Finally, after a fifteen-year effort, the Constitution of 1971 was adopted by a vote of the people, including, for the first time in the history of the state, a constitutional guarantee of freedom of speech. The provision reads: *"Freedom of Speech and Press.* Freedom of speech and of the press are two of the great bulwarks of liberty and, therefore, shall never be restrained, but every person shall be held responsible for their abuse."[16] Notably, this provision of the 1971 Constitution does not create the right of freedom of speech but merely guarantees that such existing right shall not be impaired. To understand the nature of this pre-existing right, we look to the common law for evidence of just what it was that was being guaranteed.

The Common Law

The common law embraces that great body of unwritten law founded upon general custom, usage or common consent, and based upon natural justice or reason. It is the system of rules and declarations of principles from which our judicial ideas and legal definitions are derived.[17]

In the years before the Revolution, freedom of speech in America was a restricted freedom. In England, the source of our common law, free speech had been denied to papist and religious heretics, and even with respect to others the right to speak was limited.[18] In fact, it has been said that freedom of speech was "little else than the right to write or say anything which a jury, consisting of twelve shopkeepers, think it expedient should be said or written."[19] One could say what he pleased if he was willing to assume the risk of the consequences. Nevertheless, insofar as it existed in England, freedom of speech was a part of the common law of North Carolina at the time of the American Revolution. Thus, when the colonists came to America, they brought with them such limited freedom of speech as Englishmen enjoyed at that time.

Without a constitutional guarantee of freedom of speech, how in practice was this important right addressed in the state courts of North Carolina?

A review of the North Carolina decisional law indicates that until 1925[20] the courts of this state basically failed to apply what are now considered fundamental freedom of speech principles. Research does not disclose a single case in North Carolina prior to 1925 where the result of the trial court was reversed or overturned because of a violation of freedom of speech rights. This lack may have been due to the failure of counsel to brief and argue freedom of speech issues to the appellate court in cases where these issues could have been addressed. Courts are generally reluctant to decide cases upon principles which have not been argued and briefed by the parties. But the global—or perhaps we should say statewide—absence of awareness of the possibility of argument based on free speech principles may have been due to a larger social concern focused more on the economic development of the state than the liberties of particular individuals.

Prior to 1865, the state courts of North Carolina apparently were principally concerned with protecting and stimulating the economy, preserving property rights rather than personal liberties, maintaining quiet and good order, and preserving the status of slaves. The reported decisions of the appellate courts of North Carolina with which we are concerned can be roughly separated into several groups. The first contains cases in which sanctions were sought to be imposed upon individuals whose speech was allegedly libelous or slanderous. In this category we find the early case of *Hamilton v. Dent*, the first case in which the Supreme Court of North Carolina had an opportunity to apply First Amendment principles to its analysis.[21] In this case, plaintiff had accused defendant of swearing false in two particulars in an oath in court. The jury returned a verdict in favor of the plaintiff in the amount of 60 pounds. Upon appeal, the Court was concerned only with the question of whether the words so spoken were required to impute a crime on the part of the plaintiff in order to state a cause of action. No argument was made by counsel based on freedom of speech nor was it mentioned by the Court in its reported opinion. Some twenty-two years later, in *McGuire v. Blair*,[22] the Court again avoided freedom of speech issues by the simple expediency of declaring that the allegedly defamatory words spoken by the defendant were not slanderous. In so doing, it is obvious that the Court was not cognizant of the application of First Amendment principles to the language used by the defendant.

During the early development of the state, protecting peace and tranquility from disruption was one of the state's primary objectives. In this regard, a second group of cases is found in which the courts used the doctrine of common law nuisance in order to punish such activities as profane swearing or other disruptive conduct. For example, in *State v. Kirby*, a profane swearing case, defendant "swore several oaths in the courtyard during the sitting of the court. . . ."[23] The appellate court held that profane swearing in and of itself was not an indictable offense, unless it caused a nuisance by greatly disturbing citizens who heard it. No reason was given for the holding that swearing in and of itself was not indictable.[24] By limiting its analysis to the framework of a common law nuisance theory, the Court inadvertently protected the defendant's individual right of speech, a result consistent with present interpretations of the First Amendment. The same analysis was applied in *State v. Ellar*,[25] where the Court again held that, although a single act of drunkenness or profane swearing was not indictable, if such acts were repeated publicly to the annoyance and inconvenience of the citizens at large, they would be indictable as common nuisances. In this kind of case, instead of considering the speech rights of the speaker, the Court appeared to be deciding the appeal on the basis of whether the act complained of was significant enough to punish.

In *State v. Baldwin*,[26] seventeen defendants were indicted for having gathered at a meetinghouse and using loud and profane swearing, thereby disturbing a singing school then in session. The Supreme Court decided the case by determining that the indictment for these offenses was invalid on its face. Writing for the Court, Justice Gaston did not use the phrase "freedom of speech," although he anticipated later constitutional doctrines when he wrote:

If we sustain this as an indictment for a common nuisance, we shall be obliged to hold, that whenever two or more persons talk loud or curse or quarrel in the presence of others, it may be charged that this was done to the common nuisance, and if so found, will warrant punishment as for a crime. This would be either to extend the doctrine of common nuisances, far beyond the limits within which they have hitherto been confined, or to allow a vagueness and generality in criminal charges, inconsistent with that precision and certainty on the records so essential as restraints on capricious power, and so salutary as the safeguards of innocent men.[27]

The Supreme Court often seized upon defects in indictments to reject guilty verdicts in such cases. Another of these was *State v. Jones*, in which the Court held that, in order for an indictment to be proper, it had to allege that the acts of profane swearing were "so repeated and public as to become an annoyance and inconvenience to the public."[28] It can be inferred from cases in which the Court was relying upon defective pleadings to overturn convictions that the Court was tacitly recognizing the inherent right of an individual to speak his mind and was restricting the use of common law nuisance in the control of speech. This is also apparent in *State v. Powell*[29] where the Court held that profane swearing in public in and of itself was not a crime. This was, in effect, a holding that, absent an allegation of facts to support a common or public nuisance, swearing in and of itself was not indictable.

During the Reconstruction Era, the Court tended to interpret what we would now acknowledge as cases involving free speech claims more favorably to the State. For example, in *State v. Widenhouse*,[30] the defendants were convicted of forcible trespass upon the theory that they rode up and down the public road in front of the prosecutor's house, all the while singing, dancing, cursing, and swearing and causing serious disturbance to the prosecutor and his wife. Obviously, under the previous cases these acts did not constitute a common nuisance as only the prosecutor and his wife were affected— there was no allegation that the disturbance affected the public at large. Moreover, it is certainly questionable whether one can "trespass" against anyone while travelling on a public road. The Court, however, sustained the forcible trespass conviction upon a theory that, although the road was public, the prosecutor owned the land on both sides of the road and, therefore, he owned the soil beneath the road, the highway being only an easement for public purposes. This indeed was a strained theory of property law used to punish defendants for actions clearly defensible within freedom of speech principles.

Similarly, in the 1881 case of *State v. Chrisp*,[31] the Court also seemed to be moving towards a more restrictive treatment of free speech rights. Here, the Court relied on Blackstone's *Commentaries* when holding that, although a man may be, in private, wicked and abandoned in his principles, if he so acts publicly then it is "the business of the law" to correct him, for such conduct "outrages decency, or is injurious to public morals."[32] It went on to hold that the use of profane language in a public place on a single occasion for five minutes could amount to a public nuisance, provided the public at large is offended and annoyed. The Court thus abandoned its prior holdings that there must be repeated acts of such conduct before the indictable behavior constituted a common law nuisance.

During this time, various municipalities began to adopt ordinances prohibiting certain forms of speech. In *State v. Cainan*,[33] the defendant was charged with violating an ordinance prohibiting loud and boisterous cursing and swearing. Defendant had apparently loudly cursed and sworn for some twenty minutes on someone's private property. The ordinance involved did not prohibit behavior which could be analyzed as a nuisance, as the forbidden acts did not have to be done in the presence or hearing of other persons in order to be punishable. However, the Court did note that the purpose of the ordinance was "to promote good morals, the decencies and proprieties of society, and [to] prevent nuisances and other criminal offenses. . . ."[34] The use of such ordinances to control speech and conduct spread rapidly. E.g., *State v. Debnam*[35] involved another "boisterous cursing" ordinance. There, defendant, a "colored man," and two women had blocked a sidewalk so that a local doctor could not pass without touching one of them. While walking by them, the doctor's arm gently brushed the arm of one of the women. Defendant began to verbally abuse the doctor in an angry manner loud enough to attract the attention of people

nearby. The doctor testified that he proceeded on and, although he heard the defendant abuse him in an angry manner, he did not hear defendant curse or swear. Another witness testified that he did hear the defendant swear. The opinion makes note that all of the defendant's witnesses were "colored." The Court also referred to the [presumably] white doctor as a "cultivated, refined, and spirited" witness.[36] Based upon *Cainan*, the Court upheld the ordinance and affirmed the conviction. Neither the court nor counsel made any reference to freedom of speech issues, and the case clearly appears to have racial overtones.

Finally, from the year 1893, we find a case at least recognizing freedom of speech in North Carolina. In *State v. Warren*,[37] the defendant pled guilty to violating a statute making it unlawful to use profane language to the disturbance of the peace on the lands of Henrietta Cotton Mills in Rutherford County. The question on appeal was whether the facts charged and admitted constituted an offense punishable under the law and Constitution. The constitutionality of the statute was questioned upon two grounds, one being that the statute interfered with the freedom of speech. In addressing this issue, the Court merely stated:

The Legislature could have empowered a municipality to make the use of such language punishable by its ordinances, when it falls short of being a nuisance, punishable by State law, from not having been "committed in the presence and hearing of divers persons, to their annoyance," etc. *S. v. Cainan*, 94 N.C., 880; *S. v. Debnam*, 98 N.C., 712. Of course the Legislature could do this directly, if it could do it indirectly, as by authorizing a municipality to make an ordinance to that effect.[38]

This is the first opinion our research disclosed in which the words "freedom of speech" were used by the North Carolina Supreme Court. Although counsel for the defendant was able to convince the trial judge that the statute was unconstitutional in this case, the Supreme Court reversed on other grounds. Speaking for the Court, Justice Clark did not analyze the freedom of speech question at all, merely reasoning that under *Cainan*, had a municipality been properly delegated with the authority to adopt such an ordinance, it would have been constitutional, and, therefore, the Legislature's enactment of this statute was also properly constitutional. It appears that this opinion may have been motivated in part by economic interests, because at that time Henrietta Cotton Mills was one of the larger industries in Rutherford County. This lends credence to the general notion that economic property interests at that time were paramount to personal rights.

Another first was the 1894 case of *State v. Horne*.[39] Here, the Court did hold an anti-swearing ordinance invalid, although not on grounds that would predictably be applied by contemporary First Amendment legal analysis. Again, this is not surprising as there were no constitutional guarantees protecting freedom of speech in North Carolina at the time this case was decided. In *Horne*, Justice Clark, again writing for the Court, held that the absence of a requirement that the conduct be "loud or boisterous" or that it "disturbed the peace" rendered the ordinance invalid.[40] Although not discussed in terms of First Amendment principles, the underlying assumptions of the opinion appear to be congruent with what would be considered First Amendment issues today. In the *Horne* case, it is also to be noted that there were no overt property or economic interests competing with the defendant's interest in being able to speak freely.

Beginning in the 1890's, we find disorderly conduct ordinances being enforced for the purpose of controlling speech as well as behavior. For example, in *State v. Sherrard*, a defendant was convicted of violating an ordinance prohibiting "all disorderly conduct . . . within the city limits."[41] The evidence showed that defendant entered a restaurant and

called the prosecuting witness "a damned highway robber" in a loud manner that could be heard on the street. Upon a verdict of guilty, he was fined a penny. When defendant appealed, the conviction was upheld and the validity of the ordinance was sustained, even though the conduct did not amount to an indictable nuisance. The appellate court stated that, although the behavior involved was not prohibited by a state statute, "if it could not be punished by the city ordinance, [it would] become a serious annoyance to the public passing along the streets, hearing such loud boisterous and unseemly language and threats of violence."[42] Again, Justice Clark was the opinion writer and failed to discuss any freedom of speech issues. In *State v. Moore*,[43] a female defendant was convicted of cursing on the streets in a loud and disorderly manner. As she stepped into her buggy, she told a policeman, who cautioned her not to drive through the town, that she would drive "where she damned please [sic]."[44] No one other than the policeman heard the statement. The Court declined to enter upon a casuistical discussion of whether "damn" was profanity and decided the case upon the theory that defendant's conduct was not disorderly within the meaning of the ordinance. The conduct did not tend to disturb the peace or good order of the town and had no vicious or injurious tendency.[45] It is possible that the Court may have considered the case lightly because of the fact that the defendant was female. The Court stated "[t]he defendant expressed her displeasure, or futile indignation, a little too strongly, and should not have used so indecorous an expletive in doing so, but it did not reach beyond the ears of the policeman, and hardly made a ripple on the placid surface of municipal peace."[46]

An interesting non-criminal case involving freedom of speech issues arose in *Seawell v. R.R.*[47] This case involved an action against a railroad for failing to protect the plaintiff, a ticketed passenger, who was waiting for his train. While standing on the railway platform, plaintiff was assaulted by a mob throwing eggs at him. Plaintiff was the Republican Party candidate for Lieutenant Governor of North Carolina, and he had spoken that day in Cleveland County, a Democratic stronghold. In the opinion, Clark, then Chief Justice, said:

> The Constitution and laws of this State guarantee freedom of speech, and nothing could be more unmanly than a mob assailing one man in such manner for his difference from them in his political opinion. No right thinking man, here or elsewhere, will express other opinion of the proceeding, and the most that can be said is that it was the act of a mob, for which the community was not responsible.[48]

Unfortunately, this was the extent of the Court's remarks with respect to freedom of speech. As we know from our earlier discussion, the Chief Justice was in error in stating that North Carolina had a state or enforceable Federal constitutional guarantee of freedom of speech at the time this case was decided. There was also no statutory law guaranteeing free speech at the time. However, as shown earlier, the common law of North Carolina did protect free speech to some degree.[49] It may have been that Justice Clark based his statement upon this sort of precedent.

Another series of cases that would nowadays trigger an analysis under First Amendment principles involved the disturbance of religious services. In these cases, the Court would often discuss freedom of religion while not discussing the doctrine of freedom of speech. For example, in *State v. Jasper*, defendant was charged with disturbing a congregation by laughing, talking, and making "ridiculous and indecent actions and grimaces."[50] His conviction was affirmed on appeal. The Court recognized the freedom of persons to

worship according to their own consciences, noting that the Constitution guaranteed freedom of religion as a pre-existing natural right. Although there was no statute prohibiting the disturbance of religious assemblies, the Court found that the common law of the state proscribed such conduct, reasoning that it constituted an injury to the whole community. Even though the Court expressly stated that the offense was not charged as a nuisance, the logic the Court applied is similar to that found in common law nuisance cases, which at one time required that the action complained of be an annoyance to the community. *State v. Linkhaw*[51] concerned a defendant who was indicted for disturbing a religious congregation by the manner in which he sang the hymns. His singing was "described [as being] so peculiar as to excite mirth in one portion of the congregation and indignation in the other."[52] In addition, his voice was heard after all the other singers had ceased. The Court upheld the defendant's right to sing even though it did disturb the congregation, reasoning that the singing of hymns was a part of the worship service and protected under the constitutional guarantee of freedom of religion. In *State v. Ramsay*,[53] the defendant was charged with the offense of disturbing a religious congregation and obstructing public worship. The events giving rise to this charge arose when defendant spoke out in church concerning his expulsion from the congregation two weeks previously. Defendant was removed from the church house, but re-entered immediately and began speaking. In the confusion, the meeting was broken up, and those present left the church and returned home. The Supreme Court held that, even if the jury found that defendant was still a member of the congregation, his conduct was subject to criminal penalties because he was not participating in the worship service as was the defendant in *Linkhaw*. Instead, he was interfering with the religious devotions of others by "making known his own grievances . . . in so boisterous a manner as to disturb and finally break up the meeting altogether, and thus frustrate the object for which it was held. . . ."[54]

The Court also dealt with cases involving other types of conduct which could be analyzed under freedom of speech principles. In *State v. Waller*, the defendant was charged with repeated incidences of common drunkenness "contrary to morality, [and] to the great displeasure of Almighty God. . . ."[55] Without referring to First Amendment principles, the Court held that private drunkenness was no offense under the law. To be subject to criminal indictment, it must be so open and exposed to public view as to be a public nuisance. The Court in *State v. Deberry*, expanded and solidified this rule by requiring a showing the defendant's conduct must operate to the "annoyance" of the public at large in order to be indictable.[56] The Court stated there were many immoral acts best left to correction by the religious and moral influence of society, instead of being held to the level of an indictable offense. However, in so doing, the Court did not rely on First Amendment concepts.

In cases involving slaves, the Court adopted more stringent rules. Although lenient in the treatment of slaves while on their masters' property, harsher efforts were otherwise made to control them when off the plantation. One of two cases illustrating this is *State v. Boyce*.[57] There, the Court upheld the right of a master to allow his slaves to meet and dance on his premises on Christmas night even though some white persons as well as slaves owned by other people joined in the merrymaking. In *Boyce*, the defendant slaveowner was found guilty at the trial level of keeping a disorderly house by, *inter alia*, permitting whites and blacks to mingle together, "drinking, tippling, and otherwise misbehaving themselves . . . to the common nuisance, etc., and evil example, etc. [of the community]."[58] On appeal, the Supreme Court observed that the most that the evidence would support was a finding that "[t]he criminality here, then, must consist, if in anything, in the assemblage of negroes and their dancing and thereby making a noise—for no other

kind of noise or disorder is suggested—and in the mingling of the two colors together in the same house and dance. . . ."[59] The Court vacated defendant's conviction, holding that the activities described did not rise to the level required for a conviction of the crime of keeping a disorderly house. To the contrary, "[a]s far as appears, it was but harmless merriment. . . ."[60] Thus, without deciding the case under clear freedom of speech principles, the Court seems to have allowed greater leeway for permitting slaves to assemble, sing, and dance than in an ordinary public nuisance case.

In contrast to *Boyce*, the case of *Town of Washington v. Frank and John*[61] shows that once slaves were off the property of their master, harsher rules were applied restricting their attempted exercise of free speech. Frank and John, two slaves, were charged with violating an ordinance forbidding all disorderly shouting, dancing and disorderly assemblies by slaves and free Negroes on the street, in the market and in other public places in the town. A slave convicted of violating the ordinance was to receive not more than thirty-nine lashes. The Court found the ordinance lawful and constitutional without applying any free speech principles to its analysis. In fact, the Court held defendants were guilty even though the noise was made in otherwise harmless play. Perhaps a true insight into the Court's decision is found in the statement that slaves "compose so large a portion of the population . . . that, in passing rules and regulations for their government, much must be left to the judgment and discretion of those who are to enforce them in their application to particular cases."[62]

Turning to yet another group of cases, we find again that the 19th century Supreme Court failed to discuss freedom of speech principles when faced with facts involving the right to peaceably assemble. In *State v. Hughes*,[63] defendants were charged with rioting, committing common nuisances, and obstructing the streets, all as results of parading down the streets of Oxford, North Carolina. This case arose shortly after the termination of martial law following the Civil War; the charges arose out of defendants' celebration of the Emancipation Proclamation. Defendants, some on horseback, had assembled in town and paraded through the streets, with drums and fifes for two or three hours. They dismounted upon request but refused to disburse, going instead to the mayor's house with drums beating, apparently intending to test the right of the mayor to forbid the procession. No violence in any form was exhibited. The Supreme Court held for the defendants, finding that the assembly was lawful and, therefore, could not be a riot. The beating of the drums and blowing of the fifes did not create a common nuisance; only a few persons and one horse that "broke loose" were disturbed, not the community as a whole. With a good First Amendment argument, the Court concluded its opinion:

> In a popular government like ours, the laws allow great latitude to public demonstrations, whether political, social or moral, and it requires but little reflection to foresee, that if such acts as are here found by the jury, are to be construed to be indictable, that the doctrine of riots and common nuisances, would be extended far beyond the limits heretofore circumscribing them, and would put an end to all public celebrations, however innocent or commendable the purpose.[64]

A similar case arose in *State v. Hunter*,[65] in which defendant was charged with violating an ordinance prohibiting assembling and loitering on the streets in sufficient numbers to cause an obstruction to free passage on the streets or sidewalks. Four or five men were on the sidewalks; when they were requested to disburse, all left except one who refused to move one. He was thereupon arrested. The Court held that one man cannot be guilty of a nuisance by merely standing still on the sidewalk and refusing to move at the command

of an officer. Any obstruction present was removed when the other persons disbursed. The Court further recognized that city ordinances were subject to the state and Federal constitutions, and that the ordinance was void because it purported to give the officer power to arrest a person and take him to prison without warrant, preliminary hearing, or opportunity for bail. Here, a state court at least recognized that Federal constitutional principles could be applied in the determination of the constitutionality of a local ordinance, some thirty-five years before the United States Supreme Court took this step.

Even with a limited common law right of freedom of speech, the courts failed to analyze and apply freedom of speech principles. This may have been due in large measure to the absence of any constitutional guarantee of freedom of speech and the accompanying guidelines created by the development of a constitutional body of law. The application of the Federal First Amendment to the states in 1925 and the adoption of freedom of speech clauses in state constitutions removed this impediment to the development of freedom of speech law at the state level.

Notes

1. John Locke, *A Collection of Several Pieces of Mr. John Locke* (London, 1720) 1–53.

2. J. Cheney, Jr., ed., *North Carolina Government 1585–1974* (1975) 97–98.

3. "Charter to the Lords Proprietors of Carolina, March 24, 1663," *North Carolina Government*, supra note 2, 99, 102.

4. Magna Carta (1215). For a general discussion of the Magna Carta, see J. Holt, *Magna Carta* (1965); A. Howard, *The Road From Runnymede: Magna Carta and Constitutionalism in America* (1968); 1 F. Pollock & F. Maitland, *The History of English Law*, 2d ed. (1968) 171–173. Many of the limits to the right imposed at that time—such as the publication of libelous, blasphemous, or indecent articles or other publications injurious to public morals or private reputation—continue to apply in varying degrees today.

5. I. W. Blackstone, *Commentaries* (1783) *128.

6. *Id.*

7. *Id.*, North Carolina Constitution, *A Declaration of Rights* (1776).

8. John Locke, supra note 1.

9. *Id.* 30, 32–33, 42–47.

10. *Id.* 2.

11. "The Halifax Resolution of 12 April 1776, *North Carolina Government*, supra note 2, 405.

12. Clark, ed., "The Declaration of Rights," *XXIII State Records of North Carolina: Laws 1715–1776* (1905) 977.

13. North Carolina Constitution (1776).

14. Delaware Constitution (1776), New Jersey Constitution (1776), Rhode Island Constitution (1845).

15. North Carolina Constitution (1868).

16. Section 14, Article I., Declaration of Rights, North Carolina Constitution (1971).

17. See generally O. W. Holmes, Jr., *The Common Law* (1881).

18. A. Dicey, *Introduction to the Study of the Law of the Constitution*, 8th ed. (1920) 240–41.

19. *Id.* 242.

20. In 1925, the Supreme Court of the United States held for the first time that the First Amendment of the Federal constitution applied not only to Federal action, but also to the official actions of individual states as well. Until then, neither the common law nor legislation of North Carolina was constrained by the guarantee of freedom of speech provided by the Federal constitution. *Gitlow v. New York*, 268 U.S. 652, 45 S. Ct. 625, 69 L. Ed. 1138 (1925).

21. 2 N.C. (1Hayw.) 116 (1794). The First Amendment to the Constitution of the United States became effective in 1791.

22. 4 N.C. (Car. L. Rep.) 328 (1816).

23. 5 N.C. (1 Mur.) 254, 254 (1809).

24. Although not rising to the level of an *indictable* offense, a single act of profane swearing was apparently punishable as a less serious offense. See *State v. Kirby*, 5 N.C. (1 Mur.) (1809) 254, 254 (stating that profane swearing in and of itself "is cognizable before a justice of the peace, under the Act of 1741, ch. 14.") This remained the case at least as late as 1848. See *State v. Jones*, 31 N.C. (9 Ired.) 38, 40 (1848) (single act of profane swearing punishable by "a fine for each act, to be imposed by a single magistrate, upon conviction before him.")

25. 12N.C. (1 Dev.) 267 (1827).

26. 18 N.C. (1 Dev. & Bat.) 195 (1835).

27. *Id*. 199.

28. 31 N.C. (9Ired.) 38,40 (1848).

29. 70 N.C. 67 (1874).

30. 71 N.C. 279 (1874).

31. 85 N.C. 528 (1881).

32. *Id*. 534.

33. 94 N.C. 880 (1886).

34. *Id*. 881.

35. 98 N.C. 712, 3 S.E. 742 (1887).

36. *Id*. 716.

37. 113 N.C. 683, 18 S.E. 498 (1893).

38. *Id*. 685, 18 S.E. 498–99. See also *State v. McNinch*, 87 N.C. 567, 570 (1882) in which the Court remarked that an ordinance prohibiting loud and profane swearing and public drunkenness was "adopted not merely to secure the citizens of the city against annoyance, but to prevent the evil example of such immoral conduct."

39. 115 N.C. 739, 20 S.E. 443 (1894).

40. 115 N.C. 741, 20 S.E. 443.

41. 117 N.C. 717, 718, 23 S.E. 157, 157 (1895).

42. *Id*. 720, 23 S.E. 158.

43. 166 N.C. 371, 81 S.E. 693 (1914).

44. *Id*. 371, 81 S.E. 694.

45. See generally Rabban, *The First Amendment in Its Forgotten Years*, 90 Yale L.J. 514, 543–49 (1981) (discussing the "bad tendency doctrine" applied by state courts in restricting free speech.

46. 166 N.C. 373, 81 S.E. 694.

47. 133 N.C. 515, 45 S.E. 850 (1903).

48. *Id*. 516, 45 S.E. 851.

49. See discussion infra, beginning at page 5.

50. 15 N.C. (4 Dev.) 323, 323 (1833).

51. 69 N.C. 214 (1873).

52. *Id*. 216.

53. 78 N.C. 448 (1878).

54. *Id*. 453.

55. 7N.C. (3 Mur.) 229, 229 (1819). Strangely, although the indictment in this case alleged that defendant's drunkenness was "open and notorious," the Supreme Court held that the indictment was defective because it failed to allege that the drunkenness "was open and exposed to public view. . . ." *Id*. See also *State v. McNinch*, 87 N.C. 567, 570 (1882) (noting "the difference between public drunkenness and drunkenness in a public place").

56. 27 N.C. (5 Ired.) 371 (1845). Again, certain individual acts were punishable by fine. See supra, footnote 24.

57. 32 N.C. (10 Ired.) 536 (1849).

58. *Id*. 537.

59. *Id*. 540.

60. *Id*. 542.

61. 46 N.C. (1 Jones) 436 (1854).

62. *Id*. 440–41. This is certainly consistent with the common practice of the time colloquially called "pattyrolling." See B. Hurmence, *My Folks Don't Want Me Talk About Slavery: Twenty-One Oral Histories of Former North Carolina Slaves* (1984). In "pattyrolling," agents of the overseers of plantations would stop blacks thought to be slaves travelling off their masters' property and would

demand to see passes justifying their free travel. They would then administer ad hoc punishment at their discretion if the person stopped was traveling without a pass. Cf. also M. Tushnet, *The American Law of Slavery 1810–60* (1981) 90–121 (offering an interpretation of cases from the North Carolina courts dealing with slave crimes); Nash, *Fairness and Formalism in the Trials of Blacks in the State Supreme Courts of the Old South*, 56 Va. L. Rev. 64 (1970); Taylor, *Humanizing the Slave Code of North Carolina*, 2 N.C. Historical Review 323 (1925).

63. 72 N.C. 25 (1875).
64. *Id.* 28.
65. 106 N.C. 796, 11 S.E. 366 (1890).

An Inquiry into the Legal and
Ethical Problems of Campus Hate Speech

Robert M. O'Neil

Few topics have aroused as much recent interest as that of speech which wounds or offends by its reference to race, gender, religion, nationality, handicap, or sexual orientation. Much has been written on the subject in the years since it achieved its current prominence. A dozen state legislatures have addressed the issue within the past decade. A growing number of colleges and universities have adopted rules and regulations designed to ban or punish such speech, and a few of those policies have been tested in court. Yet, the issue remains curiously lacking in focus and a cause of extraordinary ambivalence within the academic community for reasons that derive from the conflict of values at the core of the issue.

The issue has had a special appeal to me for nearly a decade since I first appreciated the deeply troubling tension of constitutional values. In the time since I first addressed it in 1982, relatively little has changed. There have been more laws, more rules, more regulations—but not necessarily any clearer understanding of the central questions at stake.

This issue has clearly been most prominent of late on the university and college campus. A *New York Times* editorial several years ago marked the emergence of the issue to its current prominence, on the eve of the rule-making frenzy. The editorial was captioned, "Racism: From Closet to Quad." The opening paragraph sets the tone: "Crude, overt racial bigotry has again come out of campus closets and onto the quad. Reports of public slurs, cross burnings, even outright physical conflict now ring routinely from schools throughout the country, including some of the most prestigious. A society's universities ought to be among its chief civilizing influences. Lately, however, America's seems to be incubators of racial intolerance."

The editor who probably wrote the editorial might recall that the issue is not entirely a product of the 80s. He and I were college classmates in the 1950s and shared many relevant experiences during those superficially tranquil times. Since we, as undergraduates, lamented editorially the small number of minorities and the omission of other groups from much of the academic mainstream, we surely know the issue is not new. Yet, he rightly cautions that within recent years there seems to have been a resurgence of incivility, of insensitivity and downright hostility on college and university campuses where—of all places—people should know better.

A recent sampling of incidents should illustrate the range of issues and problems. In this survey I omit, of course, physical assaults and the like and confine myself to events involving expression that arguably claims constitutional protection, but causes deep con-

cern not only for those who are its targets but also for those who must mediate contending viewpoints and contending forces.

The central issue we face, which is the theme of my comments here, is to what degree we should treat speech of this kind differently from other and more familiar forms of expression.

Several years ago, a group of Jewish students at the University of Maryland asked the administration to bar speakers with extremist views in the wake of comments made by a visitor to College Park during Black History Month. The speaker, now called Kwame Toure, was once known as Stokely Carmichael. He was reported to have said during his talk, "The only good Zionist is a dead Zionist."

A somewhat similar issue had troubled the State University of New York at Stony Brook during the late 1980s and in June of 1990 occasioned AAUP censure of the institution. The campus and eventually the SUNY system denied tenure to a black faculty member who in 1983 said to one of his class that he believed Zionism was a form of racism—although other and different factors apparently entered the decision by that time. His presence on the faculty had been strongly criticized by jewish and other groups. Others protested that a denial of tenure would abridge his academic freedom if it implicated in any ways his expressed views on this sensitive subject.

About the same time, a trustee of Wellesley College was taken to task for having remarked that blacks she employed in Los Angeles preferred pushing drugs to working in her factory; she added that she had trouble keeping minority assembly line workers "from going back to the street to earn more money" selling drugs. While the trustee's resignation from the board and her apology largely mooted the issue, vigorous debate followed over whether such a comment was impermissibly racist or was simply, as one senior faculty member argued, a perception of real life on the factory floor.

The institution with which I was formerly associated had two troubling experiences after I left Wisconsin. In the fall of 1985, a group of protestors, mostly women, demanded the removal from the memorial union newsstands of certain allegedly sexist magazines. Some of the group staged a "pornography read-in" outside the Chancellor's office. The Chancellor insisted, however, that the newsstand policies be content-neutral in selection of magazines, although that judgment did not end the dispute.

Later, the Madison campus was offended by a degrading caricature of a black man displayed in front of a fraternity house during an early May weekend. The chapter was suspended and the Regents resoundingly condemned racism throughout the university system. But feelings among black students and others remained high through the end of the academic year. These experiences and one or two others led the Regents of the University of Wisconsin System in 1989 to adopt restrictions on offensive and demeaning speech, which have recently been challenged in Federal court by the Wisconsin chapter of the American Civil Liberties Union.

Speaking of Greek letter organizations, a fraternity and a sorority at the University of Southern California were suspended several years ago because some of their members had chanted anti-Semitic slogans and painted "Jew Week" on the sidewalk in front of a predominantly Jewish fraternity house.

Finally, the University of Michigan seems to have had an unusually difficult experience, doubtless leading in part to the adoption of the most widely publicized restrictions in the university world. In 1987, a student disc jockey broadcast racist jokes on the campus radio station. Several weeks later, a white student admitted having prepared and distributed a

flier that declared "open hunting season" on blacks. Copies were slipped into a lounge where a group of black women were meeting.

Then, that April came the most curious event of all. Someone discovered in a campus mainframe computer a large collection of racist and ethnically offensive jokes. The student who started the file then froze it, using access which many members of the university community shared. The campus administration condemned the contents of file, although no rule or policy specifically forbade.

So much for the incidents; there are many more in the files. But these examples should pose the issue. Surely it is not new—recall, for example, the bitter controversy at several universities which had an American Indian as their mascot or symbol; some decided to change symbols, while others retained the Indian despite protest from native Americans.

It is also notable that such tensions are not unique to this country—as witness a *New York Times* story from China several years ago headed "African Students in Beijing March in Outrage at a Racial Slur." The march followed release of a letter by Chinese students, warning that Africans must "correct their behavior" and that if they did not, "lessons of friendship" would follow, which "will be based on the experience of Americans, who know very well what to do to curb Negroes in their country." The growing number of African students in the Chinese capital reacted predictably, with a protest much like those that have troubled American campuses this spring. So the problem is neither very recent nor peculiar to this country.

Yet, there are new dimensions that bear watching as we assess the legal issues. It is quite probable that we have more tensions because we experience far greater diversity in our student bodies than we did a quarter century or even a decade ago. It is, in fact, our finest universities at which the tensions seem greatest; if you will recall the institutions from which I chose my examples, it was a roster of the pre-eminent public and private universities in the country and not simply because those institutions are more visible to the media. You will also recall that they span the continent; they involve women, racial groups and religious minorities; and certain groups actually appear on both sides of the controversy at different times and places.

Perhaps least clear is what has caused the apparent rise in such incidents—even whether there has been an actual rise or whether we have simply seen the product this spring of a heightened media awareness of this facet of academic life. Whatever the facts, there is little doubt that the academic community is now expected to address these tensions in new ways that may pose First Amendment dilemmas.

Let me return for a moment to the University of Michigan computer ethnic joke file. Realistically, we know that a certain amount of extraneous matter will find its way into a campus computer these days despite the best efforts to restrict access and to delete what is not really needed for continuing online access. In fact, there is an argument that the computer bulletin board offers a new and most appropriate forum for discussion of just such issues—and that is just what happened at Ann Arbor when the offending file came to light. Several students with passwords offered their divergent views on what ought to be done, noting in several cases the possible relevance of the First Amendment to this novel medium of communication.

While Michigan had at that time no applicable rule, several institutions had already done so. Dartmouth, for example, had a policy that prohibits offensive material in its general code of ethics for computer users, warning: "Obscenities should not be sent by computer nor stored where they could offend other users." After the ethnic joke file came to light, Michigan's Vice Provost for Information Services did issue a statement that is

even closer to the mark: "Abusive or insensitive language, even in items with humorous intent, could impede the community's progress and damage the social fabric on which we all depend."

The issue on which I would focus is thus clearly joined. It is, simply stated, whether we ought to have a single standard of campus speech and press or a special standard when it comes to racist, sexist or ethnically demeaning expression. It may be that we should frame different answers for different situations. If, for example, a campus newspaper in its reporting or editorials offends a minority group or women among its readers, a plausible case could be made for a more restrictive policy than would apply to other items in the same journal.

Proponents of a special standard cite, for example, a desire to shield minorities and women from needless offense and insult, the need to preserve harmony within the unusually sensitive academic community, and the value of a higher level of civility than exists in the larger society. Such values as these were invoked by many states in adopting group defamation laws after World War II; these laws have technically survived since the 1951 Supreme Court decision upholding Illinois' group libel statute. Quite recently, a half dozen states (including New York, California and Illinois) have adopted laws that make either criminal or civilly actionable certain forms of offensive and demeaning speech; the constitutionality of these laws remains to be tested because they have hardly yet been applied.

In fact, the only case of which I know is a civil suit in New York between two neighbors, one Jewish and the other Italian, who exchanged ethnic and religious barbs for years until one of them went to court under the new law; the judge ordered that her adversary perform a number of hours of community service to atone for her racial insults. So there is some basis on which one might rest a double standard in the university context.

What is different about ethnic slurs or racial jokes is that some people find them offensive—deeply offensive. In some instances, they may even provoke physical retaliation. They may also fan flames of hatred and distrust in a campus community where harmony and confidence are essential to the learning process.

Under such conditions, the case for special consideration may seem persuasive. Yet, the claim to treat all forms of speech alike is also compelling. The framers of the First Amendment knew that many types of expression posed just such risks. They made a conscious judgment to allow it except in those rare instances we describe as clear and present danger, fighting words, obscenity and a few others. Elsewhere, we insist on the right to speak or write freely and take the consequences. Thus, on the campus as in the community—many would say *especially* on the campus—the general policy ought to be a single standard applicable to "pure speech," written or spoken.

Recent experience in the analogous area of public employment might be helpful. The earliest cases applied a double standard to teachers who made racist remarks in class and others who offended minority colleagues or clients. Most recently, however, the Fourth Circuit Federal Court of Appeals has for the first time, in a case involving a Baltimore policeman who performed in black-face while off duty, insisted on a single standard which took no special account of the racial sensitivity of the expression that drew agency sanctions.

Some of the cases I reported are not, however, so easily resolved by this general rule. Starting at the other end of the scale, I would suggest that symbolic speech matters can be treated differently—those involving, for example, an Indian mascot, a yearbook logo, an athletic slogan or a fraternity display of a racist caricature. Here the university interest

in preserving harmony and showing support and respect for minorities and their feelings may well outweigh the interest (such as it is) in maximum freedom of expression. Even making that concession causes me some discomfort, but it so clearly reflects the conscience of the academic community that I could not responsibly argue against any sanction in such cases.

Moreover, the sanction imposed is usually quite collateral to the speech itself—for example, suspending a fraternity house or changing a mascot or logo. The degree to which, in such situations, individual expression is inhibited seems to me marginal, save possibly for the student who plays the Indian or the fraternity brothers who built and hung the racist effigy. That factor that seems to me legally significant in deciding otherwise close cases.

Finally, I come to the hardest cases—or at least those that give me the greatest pause. They are of several types, illustrated by my examples. The anti-Semitic sidewalk phrases at USC were pure rather than symbolic speech, as were the racist threats in the University of Michigan leaflet and the remarks of the Wellesley trustee. So too were the views on Zionism of the Stony Brook professor. One who argues, as I usually do, for a single standard, would have great difficulty imposing in these situations a sanction that directly impinges on speech. Yet, I see a clear difference between suspending the fraternity or sorority for the ethnic outrages of some of its members and expelling those members from school.

There also seems to me a clear difference between (on the one hand) bringing dismissal charges against an already tenured professor for anti-Semitic teaching and (on the other hand) taking into account in the re-appointment or tenure process the academic relationship between that professor and the diverse student body who comprise his classes. While such a distinction may seem to fix unduly upon procedure rather than substance, we are all lawyers, and for us that distinction is of the essence of our professional roles and responsibilities.

Let me conclude, if I may, without having answered all the questions. These are exceedingly difficult and troubling cases—not only because people on both sides have strong and deep feelings, but also because they place in conflict two of the highest values of the academy. On one hand, we are more deeply committed than is the general society to tolerate, even encourage, diverse points of view and to protect expression which provokes, challenges, shocks and offends. At the same time, we are also committed to maintain and encourage diversity in our student bodies—a value which Justice Powell in his *Bakke* opinion recognized as a First Amendment interest of a different but not necessarily lower order. Occasionally, we may conclude that we cannot remain diverse without limiting certain forms of expression. At other—and I would hope most—times, we come out the other way and insist on tolerance for free expression, however offensive it may be to some of our colleagues.

Reaching the right balance is the inescapable goal, not only of policy but quite as much of constitutional law. No one ever claimed the issues at the edge of free expression were easy. Few such issues have been more profoundly challenging, at times even agonizing, than this one. Yet, those who have responsibility for the governance of our institutions of higher learning must do the best they can to achieve such a balance. And the courts will then be called upon to judge the degree to which they have succeeded in doing so.

When Money Talks:
Corporate Campaign Expenditures and
the First Amendment

Rodney A. Smolla

The diversity in the faculties of men, from which the rights of property originate, is not less an insuperable obstacle to a uniformity of interests. The protection of these faculties is the first object of government. From the protection of different and unequal faculties of acquiring property, the possession of different degrees and kinds of property immediately results; and from the influence of these on the sentiments and views of the respective proprietors ensues a division of the society into different interests and parties.

The latent causes of faction are thus sown in the nature of man; and we see them everywhere brought into different degrees of activity, according to the different circumstances of civil society. A zeal for different opinions concerning religion, concerning government, and many other points, as well of speculation as of practice; an attachment to different leaders ambitiously contending for pre-eminence and power; or to persons of other descriptions whose fortunes have been interesting to the human passions, have, in turn, divided mankind into parties, inflamed them with mutual animosity, and rendered them much more disposed to vex and oppress each other than to co-operate for their common good.

—James Madison, *The Federalist No. 10* (1788)

Americans seem increasingly disillusioned with the quality of political discourse in our national life. Blame is cast in all directions. Politicians are blamed—for lack of candor, for cynical manipulation, for pandering to prejudice, for failing to address policy issues with any rigor or detail. Political consultants are blamed—for encouraging the worst in politicians, for their thirty-second spots, their glib and banal speech-writing, and their glittery resort to superficial imagery and image-making, as they market politicians like cars and cologne. Special interest groups are blamed—for their disproportionate influence, their single-issue stridency, their polarization of the democratic process. Voters are blamed—for their apathy and disengagement, their lack of knowledge of issues and candidates, their gullibility, their cynicism. Journalists are blamed—for their prurient preoccupation with scandal, for their lack of thoughtful reporting of serious issues, for their obsession with opinion polls, for their projections of winners minutes after polls close, for their sensationalizing, for their bias. And modern communications technologies are blamed (not journalists or news organizations, not "the media," but the *technologies themselves*)—for being so costly, so influential, and so inherently "image-intense" as to drive all authentic intellectual public policy discourse out of the marketplace.[1]

Portions of this article will appear, in somewhat different form, in a forthcoming book by Professor Smolla on freedom on speech.

When there is this much blame to cast about, zealous calls for reform are inevitable. What can be done to revitalize American politics? Can laws be passed that will do the trick? Does the First Amendment permit government to pass laws mandating "truth in campaigning," in much the same way that advertisers are constrained by modern consumer protection legislation? Can the media be forced to alter the nature of its coverage? Can politicians be forced to engage in structured, in-depth policy debates? Can thirty-second political advertising spots be banned? Can the influence of money be diminished? Can elections be publicly financed? These and other questions have become increasingly important as Americans contemplate ways to inject new vigor into our democracy.

Reforms may be classified into three general types: "anti-corruption" reforms, "leveling reforms," and "content-quality reforms." Anti-corruption reforms seek to eliminate the reality or appearance of illicit political activity, such as the bribing of candidates. Leveling reforms seek to diminish the influence (not necessarily a corrupt influence) of special interest groups and the wealthy (either wealthy individuals, organizations, or corporations).[2] Content-quality reforms refer to a whole basket of proposals that deal in various ways with the actual content of political discourse, either by candidates, citizens, interest groups, or the media itself.

At the national level, serious reform efforts began in the aftermath of the Watergate scandal.[3] Congress set out to deodorize and disinfect presidential campaigns by passing amendments to the Federal Election Campaign Act.[4] In a 1976 decision, *Buckley v. Valeo*,[5] the Supreme Court examined the four key features of the congressional reform effort: (1) disclosure requirements; (2) limits on campaign contributions; (3) limits on political expenditures; and (4) public financing of elections.

The Court upheld the law's disclosure provisions, which required the revelation of the identity of persons or organizations contributing to political campaigns. However, the Court did leave open the possibility that disclosure requirements might be unconstitutional if they were applied to dissident or unpopular groups, in which public disclosure of the names of contributors might chill the willingness of persons to join the cause.[6]

The Court also upheld the public financing of presidential election campaigns, holding that such financing does not abridge speech, but instead fosters the purposes of the First Amendment by permitting public money to be used to enlarge and facilitate public discussion and participation in the electoral process.[7]

The most interesting part of the Court's decision, however, involved limits on political expenditures and contributions. In its discussion of those limitations in *Buckley*, and in the cases decided since *Buckley* that have continued to elucidate the First Amendment rules governing limits on political expenditures and contributions, the Court has explored the most fundamental premises of freedom of speech in its relation to modern American political life.[8] The Court in *Buckley* drew a line between limits on contributions and limits on expenditures. Contributions are payments made to a political candidate or campaign fund, or spent in coordination with the candidate's campaign organization. Expenditures, on the other hand, are sums spent directly by someone to foster a political cause. A candidate may, for example spend his own money to advance his or her election. Similarly, an individual or corporation may independently advertise to promote or defeat a candidate, without the approval or cooperation of the candidate or his campaign.

The Court in *Buckley* upheld limits on campaign contributions, but struck down limits on expenditures. This differential treatment was grounded in two judgments. First, the

Court thought that contributions were potentially far more dangerous to the integrity of the political process than expenditures. Second, the Court regarded limits on contributions as significantly less intrusive incursions on free expression and association than limits on expenditures.

From the perspective of their potential to cause harm, the Court was correct in its judgment that contributions are more threatening than expenditures. The Court properly reasoned that limits on how much money a person may spend on a political campaign violate the First Amendment, for such limits directly impinge on speech, by placing ceilings on how much political speech may be purchased.[9]

The rich will, of course, have greater speech "buying power" than the poor—the marketplace of ideas in this sense is no different than any other marketplace. As Professor Mark Tushnet has argued, to protect their positions of privilege, the wealthy may make prudent investments in political activity, or in economic ventures, such as factories or stocks.[10] In America today, the economic investments of the wealthy are subject to extensive regulation. But under the First Amendment, the government may find itself blocked from regulating "investments" in politicians and political causes. The wealthy, quite naturally, will often engage in such political investments, thereby protecting their status, and perhaps deterring the heavy regulation of their economic investments to boot.

Expenditure limits attempt to curb the political market power of the wealthy, serving the egalitarian goal of leveling the influence of various individuals among the populace—a sort of "one person, one dollar, one vote" ideal. But the Court in *Buckley* appeared to hold this sort of leveling unconstitutional, reasoning that the First Amendment entitles those with wealth to speak to their heart's content and wallet's capacity on political matters.[11]

While the Court in *Buckley* struck down limits on how much a person could *spend* on an election, the Court upheld limits on how much a person could *contribute*. Contributions, the Court held, could be limited, because contributions posed the special problem of financial corruption, *and* because large contributions could generate an *appearance* of corruption. Particularly when large sums are involved, contributions may either be or appear to be bribes, given with the expectation of a *quid pro quo*.[12]

In *Citizens Against Rent Control/Coalition for Fair Housing v. Berkeley*,[13] the Court struck down an ordinance placing a $250 limit on contributions to committees formed to support or oppose ballot measures submitted to popular vote, stating that the "First Amendment's protection against governmental abridgement of free expression cannot properly be made to depend on a person's financial ability to engage in public discussion."[14] Limits on contributions to political causes, as opposed to political candidates, were unconstitutional, because the danger of financial *quid pro quo* corruption does not exist for such contributions.

It is easy to take potshots at the Court's distinction between contributions and expenditures. Both, after all, involve the use of money; both pose at least some danger of corrupt influence. A wealthy supporter of a candidate, for example, might pay an ad agency to produce television spots supporting a candidate. If the candidate wins the election, and if the ads played a substantial part in the victory, the candidate may well feel that a political "debt" has been incurred. How can it make a difference, it might be asked, that the check is made out to the political consulting agency directly employed by the candidate's campaign, as opposed to an agency retained separately by the candidate's supporter? It is true that there is no true "deal" cut in the case of an independent expenditure. But often there will be no explicit "deal" when contributions are involved, either.

There are, of course, forms of corruption that involve an overt meeting of the minds: "I will contribute money to your campaign in exchange for your sponsorship of a tax break for my company." Far more common, however, are a vast range of less formal arrangements, from "understandings" to "expectations" to "hopes," in which the money is given to a candidate with no clearly defined obligation in return. Indeed, many individuals and organizations have traditionally contributed to candidates for reasons that are less than altruistic but not corrupt. They make the contribution hoping the candidate, if elected, will be "friendly," but with no specific agenda in mind. This is why many groups hedge their bets and contribute to both candidates in a campaign, as a sort of general "good will" insurance absorbed as business overhead. (Large law firms, for example, routinely contribute to both candidates in judicial races.)

Despite these shortcomings in the dichotomy between contributions and expenditures, the Court's instincts in *Buckley* were essentially sound. For while it is possible to assail the distinction by pointing to a certain blurriness at its edges, at the core there is a bona fide difference between a contribution and an expenditure. One involves a transaction with the candidate, the other does not. This is no triviality from a First Amendment perspective. The distinction in *Buckley* between expenditures and contributions was consistent with the general principle that speech may not be regulated by government merely because of the influence that speech is likely to have on those exposed to it. To justify regulation of speech, government must instead demonstrate that it will lead to some more palpable harm, such as an interference with physical or relational interests. No palpable physical or relational harms are present when there is no transaction. The expenditure may *influence* the candidate, and that influence may be regarded as unsavory, but it does not *obligate* the candidate. The expenditure might be unseemly, but it cannot be fairly characterized as "corrupt," because there is no genuine *quid pro quo*.

A campaign contribution, on the other hand, carries the potential for relational harm, because the contribution may be payment for an illicit favor. When the contribution is part of a transaction to induce a breach of public trust by a candidate for public office, it is not protected by the Constitution. There is no First Amendment protection for bribery. Bribery laws do not regulate the content of speech, but the underlying transaction. To the extent that they incidently impact on speech, they are easily justified under the lenient test of *United States v. O'Brien*.[15]

Most campaign contributions, however, are not sinister. They are neither offered nor accepted as bribes.[16] If the First Amendment permits prosecutions for bribery, does it also permit government to curtail campaign contributions merely because they are *potentially* meretricious? Here the proper First Amendment analysis is more difficult to sort out. The result will turn on how heavy-handed the regulation is, and on how conscientiously we treat the First Amendment requirement that the law be narrowly tailored to effectuate its purposes. It was at this stage in its analysis in *Buckley* that the Court introduced its second crucial judgment—that circumscribing contributions posed less severe restrictions on expression than limiting expenditures.

The Court had an awkward time translating this intuition into First Amendment doctrine. If we were to apply the rigorous "strict scrutiny" test to contributions, it would be difficult to sustain most modern campaign contribution laws. In the parlance of "strict scrutiny" analysis, the prevention of political corruption is clearly a "compelling" state interest. But it is more difficult to make the argument that a sweeping limit on all contributions is a "narrowly tailored" method of effectuating that interest, when only a small percentage of the contributions are likely to be corrupt.

The *O'Brien* test offers one possible escape from this box. Bringing *O'Brien* in would be a two-step process. Contribution limitations would first be characterized as regulations of conduct—the "conduct" of giving money—enacted for reasons unrelated to the content of speech. The *O'Brien* test would then be interpreted as imposing a less rigorous nexus requirement between means and ends, and campaign limitations would be sustained under that more pliable standard. While even on its face the *O'Brien* test contains the requirement that the law employ the least restrictive means of effectuating the government's interest, arguably *O'Brien* does not mandate as tight a nexus between means and ends as the strict scrutiny test. Limitations on contributions as a prophylactic measure could be justified under the less exacting requirements of *O'Brien* even though the limits would be over-inclusive. This analysis would permit the government to proscribe all contributions above the limitation levels—including innocent contributions—so as to guarantee prevention of evil contributions.

Are these steps legitimate? Remember that it clearly would not be fair to treat expenditure limitations as outside of the strict scrutiny test, and subject only to the lesser demands of *O'Brien*. Thus in *Buckley* the Court stated that "the use of funds to support a political candidate is 'speech,'" and that "independent campaign expenditures constitute 'political expression at the core of our electoral process and of the First Amendment freedoms.' "[17]

But contributions are arguably different. A contribution seems less a form of "speech" than an expenditure. A contribution simply involves writing a check. An expenditure requires that one write a check and devise the message. Indeed, while an expenditure on speech is not literally speech, it is often so inextricably intertwined with speech as to be practically inseparable. Money purchases the medium necessary to communicate the message. Almost all speech committed to tangible form involves at least some trivial expenditure, if nothing more than the cost of paper, pen, envelope, and stamp. To reach a large audience—as when one tries to influence an election—the expenditures mount up quickly. To regulate how much one can spend to disseminate one's message is thus intimately wrapped up with the act of speaking. The campaign contribution, by contrast, is arguably a far less personalized form of expression. One's check goes into the general campaign coffers and might be spent on anything from balloons to barbecue.

None of these generalizations, of course, will be valid in all cases. It is not always true that the contribution will be a less "pure" form of speech than the expenditure. A contributor often does "vote" with his or her pocketbook for purely altruistic, non-corrupt reasons. The check may go into the general campaign budget, but all of that budget presumably will aid the enterprise, advancing candidates and causes that the contributor cares about passionately. Alternatively, the person who incurs an independent expenditure may not always supervise closely the content of the message purchased. A wealthy supporter may say to an ad agency, for example, "Here is $500,000—use it to produce the most effective radio campaign spots you can; I leave it in your hands."

In the end, the Supreme Court in *Buckley* refused to accept the argument that limits on campaign contributions were mere regulations of conduct, subject to the more indulgent standards of *O'Brien*.[18] Nevertheless, the Court did accept what we might call a "modified *O'Brien*" argument, by treating contributions as less forms of speech than expenditures. It is commonly said that "money talks." Perhaps the easiest way to understand the Court's analysis in *Buckley* is to characterize it as saying, "contributed money talks, but not as much as independently expended money."

Contributions, the Court noted, do not reveal the underlying political reason for the contributor's support. Unlike expenditures, where the money is the medium through which

one purchases the message, with contributions the money is the *only* message. The contribution expresses the contributor's generalized support for the candidate, and the size of the contribution, relative to the contributor's wealth, is a rough index of the fervor of that support. But the literal "talking" is done by someone else—by the candidate or someone in his or her campaign—and not by the contributor.

Since contributions carried greater capacity for breeding corruption than expenditures, and were less intense forms of speech and association, the Court was willing to permit limits on one but not the other.

Ever since the *Buckley* case, a number of reform-minded state and federal legislators have searched for ways to continue down the track of improving the American political arena without violating the First Amendment. Although the Supreme Court in *Buckley* seemed to reject the "leveling" theory as a rationale for reform, the egalitarian impulse to level is persistent.[19] And the Supreme Court gradually seems to be giving in.

A shift in the wind began in 1986 with *Federal Election Commission v. Massachusetts Citizens for Life, Inc.*,[20] (commonly called "*MCFL*"). The *MCFL* case involved political expenditures by corporations. A federal statute required corporations to make independent political expenditures only through special segregated funds, rather than the general corporate treasury. Massachusetts Citizens for Life was an non-profit corporation organized exclusively to advance anti-abortion efforts. Its articles of incorporation stated the corporate purpose to "foster respect for human life and to defend the right to life of all human beings, born and unborn, through educational, political and other forms of activities."[21]

At first blush the proper constitutional analysis seemed simple: The Supreme Court had decided in *Buckley* that political expenditure limits on individuals were unconstitutional. In a number of cases the Court had established the principle that corporations enjoy First Amendment free speech rights. In *First National Bank v. Bellotti*,[22] for example, the Court held that states cannot prohibit corporations from spending money to express their views on referendum questions even if such issues are not directly related to their business interests.[23] The Court had similarly held that political advocacy groups, such as "political action committees" or other special-interest groups, do not forfeit their First Amendment rights merely because they are incorporated. Putting one and one together normally makes two; if political expenditures are protected speech, and corporate speech is protected speech, than corporate political expenditures should be protected speech.

In *MCFL*, however, the Court rejected this simple arithmetic. Did it necessarily follow that limits on *corporate* expenditures, like limits on *individual* expenditures, were unconstitutional? Or do corporations, because of their special capability to amass vast sums of wealth, permit the government to advance "leveling" as an interest sufficient to justify curtailing corporate expenditures?

The Supreme Court struck down the statutory limitation as applied to Massachusetts Citizens for Life, holding that the group had features more akin to voluntary political associations than business firms, and therefore should not have to bear special burdens merely because of its incorporated status.

In a significant passage in the *MCFL* opinion, however, the Court seemed to embrace the validity of the leveling theory, at least as applied to corporate wealth. Justice Brennan's opinion for the Court stated that "[d]irect corporate spending on political activity raises the prospect that resources amassed in the economic marketplace may be used to provide an unfair advantage in the political marketplace."[24] Brennan acknowledged that "political 'free trade' does not necessarily require that all who participate in the political marketplace

do so with exactly equal resources." Indeed, since the ability of an organization to accumulate funds was a rough barometer of public support for its causes, it is perfectly appropriate that groups able to generate financial support for their positions should be able to flood the marketplace of political ideas with all the speech their funds will purchase.

Justice Brennan argued, however, that this principle did not apply to conventional business corporations, because "the resources in the treasury of a business corporation however are not an indication of popular support for the corporation's political ideas." The general funds of a corporation instead reflect the economically motivated decisions of investors and customers. "The availability of these resources," the Court noted, "may make a corporation a formidable political presence, even though the power of the corporation may be no reflection of the power of its ideas." While the Court would not permit special limitations on expenditures for non-profit corporations organized for the principal purpose of advancing political causes, it thus seemed willing to endorse the constitutionality of restrictions aimed at curbing the influence of other corporate political war chests.

In 1990, the Court again visited this issue, in a case entitled *Austin v. Michigan Chamber of Commerce*.[25] The controversy arose from the Michigan Campaign Finance Act,[26] which contained a provision of the law prohibiting corporations from using corporate treasury funds for independent expenditures in support of or in opposition to any candidate in elections for state office. Corporations could, however, create a special segregated fund for political expenditures. The corporation could solicit contributions to that segregated fund only from an enumerated list of persons associated with the corporation. Corporations were permitted to engage in political expenditures for or against a candidate only from such special segregated political funds.

In 1985 Michigan scheduled a special election to fill a vacancy in the Michigan House of Representatives. One of the candidates was Richard Bandstra. The Michigan State Chamber of Commerce, a non-profit Michigan corporation with over eight thousand member companies, associations, and local chambers of commerce, sought to use its general treasury funds to purchase an advertisement endorsing Bandstra in a local newspaper. The advertisement argued that Michigan needed regulatory policies on business matters designed to make the state's businesses more competitive, and stated: "The Michigan State Chamber of Commerce believes Richard Bandstra has the background and training to do the best job in Lansing for the people of the 93rd House District."[27]

The state of Michigan defended its restriction by contending that state law granted corporations unique advantages—such as limited liability for shareholders, perpetual existence, and favorable treatment of the accumulation and distribution of assets—that enhanced their ability to attract capital and deploy resources. Following the lead of Justice Brennan's opinion in *MCFL*, Michigan maintained that corporations enjoyed an unfair advantage in the political marketplace, because the size of their resources did not correspond to the level of support their shareholders had for the corporation's political agenda. Michigan did not deny corporations all power to engage in political speech—they were permitted to do so if they used the special segregated political fund mechanism. By forcing corporations to make political expenditures only through segregated funds in which the money was raised expressly for political causes, Michigan argued, the statute guaranteed that the money amassed by corporations for political expenditures would in fact reflect the level of commitment of supporters for those political causes. Because the money in the general treasury of corporations represented only the economic choices of investors and

consumers, and not political choices, however, the law did not permit those non-political funds to be diverted to political ends.

The Michigan Chamber of Commerce defended by relying upon the *MCFL* decision. Even if the statute were constitutional as applied to a conventional business corporation, it argued, the First Amendment prohibited such restrictions when applied to non-profit corporations. *MCFL* involved a single-issue organization with an exclusive interest in abortion. The Chamber of Commerce had a significantly broader agenda, concerned with a wide range of activities and causes of interest to a diverse business community. The Chamber existed to promote economic conditions favorable to private enterprise, to serve as a clearinghouse for information on economic conditions and political developments of interest to the business community, to lobby government and inform the views of the business community on policy issues, to foster ethical business practices, and to generally investigate and attempt to influence social, civic, and economic issues, through active involvement in political debates and campaigns.

But the Chamber argued that it was still primarily a non-profit organization that had taken a perfectly legitimate interest in a local political candidate, and that for First Amendment purposes its speech was essentially no different from the speech of the Massachusetts Citizens for Life, which the Court had protected in *MCFL*.

The Chamber of Commerce also attacked the Michigan statute for dealing with expenditures in a manner that was not even-handed. The law exempted from its restrictions the political expenditures of unincorporated labor unions. More significantly, the law contained a "media exception" applicable to media corporations. That exception excluded from the definition of "expenditure" any "expenditure by a broadcasting station, newspaper, magazine, or other periodical or publication for any news story, commentary, or editorial in support of or opposition to a candidate for elective office . . . in the regular course of publication or broadcasting."[28]

The Supreme Court, in a 6–3 decision written by Justice Thurgood Marshall, rejected the arguments of the Chamber of Commerce, and sustained the Michigan law. Justice Marshall did not believe that the Chamber of Commerce was truly like the special-interest group in *MCFL*. In both *MCFL* and *Michigan Chamber of Commerce*, the groups were organized to advance ideas. But Justice Marshall found the nature of their causes distinguishable. The Chamber's purposes, he said, were much more varied than those of the Massachusetts Citizens for Life, and many of those purposes were "not inherently political." Justice Marshall cited as examples the Chamber's compilation and dissemination of information on social, civic, and economic conditions, its training and education of members, and its promotion of ethical business practices. The Chamber's educational activities, he argued, are not "expressly tied to political goals;" many of its seminars, conventions, and publications, he observed, "are politically neutral and focus on business and economic issues."

In *MCFL*, the Court had emphasized that the anti-abortion group did not have shareholders with a claim on its assets or earnings. But neither did the Michigan Chamber of Commerce. Yet, claimed Justice Marshall, the members of the Chamber had many of the attributes of shareholders. Like shareholders, they may have joined the Chamber, and paid dues, for reasons unrelated to the corporation's political agenda. Because the members may wish to take part in the Chamber's educational and outreach programs, he maintained, they may be reluctant to quit or withhold their dues even though they disagree with the Chamber's political positions. In this respect, the Chamber's political war chest was vulnerable to the same objection lodged against the political war chests of conventional

business corporations—the accumulation of wealth does not reflect the political beliefs of the members.

In *MCFL*, the organization was relatively free of business influence—the group, in fact, had a policy of not accepting contributions from business corporations. The Michigan Chamber of Commerce, by contrast, was an organization of business, by business, and for business. Justice Marshall thought that this made it a tempting conduit for the type of direct corporate spending that the Michigan law was designed to curtail. If General Motors was prohibited from influencing a Michigan election through direct spending from its corporate treasury, the integrity of the prohibition might be undermined if General Motors could simply funnel its contribution through the Chamber of Commerce.

The Court was not troubled by the exceptions in the Michigan law for media corporations or labor unions. The exception for media corporations, it held, was justified by the special watchdog role of the institutional press. And labor unions, Justice Marshall argued, were unincorporated. The wealth they accumulated was thus more akin to the wealth accumulated by individuals. Furthermore, labor union members who disagree with a union's political activities need not give up union membership to avoid supporting the union's political agenda. The Supreme Court had previously held that a union member had a right to withhold support for those union activities not germane to contract administration, collective bargaining, or grievance adjustment.[29] The political funds of labor unions thus did not suffer from the infirmity of being out of proportion to the intensity of the support of its members for the union's political positions.

Justice Brennan joined in Marshall's opinion for the Court, and also wrote a brief concurring opinion, in which he stressed the point that corporate campaign expenditures may conflict with the political interests of some shareholders. Not only does the vast wealth of corporations permit them to yield a disproportionate influence in the political arena, he argued, but a shareholder's money might be used for political causes he or she does not support. Justice Stevens also wrote a brief concurring opinion, stating that in his view the distinction between expenditures and contributions recognized in *Buckley v. Valeo* should have little relevance to corporations.

Justices Scalia, Kennedy and O'Connor dissented. Justice Scalia's opinion (not joined by O'Connor or Kennedy) was scathing and bitter. He began with an announcement:

Attention all citizens. To assure the fairness of elections by preventing disproportionate expression of the views of any single powerful group, your Government has decided that the following associations of persons shall be prohibited from speaking or writing in support of any candidate: _____.[30]

Justice Scalia labelled the Court's holding as "Orwellian," and based on the principle that "too much speech is an evil that the democratic majority can proscribe." He described the Court's holding as "incompatible with the absolutely central truth of the First Amendment: that government cannot be trusted to assure, through censorship, the 'fairness' of political debate." Under the Court's analysis, he argued, anything the Court "deems politically undesirable can be turned into political corruption by simply describing its effects as politically 'corrosive,' which is close enough to 'corruptive' to qualify."

Justice Kennedy, in an opinion joined by Justices O'Connor and Scalia, also dissented. In his view the majority opinion validated two acts of censorship—one by the Michigan statute itself, and one by the Court's own value-laden distinctions among various types of speakers. Since *Buckley* had drawn a line between contributions and expenditures, the

Court's opinion made sense only if yet a second line could be legitimately drawn between individual expenditures and corporate expenditures. Justice Kennedy went for the jugular: "With the imprimatur of this Court," he opined, "it is now a felony in Michigan for the Sierra Club, or the American Civil Liberties Union, or the Michigan State Chamber of Commerce, to advise the public how a candidate voted on issues of urgent concern to their members. In both practice and theory, the prohibition aims at the heart of political debate."[31]

The Court's argument in *Michigan Chamber of Commerce* contains many debilitating flaws. As a general proposition, the neutrality principle of the First Amendment should not permit government to pick and choose among various genres of social, civic, economic, and educational speech, determining which of them is "inherently political."

The fine content-based distinctions employed by the Court in *Michigan Chamber of Commerce* have traditionally been an anathema in First Amendment jurisprudence. All of the activities of the Chamber involved the flow of information on matters of interest to its members; this was all speech presumptively protected by the First Amendment. Why should the single-minded speech of an anti-abortion group command greater constitutional protection than the more eclectic speech of the Chamber of Commerce?

Even worse was the Court's handling of the media exception in the Michigan law. Its analysis was rickety at best. The Michigan law treated media corporations differently than non-media corporations. A Michigan newspaper could have run an endorsement of candidate Richard Bandstra on its editorial page. But the Chamber of Commerce would be prohibited from purchasing a political advertisement in the same newspaper to run, verbatim, the same endorsement. (As the Michigan law operated, a media corporation apparently could not, however, purchase advertising space in some other media outlet and run its endorsement of the candidate there—for that would not be "in the regular course of publication or broadcasting.")

The Court analyzed this scheme under the Equal Protection Clause. There was nothing wrong in that choice—since the law did discriminate in the exercise of the fundamental right of free speech, strict scrutiny under the Equal Protection Clause was perfectly appropriate. Arguably, however, it was not technically necessary to bring the Equal Protection Clause into the picture. The First Amendment contains an "equality component" of its own that would have required strict scrutiny in any event. Since the discrimination in this case involved the status of the speakers, and not the content of the speech, the Court may have thought that the Equal Protection Clause was the more fitting constitutional provision. Even so, the Court has emphasized in many First Amendment cases (in which equal protection as such was not mentioned) that entitlements to First Amendment rights may not turn on the identity of speakers, unless the strict scrutiny standard is satisfied.[32] Whatever the choice of constitutional clause, because this was a clear-cut act of discrimination impinging upon the fundamental right of free expression, the Court conceded, as it had to concede, that the strict scrutiny test was the appropriate measure. According to the test the Court set for itself, the statutory classification in the Michigan law must therefore serve a compelling interest and be narrowly tailored to achieve that interest.

The Court found the compelling interest requirement easy to satisfy: it simply touted the importance of freedom of the press. Media corporations play a special role in society, the Court reasoned, that supplied Michigan with a compelling interest in exempting them from the expenditure limitations for expenses incurred in producing news stories, commentaries, and editorials in the regular course of broadcasting or publishing. The

Court had continuously recognized, Justice Marshall stated, the "unique role the press plays in 'informing and educating the public, offering criticism, and providing a forum for discussion and debate.' " Quoting from *Mills v. Alabama*[33] Justice Marshall emphasized that the "'press serves and was designed to serve as a powerful antidote to any abuses of power by government officials and as a constitutionally chosen means for keeping officials elected by the people responsible to all the people whom they were selected to serve.' " The media exception, Marshall argued, served the compelling state interest of ensuring that the statute "does not hinder or prevent the institutional press from reporting on and publishing editorials about newsworthy events." Since Michigan plainly had a compelling interest in protecting this vital role for the press, the Court reasoned, the law satisfied strict scrutiny.

There are many things wrong with this analysis. The most puzzling omission was the Court's failure to even address the second prong of strict scrutiny. Having decided that protecting freedom of the press was a compelling state interest, the Court never bothered to visit the second requirement, that the law be narrowly tailored to effectuate that interest. Yet this is the prong of strict scrutiny on which statutory classifications most often founder.

Had the Court followed through to complete the analysis, it might have uncovered a deeper embarrassment in the Michigan law. The Court treated this, remember, as an equal protection matter. Corporation A (a media corporation) and Corporation B (a non-media corporation) both wish to exercise their fundamental right to freedom of speech. Corporation B is told by the state that it may not do so, even though Corporation A may. How is this discrimination defended? On the grounds that preserving the right of Corporation A to speak is a compelling state interest. But *of course* preserving A's right to speak is compelling: for after all, A is exercising a fundamental right—the fundamental right that triggered the application of strict scrutiny in the first place.

The Court applied strict scrutiny backwards. The question is not whether the state has a compelling interest in allowing A to speak, but whether it has a compelling interest in *not* allowing B to speak.

It is not enough to say to Corporation B, you may be silenced, because A's speech is precious. From B's perspective, its own speech is equally precious. What the Court *really* approved in this case was thus a quite radical departure from its prior jurisprudence. There is simply no escaping the bottom line implicit in the Court's analysis: the *same* political endorsement could be run by a newspaper but not by the Chamber of Commerce, *because the newspaper's speech is more important to society.* The Court took this radical step cavalierly, in one paragraph, without even following through to completion the applicable analytic framework. In one lame, contradictory, and conclusory sentence, the Court stated: "Although the press's unique societal role may not entitle the press to greater protection under the Constitution, it does provide a compelling reason for the State to exempt media corporations from the scope of political expenditure limitations."

This is hardly candid. It would have been more forthright if written: Because the unique societal role *does* entitle the press to greater protection under the Constitution, there is a compelling state interest for exempting it from the limitations. That, at least, would have forced the Court to think the matter through.

Thinking the matter through is not easy. Whereas *Buckley* had been grounded in the concept of real corruption, in the traditional *quid pro quo* sense, and had thus adopted an intelligible distinction between contributions and expenditures, *MCFL* and *Michigan Chamber of Commerce* are not, if we are to use words honestly, based on a corruption

rationale. They are leveling cases. (Even though the Court struck down the corporate limits as applied in *MCFL*, Justice Brennan's approval of the leveling rationale for corporate political speech presaged *Michigan Chamber of Commerce*, where his analysis came to roost.)

That leveling is the rationale, however, does not prove that limits on corporate political expenditures are wrong. For leveling has much to commend it.

Is the "checking function" of the First Amendment a special province of the press, or is it a general citizens' right?[34] In an open culture only one response seems imaginable. Because the participatory interest served by freedom of speech in a democracy grows primarily out of the entitlements of citizens, and not the needs of the state, each *individual citizen* must enjoy an undiminished right to join the political fray, to stand up and be counted, to be an active player in the democracy, not a passive spectator.

When the government singles out the press for specially *disadvantageous* treatment, of course, the Court has been stalwart in striking such discrimination down.[35] But this has been understood as a constitutional requirement of parity, and decidedly not a principle of preferred status.[36] Under prevailing constitutional theory, it appears clear that the private citizen has as strong an entitlement to First Amendment rights as the institutional press. In the words of Justice White, (speaking in the context of defamation suits): "the First Amendment gives no more protection to the press . . . than it does to others exercising their freedom of speech. None of our cases affords such a distinction; to the contrary, the Court has rejected it at every turn."[37] In the same case Justice Brennan wrote, in an opinion joined by Justices Marshall, Blackmun, and Stevens: "We protect the press to ensure the vitality of First Amendment guarantees. This solicitude implies no endorsement of the principle that speakers other than the press deserve lesser First Amendment Protection."[38]

If a sense of lack of accountability in politicians is one of the major concerns of our time, then the needs of a healthy democracy are best served by increasing, not decreasing, the number of voices seeking to hold leaders accountable. Within the state of Michigan, political dialogue was enriched by the political statements contained in the ad placed by the Chamber of Commerce.

The effectiveness of speech is often connected to the identity of the speaker. The very concept of a "political endorsement" contemplates that *who* backs the candidate may be as important as *why* the candidate is being backed.

The labor union exemption was offensive to First Amendment values from a larger perspective ignored by the Court. Looking at this case with a dose of *realpolitik*, the discrimination inherent in the labor union exemption is indefensible. The Michigan Chamber of Commerce was the voice of business. The ad it ran contained, as a central theme, an attack on Michigan's workers compensation system, and its policies toward job competitiveness—issues directed toward Michigan's policies concerning labor and management. Organized labor was under no legal restraint in this policy battle. A powerful and wealthy union in Michigan could have taken out ads from its general treasury against candidate Bandstra, stating "This candidate is in favor of reducing workers compensation benefits and decreasing regulatory protection for workers, vote against him." But the Chamber of Commerce is banned from using its general treasury resources to counter that position.

The Court's shallow treatment of the media exception was worrisome from yet another perspective. The Court held that Michigan could exempt the press from its limitation, but did not say that it was required to create such an exemption. The Court's proportional leveling theory would not be illogical if applied against the media. Media corporations

"speak" every day with resources that cannot be said to reflect the views of those who have generated them. Vast interlocking communications empires accumulate wealth from stockholders who invest primarily to make money. Shares in CBS are bought and sold for the same economic reasons as shares in General Motors. When Andy Rooney editorializes, he commandeers the collective economic resources of CBS to express views that bear no necessary correspondence to the views of CBS shareholders. Indeed, the power of media corporations to skew political discourse is exponentially greater than non-media corporations.

Yet it is utterly impossible to imagine the Court approving a law that forbade publishers or broadcasters from spending their general corporate resources to endorse or attack a candidate for political office as part of their regular course of publishing or broadcasting, unless that endorsement or attack is paid for out of segregated corporate funds generated exclusively from contributions earmarked for such political use. Such a law would be instantly dismissed as a *per se* violation of the First Amendment.

If a distinction may not be drawn between media and nonmedia voices, is it *ever* permissible to pick and choose among speakers?[39] May there be one rule for the billionaire, one for an anti-abortion group, one for the Chamber of Commerce, one for the Sierra Club, and one for General Motors?

If different rules are to exist, certainly they cannot be based upon the content of the speech. We should be suspicious of any legislative restriction on the speech marketplace, for in limiting the operation of the market the legislature decreases the probability that the market will upset the status quo. Since incumbents are the persons who pass leveling legislation, our antennae should be specially attentive to any hint of the fix. Limits on political spending have an incumbency bias. Once in office, a politician is hard to displace. Since incumbents usually win, enjoying the political equivalent of a "home court advantage," those who want to unseat an incumbent will often have to spend more to unseat him than the incumbent will have to spend to hold on. In leveling how much can be spent, the natural advantage of the incumbent is enhanced. An ostensibly level playing field is in reality tilted.

Why is it not good enough that corporations are free to express their political views through funds in specially segregated accounts, by forming political action committees supported by contributions tagged for those segregated purposes? The simplest answer is that the speech of a corporate PAC is not the speech of the corporation. The corporation cannot contribute to the PAC; it cannot put its own money into the PAC's pot.

The theory floated in *MCFL* and endorsed in *Michigan Chamber of Commerce* is not "straight leveling" but "proportional leveling." It does not overrule *Buckley v. Valeo*, by embracing the radical leveling proposition that all political spending may be capped—even the independent expenditures of the individual billionaire—in order to mute the voices of the rich and equalize the relative ability of all citizens to influence the political process. Proportional leveling theory permits government to require that expenditures from a political fund be in proportion to the views of those who contribute to the fund. This explains how a majority of the Court can be comfortable in continuing to subscribe to the statement in *Buckley* that "the concept that government may restrict the speech of some elements of our society in order to enhance the voice of others is wholly foreign to the First Amendment," with the statement in *MCFL* and *Michigan Chamber of Commerce* that the availability of massive corporate resources may give the corporation formidable

political clout, "even though the power of the corporation may be no reflection of the power of its ideas."

Proportional leveling instructs that if money is to talk, it must talk for itself. You can spend all you want of your own money on political speech, but not other people's money. In order to spend the money of others on political speech, you must be able to show that they have appointed you their agent for speaking purposes. The power of the money in the pot must reflect the power of the ideas of those who pay into it.

Is this proportional leveling constitutionally defensible? Or is proportional leveling worse than straight leveling, and worse than no leveling at all?

We may start with the distinction embraced by the Court between the political speech of the individual billionaire, and the political speech of the corporation. Where does the billionaire get his billions? Presumably he or his family before him accumulated the money by trading in the capitalist market. The wealth that the billionaire has accumulated came from economic transactions with others. The money is the "billionaire's own," but in what sense does it reflect the power of ideas? Those who enter into economic transactions with the billionaire are not voting for his political agenda. The billionaire's political ideas are "powerful" only in the sense that his wealth gives him great power to disseminate them. But the wealth backing his idea has nothing to do with the idea's *intrinsic* power—with its merit. When the phrase "power of an idea" is used in that intrinsic sense, the case for letting the billionaire spend all he wants on politics becomes quite woeful. Pluck and luck in the economic market does not guarantee political wisdom in the political market. The billionaire may have a billion-dollar bad idea. The pauper may be a political genius.

The straight leveling theory rejected in *Buckley* at least has the beauty of egalitarian purity. In our democracy the pauper and the billionaire are each allowed only one vote in the ballot box. They are equal in human dignity, equal in their entitlements to participate in the democratic process, equal in their rights to freedom of speech. The egalitarian straight-leveler says, if all this is true, then why should they not be forced by the government to be equal in their influence on the political process? For the straight-leveler, *Michigan Chamber of Commerce* is on the right track, but it did not go far enough. *Buckley* should be overruled, and limits on all political expenditures approved.

The straight-leveling theory rejected in *Buckley*, however, continues to be rejected by the Court, and it seems highly improbable that the Court will reverse itself any time soon. The liberals and conservatives on the Court all seem to blanche reflexively at straight-leveling. This demonstrates how closely thinking about the marketplace of ideas in America is tied to thinking about capitalist economic markets. The government may be able to redistribute income, through devices such as the progressive income tax, and thereby *indirectly* "level" the relative capacity of all citizens to purchase speech power in the political marketplace. But the money that is left over after taxes, the money that is a person's "own," may be spent on anything the person pleases, including all the speech that his money can buy. Under the modern First Amendment, the choice of *how much* an individual chooses to talk is understood as every bit as protected as the choice of what the individual says. In America "freedom of speech" has an emphatic capitalist ring; it is not merely freedom to say whatever one pleases, but freedom to say it as often, and to as many people, as one's energies and resources permit.

If the Court will not budge from the capitalist insistence that the billionaire has a constitutional right to spend all he or she wants on political speech, why does a majority of the Court find corporate accumulations of wealth any different? No shareholder is forced to keep money in the corporation. Shareholders are not defenseless when corporate officers

use the corporation's accumulated wealth to influence political outcomes. They may attempt to influence corporate policy by how they vote their shares. They may speak up at the forums within the corporation, such as shareholder's meetings. They may sue in a stockholder suit, claiming that the corporation's political endorsement is not plausibly connected to the corporate mission of earning profit for the shareholders. And ultimately, they may sell their shares. Shareholders who prefer corporations with a different political stripe, or merely apolitical corporations with no political stripes at all, may move their investments to them. The Court in *Michigan Chamber of Commerce* seemed to think these were clumsy mechanisms; but that judgment may well have reflected a bias against business, and against business speech. Remember that the political speech the Michigan Chamber of Commerce wished to engage in was pro-business, and in no way deceptive. The Chamber of Commerce wanted a politician in office who would do business good. Presumably, the shareholders of the corporations that contributed to the Chamber of Commerce favor such speech. But even if all the shareholders in General Motors do not advocate laws favorable to Motors, so what? The power of General Motors to commandeer greater influence in the marketplace of ideas for pro-business positions, through its accumulation of wealth, is certainly no more out of proportion to the general currency of those pro-business ideas espoused than the speech of a pro-business billionaire.

Limits on political *contributions*, and the public financing of elections, are reforms that do not offend the First Amendment. But limits on expenditures do. The Court basically got it right the first time in *Buckley v. Valeo*, and should not have begun to retreat.

If America will not restrict the political speech of the individual billionaire to equalize it with that of the average citizen, it should not restrict the speech of the corporation. For as Justice Kennedy noted, the Sierra Club and the American Civil Liberties Union are also organized in corporate form. Americans who contribute to the ACLU are not likely to agree with every position in its platform, any more than the investor in General Motors agrees with all of its corporate positions. Far better to let all of this be sorted out through an unregulated market of political speech and money spent on political speech, than to permit the government to embark on the dangerous business of equalizing.

Notes

1. For an excellent review of new communications technologies as they influence politics, *see* J. Swerdlow, New Communication Technologies in Politics (1985).

2. *See generally*, Cox, *Constitutional Issues in the Regulation of the Financing of Election Campaigns*, 31 Clev. St. L. Rev. 395 (1982); Symposium *Political Action Committees and Campaign Finance*, 22 Ariz. L. Rev. 351 (1981); Symposium, *Campaign Finance Reform*, 10 Hastings Const. L. Q. 463 (1983).

3. See Fleishman, *The 1974 Federal Election Campaign Act Amendments: The Shortcomings of Good Intentions*, 1975 Duke L.J. 851, 852 (1975) "But for the embarrassing and widening wake of Watergate . . . there would very likely have been no new campaign finance reforms in 1974."

4. Federal Election Campaign Act of 1971, 86 Stat. 3 as amended by the Federal Election Campaign Act Amendments of 1974, 88 Stat. 1263.

5. 424 U.S. 1 (1976) (*per curiam*).

6. *Id.* at 68–69.

7. *Id.* at 95–96.

8. For other treatments of this topic, *see*, Bartlett & Potter, *The Political Impact of "Legal Mythology"*, 1981 Wis. L. Rev. 494 (1981); BeVier, *Money and Politics: A Perspective on the First Amendment and Campaign Finance Reform*, 73 Calif. L. Rev. 1045 (1985); Blum, *The Divisible First Amendment: A Critical Functionalist Approach to Freedom of Speech and Election*

Campaign Spending, 58 N.Y.U. L. Rev. 1273 (1983); Drew, Politics and Money (1985); Fleishman, *Freedom of Speech and Equality of Political Opportunity—The Constitutionality of the Federal Election Campaign Act*, 51 N.C. L. Rev. 389 (1973); Fleishman, *1974 Federal Election Campaign Act Amendments*, 1975 Duke L. J. 851 (1975); Malbin, *Politics: Political Campaign Finance Reform*, 10 Hastings Const. L. Q. 463 (1983); Malbin, *Political Action Committees and Campaign Finance Reform*, 22 Ariz. L. Rev. 351 (1980); Nahra, *Political Parties and the Campaign Finance Laws: Policies, Concerns and Opportunities*, 56 Ford. L. Rev. 53 (1987), Sylvester, *Equalizing Candidates Opportunities for Expression*, 51 Geo. Wash. L. Rev. 113 (1982); L. Tribe, Constitutional Choices, 193–96.

9. For additional arguments that expenditure limits are unconstitutional, *see*, Fleishman, *The 1974 Election Campaign Act Amendments: The Shortcomings of Good Intentions*, 1975 Duke L.J. 851, 880–882 (1975).

10. Tushnet, *An Essay on Rights*, 62 Tex. L. Rev. 1363, 1387 (1984); M. Tushnet, Red, White, and Blue: a critical analysis of Constitutional Law 170 (1988).

11. *Buckley*, 424 U.S. at 58–59.

12. *Id*. 424 U.S. at 26.

13. 454 U.S. 290 (1981).

14. For an interesting comparison between the Court's ruling in *Berkeley* and its ruling in *United States Postal Service v. Greenburgh Civic Associations*, 453 U.S. 114 (1981), a case that upheld a federal postal regulation forbidding the placement of "mailable matter" in U.S. mailboxes, *see* L. Tribe, Constitutional Choices 194–96 (1985).

15. 391 U.S. 367 (1968).

16. *See* Note, *Integrating the Right of Association With the* Bellotti *Right to Hear*, 72 Cornell L. Rev. 159, 171 (1986), pointing out that the Court held restrictions on contributions to be constitutional and not overbroad even though most contributors do not seek improper influence with candidates.

17. *Buckley*, 424 U.S. at 39, *quoting* Williams V. Rhodes, 393 U.S. 23,32 (1968).

18. *See* BeVier, *Money and Politics: A Perspective on the First Amendment and Campaign Finance Reform*, 73 Calif. L. Rev. 1045, 1056 (1985), stating that the *Buckley* Court rejected the draft card burning analogy, but failed to articulate a rationale for this conclusion. "The Court's assertion in *Buckley* that '[t]he expenditure of money simply cannot be equated with such conduct as destruction of a draft card' is flawed because it rests upon a specious distinction between conduct and speech. As was true with the draft card burning in *O'Brien*, the speech and conduct involved in campaign contributions and expenditures represent an undifferentiated whole."

19. There is a rich body of literature supporting the view that wealth, particularly corporate speech, may undermine the democratic process. *See, e.g.*, Lowenstein, *Campaign Spending and Ballot Propositions: Recent Experience, Public Choice Theory and the First Amendment*, 29 U.C.L.A. L. Rev. (1982); Shockley, *Direct Democracy, Campaign Finance, and the Courts: Can Corruption, Undue Influence, and Declining Voter Confidence Be Found?*, 39 U. Miami L. Rev. 377 (1985).

20. 479 U.S. 238 (1986).

21. *Id*. at 241–242.

22. First National Bank v. Bellotti, 435 U.S. 765 (1978).

23. *See* Comment, *Federal Election Law—Federal Election Commission v. Massachusetts Citizens for Life : Non-Profit Corporation Expenditures in Federal Elections*, 60 Notre Dame L. Rev. 138, 145 (1984) (Stating that the Court clearly distinguished referenda from elections of public officers because there is no danger of corruption in a vote on a public issue as there is in an election for public office.)

24. *MCFL*, 479 U.S. at 257.

25. 110 S.Ct. 1391 (1990).

26. Mich. Comp. Laws Sec. 169.254 (1979).

27. *Austin*, 110 S.Ct. at 1427.

28. Mich. Comp. Laws Sec. 169.255.

29. Communications Workers of America v. Beck, 487 U.S. 735, 744 (1988); Abood v. Detroit Board of Education, 431 U.S. 209, 218 (1977).

30. *Austin*, 110 S.Ct. at 1408 (Scalia, J., dissenting).

31. *Austin*, 110 S.Ct. at 1418 (Kennedy, J., dissenting).

32. On the role of equality in First Amendment analysis, *see generally*, Karst, *Equality as a Central Principle in the First Amendment*, 43 U.Chi. L. Rev. 20 (1975).

33. 384 U.S. 214, 219 (1966).

34. *See generally*, Blasi, *The Checking Value in First Amendment Theory*, 1977 Am. B. Found. Res. J. 521.

35. *See, e.g.*, Florida Star v. B.J.F., 109 S.Ct. 2603 (1989). Regarding this aspect of *Florida Star*, it is true, of course, that many of the most famous First Amendment decisions of the last three decades, including decisions protecting the publication of truthful information that the government had attempted to keep confidential, have involved the institutional press. *See, e.g.*, New York Times Co. v. United States, 403 U.S. 713 (1971) (the "Pentagon Papers" case); Landmark Communications, Inc. v. Virginia, 435 U.S. 829 (1978). That is only natural; the press has a unique professional and financial stake in the aggressive pursuit of First Amendment freedoms, and is often the constitutional standard-bearer. *The Supreme Court has been absolutely firm, however, in holding that the press enjoys no special First Amendment privileges not generally applicable to all citizens.* The Supreme Court has rebuffed adoption of a media-nonmedia dichotomy in First Amendment law every time it has been invited to adopt it; indeed, rejection of such a distinction is one of the few areas of modern First Amendment law on which there is substantial consensus among Justices from all jurisprudential viewpoints currently represented on the Court. *See generally*, R. Smolla, Law of Defamation, section 3.02 (1986) (collecting cases and summarizing positions of the Justices).

36. *See* Pell v. Procunier, 417 U.S. 817 (1974) (refusing to recognize any special First Amendment right of access for the press); Houchins v. KQED, Inc., 438 U.S. 1 (1978) (same).

37. Dun & Bradstreet, Inc. v. Greenmoss Builders, Inc., 472 U.S. 749, 773 (1985) (White, J., concurring).

38. *Id.* at 783 (Brennan, J., dissenting).

39. It should be noted that there *are* examples of the level of constitutional protection being related to the status of the speaker, *see, e.g.*, Hutchinson v. Proxmire 443 U.S. 111 (1979) (interpreting scope of Senator's privilege under the Speech or Debate Clause); Gravel v. United States, 408 U.S. 606 (1972) (interpreting coverage of Speech or Debate Clause for legislative aides); sometimes by the status of the speech, *see, e.g., Connick v. Myers*, 461 U.S. 138 (1983) (applying lower level of First Amendment protection to private speech of a public employee involving no issues of public concern); Dun & Bradstreet, Inc. v. Greenmoss Builders, Inc., 472 U.S. 749 (1985) (applying lower level of First Amendment protection for defamatory speech not involving issues of public concern); and sometimes by the status of the object of the speech, *see, e.g.*, New York Times Co. v. Sullivan, 376 U.S. 254 (1964) (requiring proof of actual malice in defamation cases brought by public officials); Curtis Publishing Co. v. Butts, 388 U.S. 130 (1967) and Associated Press v. Walker, 388 U.S. 130 (1967) (companion cases extending actual malice standard to defamation actions brought by public figures); Gertz v. Robert Welch, Inc., 418 U.S. 323 (1974) (refusing to extend actual malice standard to defamation actions brought by private figures.)

The Origins of the Free Speech Clause

Stephen A. Smith

The observation of the bicentennial of the United States Constitution and ratification of the Bill of Rights has provided the opportunity for numerous voices to call for a reexamination of the "intent of the Framers" and for some to recraft history to support certain views of "original intention." In his recent book, *The Tempting of America,* Robert Bork even advanced a spirited argument that intent of the framers is the *only* valid means of constitutional interpretation. To determine and articulate the implicit values of the framers, he suggested, judges can supplement documentary narratives by also seeking "enlightenment from the structure of the document and the government it created."[1] In this spirit, a chorus of purposeful ideologues including Chief Justice Rehnquist, former Attorney General Edwin Meese, and the enthusiastic young members of the Federalist Society have presented a particular rendering of history and a vision of the past that only confirms Clinton Rossiter's observation that those in "power who know least about 'the intent of the Framers' are most likely to appeal to it for support of their views."[2]

The bicentennial should also be a time for those of us in the academy to bring our particular skills to bear on the problems associated with understanding "original intention" by more carefully reconstructing and explicating the political and intellectual forces which influenced the Framers.[3] One area in which communication scholars can engage this debate and be particularly helpful is with regard understanding the origins of the First Amendment. Free speech scholars, trained in rhetorical and communication theory, grounded in the literature of jurisprudence, and utilizing historical methods can bring a unique perspective to the rhetorical history, implicit values, and contemporary consequences of "original intent" regarding the First Amendment guarantees of freedom of expression.

Unfortunately, even some of our academic colleagues seem confused about the history of actions and ideas surrounding that essential constitutional provision and have further clouded public understanding. Professor Diana Peck of William Patterson College has written that the First Amendment was "penned by Thomas Jefferson."[4] While the legislative history of the First Amendment reveals a rather haphazard process of accident, compromise, and revision in its drafting, James Madison guided that process. Jefferson, despite his ideological contributions to intellectual freedom and his personal influence on Madison, was in France during the time of the drafting of both the Constitution and the Bill of Rights.

Research for this essay was conducted during the author's appointment as Andrew W. Mellon Fellow, Department of History and Philadelphia Center for Early American Studies, University of Pennsylvania, and funded in part by an Off Campus Duty Assignment by the J. William Fulbright College of Arts and Sciences, University of Arkansas, during the 1989–90 academic year. Praise be to Wayne K. Bodle and Thomas S. Frentz for their careful reading and helpful suggestions on an earlier draft of this essay.

Stephen Klaidman, a senior research fellow at Georgetown University, has argued for limitations on freedom of expression based upon a somewhat tortured reading of John Stuart Mill. He also contended that "Madison and his colleagues were intimately familiar with John Stuart Mill's classic essay 'On Liberty,' and they knew . . . that Mill was as concerned with preventing harm as he was with promoting liberty."[5] While Madison was a man of considerable intellectual genius and a prescient political philosopher, it is doubtful that he was "intimately familiar" with Mill's essay, first published in 1859.

More dangerous than the mistakes of the uninformed, however, are the damaging consequences of erroneous arguments by scholars with national reputations for thorough research. The most influential scholarly investigation of original intent and the First Amendment's guarantees of freedom of speech and press has been Leonard W. Levy's 1960 *Legacy of Suppression*, revised in 1985 as *Emergence of a Free Press*.[6] Grounding his argument on the proposition that the Framers of the First Amendment were merely enacting Blackstone's proposition that "the liberty of the press . . . consists in laying no previous restraints upon publications and not in freedom from censure for criminal matter when published," he purported "to demolish the proposition formerly accepted in both law and history that it was the intent of the American revolution or the Framers of the First Amendment to abolish the common law of seditious libel."[7]

Levy claims that his thesis has now become the "new orthodoxy" regarding interpretation of intent of the Framers, and even those who challenge the "hegemony" of his interpretation admit that his "work in first amendment history has become the conventional wisdom of our generation."[8] A number of scholars have convincingly critiqued Levy's argument; however, as Zechariah Chafee observed 50 years ago, and as is obviously true today, "This Blackstonian theory dies hard, but it ought to be knocked on the head once for all."[9] That is the purpose of this essay.

I will argue my position through an analysis of the origins of the free speech clause. Specifically, I will first contest Levy's reliance on Blackstone's statement on liberty of the press as the basis for a consensus view of the Framers' intentions to define and protect freedom of speech. Second, I will contend that Madison's inclusion of the speech clause was a late decision, although a deliberate and important one. Third, I will show that Madison drew the language of the speech clause from amendments suggested by three state ratifying conventions, first initiated by the Pennsylvania Minority Dissent of 1787 which appropriated the language of the 1776 Pennsylvania Declaration of Rights. Fourth, I will examine both the genesis and the genius of the 1776 Pennsylvania Declaration of Rights and Frame of Government, the first constitution to guarantee the free speech rights of individual citizens and to clarify the conceptual scope of political expression. Finally, I will argue the significance of James Burgh's *Political Disquisitions* as an influential source of political theory—and especially the theory of freedom of expression in republican governments—for the constitution makers of the revolutionary generation.[10]

Levy's Blackstone

Sir William Blackstone, whom Levy dubbed "the oracle of the common law in the minds of the American Framers," offered a summary of the common law on libels which held:

Where blasphemous, immoral, treasonable, schismatical, seditious, or scandalous libels are punished by the English law . . . the liberty of the press, properly understood, is by no means infringed or

violated. The *liberty of the press* is indeed essential to the nature of a free state; but this consists in laying no *previous* restraints upon publications, and not in freedom from censure for criminal matter when published. Every freeman has an undoubted right to lay what sentiments he pleases before the public: to forbid this is to destroy the freedom of the press: but if he publishes what is improper, mischievous, or illegal, he must take the consequences of his own temerity. . . . But to punish (as the law does at present) any dangerous or offensive writings, which, when published, shall on a fair and impartial trial be adjudged of a pernicious tendency, is necessary for the preservation of peace and good order, of government and religion, the only solid foundations of civil liberty. . . . [T]he disseminating, or making public, of bad sentiments, destructive of the ends of society, is the crime which society corrects.[11]

By relying on these words from Blackstone to give definition to the free speech clause of the First Amendment, Levy's argument suffers from several fatal fallacies and internal inconsistencies. First, Levy assumes and almost casually suggests that the "citizen's personal right of freedom of speech evolved as an offshoot of freedom of the press and freedom of religion—the freedom to speak openly on religious matters," then he proceeds to lump speech and press freedoms together and treats them as undistinguished elements free only from governmental licensing. While freedom of conscience and religious speech might well have been more important than secular political speech to most British subjects from the beginning of the Reformation until the Glorious Revolution, most citizens were certainly speaking about political issues before they were printing pamphlets or newspapers on the subject. Viewing free speech as a derivative of freedom of the press is to see the historical tail wag the jurisprudential dog.

Second, another obvious flaw in Levy's trickle-down theory of freedom of speech is that the Licensing Acts could never have been applied to oral discourse. Freedom from prior restraint on speech is no freedom whatsoever; it is a *non sequitur*. As Cooley explained, "The mere exemption from previous restraints cannot be all that is secured by the constitutional provisions, inasmuch as of words to be uttered orally there can be no previous censorship, and the liberty of the press might be rendered a mockery and a delusion, and the phrase itself a byword, if, while every man was at liberty to publish what he pleased, the public authorities might nevertheless punish him for harmless publications"[12]

Other than in the context of the Parliamentary privilege of freedom of speech and debate, Blackstone does not mention freedom of speech as one of the British rights and liberties secured by common law. The reason for that omission, said Roscoe Pound, is historical. Seditious speech (both political and religious) was punished in the Court of Star Chamber; therefore, the common law courts were not confronted with the issue, and it was not a point for discussion in Coke's *Second Institute*—upon which Blackstone based his *Commentaries*.[13] Consequently, when Blackstone dealt with "Rights of Persons" in Book I of the *Commentaries*, observed Eric Barendt, he "did not mention freedom of speech in his discussion of personal liberties, and the classic passage on freedom of the press occurs in [Book IV] dealing with wrongs and libel."[14] When British subjects on both sides of the Atlantic demanded their constitutional rights and British liberties, they clearly meant the rights of persons, not the wrongs of Book IV.[15] The closest Blackstone came to articulating an individual right to freedom of speech, says Barendt, is in Book I in his treatment of the right to petition the Crown or Parliament for redress of grievances.[16] In that context, the citizen is free from both prior restraint and subsequent punishment for the content of petitions to the King, for §5 of the Bill of Rights provides, "That it is the right of the subjects to petition the King, and all commitments and prosecutions for such petitioning are illegal."[17]

Levy is correct in acknowledging that Blackstone's *Commentaries* was an influential legal treatise in colonial America. It provided a ready summary of common law to a legal community which argued its principles in the colonial courts, and those common law rights were the basis of many early rhetorical appeals demanding that the colonists be afforded the traditional rights and liberties of British subjects.[18] Even in Great Britain, however, Blackstone's views of the law were not unchallenged. As early as 1762, Adam Smith advised his classes in jurisprudence against the prosecution of even private libels and contended that the liberty to censure the Administration—and the right to publish on these subjects—was now accepted, at least in theory and often in practice.[19] In 1769, "Junius" labelled the Commentaries "a snare to the unwary" and charged that Blackstone's position on the Wilkes issue was inconsistent with his own writings.[20] By 1776, Jeremy Bentham criticized Blackstone's analysis as "at best merely expository—it describes the law as it is—or at worst it is an apology for the *status quo* disguised as an exposition."[21]

The testimony of those whom Levy counts as Framers indicate a wary skepticism of Blackstone on the key issue of rights of citizens. James Wilson, who studied law under John Dickinson and was thoroughly versed in the literature of both law and political theory, did not find Blackstone's views on government particularly applicable to post-colonial America. Blackstone was, in Wilson's view, too much under the court influence of British monarchy. "I cannot consider him as a zealous friend of republicanism," he said. "In publick law . . . he should be consulted with a cautious prudence. . . . He deserves to be much admired; but he ought not to be implicitly followed." Such critical examination should be applied to all political writers, Wilson argued to his students at the University of Pennsylvania, because the "cause of liberty, the rights of men require, that, in a subject essential to that cause and to those rights, errour should be exposed, in order to be avoided."[22] Jefferson, in discussing the legal curriculum for the University of Virginia, complained to Madison how young lawyers fed on "the honied Mansfieldism of Blackstone . . . began to slide into toryism. . . . They suppose themselves, indeed, to be whigs, because they no longer know what whigism or republicanism means."[23]

Levy's argument is further undone when he postures as if Blackstone's *Commentaries* were the only—or even the most important—influence defining the freedoms which were contested in the revolution and valued by those who wrote the state declarations of rights and later framed the First Amendment.[24] Moreover, Levy assumes the existence of a "consensus" among the Framers as to the intended extent of protected expression under the First Amendment. The probability of any consensus among the Framers on a single meaning or single theory has been convincingly refuted by Richard Parker.[25] As Robert Williams recently recognized, "we now know that there was far more fundamental contro-versy, as well as diversity of opinion and interest, in the state constitution-making process during the founding decade than was earlier thought."[26]

John Murrin, noting the difficulty involved in such an enterprise, suggested that while the Founders might agree that certain fundamental values did exist, "they did not agree on what they were or how to find them. Instead contemporaries had to choose among several competing value systems, each with brilliant articulation in the high thought of the day. Humans being what they are, few chose one set of values to the complete exclusion of all others. Most people absorbed strands from more than one source and did their best to reconcile the tensions that their efforts created."[27]

This diversity of outlook held true in the colonies even with regard to views on the common law. Richard Morris has challenged the historical accuracy of Justice Story's assertion regarding the dominance of the common law in colonial America. It was, he

said, a description of "what nineteenth-century jurists *thought* had happened to the law rather than . . . a useful rule for guaging colonial experience." Moreover, Morris suggested, "It is now recognized that no monolithic interpretation will suffice to explain the course and reception of law in America. . . . Many strands were woven into the fabric of American law, . . . and the patterns vary from place to place."[28]

Consequently, to conclude that all of the participants shared an identical vision on the meaning of any First Amendment clause would be contrary to both communication theory and historical evidence. No simplistic, single-source explanation can stand, not even one which has enjoyed the reputation and influence attributed to Levy's research. Levy cites numerous other sources of political theory and views on constitutional rights, yet he discounted almost all except Blackstone, rejected the possibility of any pre-1798 libertarian theory intended to abolish the common law concept of seditious libel, and persisted in suggesting that the free speech and press clauses of the First Amendment "substantially embodied the Blackstonian definition and left the law of seditious libel in force."[29] Levy then compounds the difficulties with the implicit required assumption that Blackstone was not only descriptive but prescriptive—a logic which would lead to the conclusion that the Framers accepted Blackstone's views on toleration of religious dissent as the basis for understanding intent of the religion clauses as well.[30] Such conclusions regarding the intended protections of the First Amendment are no more warranted than would be claims that the constitutional prohibitions on granting titles of nobility or requiring religious test oaths should be read as merely reflecting British practices and precedents at common law.

The claims of Leonard Levy and his students notwithstanding, the idea that Blackstone's discussion of libel and limitations on freedom of the press became, for the Framers, the single, universally accepted, prescriptive meaning for the free speech clause of the First Amendment is unconvincing. It falls victim to the internal logic of the argument as well as to considerable external evidence.

I do think it would be helpful to engage the arguments and understand the implications of the various theoretical positions in the colonies and states during the late eighteenth century, and it might be both possible and valuable to better understand the influential texts read by and the meanings intended by certain influential Framers. That is what I intend to do below, carefully retracing the source of the language of the free speech clause from the First Amendment to its political and constitutional origins, carefully explicating important texts and examining the intentions of those who drafted the antecedent documents. The assumptions, the texts, and the conclusions differ from those found in Levy's *The Emergence of a Free Press.*

The Evolution of Madison's Position

Madison's intellectual role as the principal Framer of the First Amendment might be dated from his amendment to expand religious liberty in the 1776 Virginia Declaration of Rights. That same document, prepared and proposed by George Mason, contained the first constitutional guarantee for freedom of the press. The press clause, however, does not appear to have been in Mason's original draft of the proposals; it was interlined in the handwriting of Thomas Ludwell Lee and appears to have been added on May 25, 1776, by the committee charged with preparing the declaration. While Madison was a member of this committee, there is no evidence to indicate that it was included at his suggestion nor any record to suggest who was responsible for its inclusion. The likely source, however, was an article appearing in the *Virginia Gazette* on May 18, 1776, referring to

"Liberty of the press [as] the palladium of our liberties" and declaring that "liberty of speech is a natural right."[31]

Madison's contribution, as an element of Federal constitutional history, began during the Constitutional Convention of 1787. On September 12, as the convention was coming to a close, George Mason argued for prefacing the proposed Constitution with a federal Bill of Rights, modeled after the state declarations; however, Elbridge Gerry's motion for a committee to prepare a Bill of Rights was unanimously defeated.[32] Madison's position on that motion is uncertain. The Virginia delegation voted as a unit against the motion, and Madison does not record that he spoke to the measure.

Madison's correspondence with Jefferson following the convention offers the first real insight to his developing support for such amendments. On July 31, 1788, Jefferson expressed his approval of the new Constitution but suggested the need to better secure individual liberties, specifically protection for freedom of the press and freedom of religion.[33] Madison, in his reply of October 17, 1788, acknowledged the public sentiment "for further guards to public liberty and individual rights" and indicated the likelihood that "a constitutional declaration of the most essential rights" would soon be added. As for his own views, he said, "My own opinion has always been in favor of a bill of rights; provided it be so framed as not to imply powers not meant to be included in the enumeration [in Article I of the original document]. At the same time I have never thought the omission to be a material defect, nor been anxious to supply it even by subsequent amendment, for any other reason than that it is anxiously desired by others. I have favored it because I supposed it might be of use, and if properly executed could not be of disservice." His lack of enthusiasm resulted from his beliefs that the federal government had only the delegated powers enumerated, that it would be difficult to secure some rights (particularly freedom of conscience) with sufficient latitude, that the states would restrain assumptions of power by the Federal government, and that "experience proves the inefficacy of a bill of rights on those occasions when its control is most needed. Repeated violations of these parchment barriers have been committed by overbearing majorities in every state." Nonetheless, he saw two positive purposes of having fundamental rights specified in the Constitution. First, he said, "The political truths declared in that solemn manner acquire by degrees the character of Fundamental maxims of free governments, and as they become incorporated with the national sentiment, counteract the impulses of interest and passion." Second, he added, if the government did attempt to usurp fundamental liberties, "a bill of rights would be a good ground for an appeal to a sense of the community."[34]

During Madison's campaign for Congress in 1789, Patrick Henry's Virginia Anti-Federalists backed James Monroe and implied that Madison was opposed to any Federal bill of rights to protect religious liberty.[35] In a letter to George Eve, a Baptist minister serving as pastor of Blue Run Church only a few miles from Montpelier in Orange County, Madison reiterated his earlier reservations about the necessity of amendments but articulated his evolving position on the issue, pledging his personal support. He wrote that such amendments could disarm opponents of the Constitution and provide "additional guards in favor of liberty." Under those circumstances, he said, "it is my sincere opinion that the Constitution ought to be revised, and that the first Congress meeting under it, ought to prepare and recommend . . . the most satisfactory provisions for all essential rights, particularly the rights of conscience in the fullest latitude, the freedom of the press, trials by jury, security against general warrants &c."[36] That commitment was sufficient to assure the political support of Eve, John Leland, and other Baptist leaders in the District, and Madison prevailed over Monroe by 336 votes.[37]

Madison was now firmly committed to securing a declaration of rights; however, some still doubted his sincerity. George Mason, for example, said that Madison knew he would "not be elected, without making some such Promises; by them he carried his Election; . . . and to carry on the Farce,—is now the ostensible Patron of Amendments.—Perhaps some milk & water Propositions may be made by Congress . . . but of important & substantial Amendments, I have not the least Hope."[38]

When the House of Representatives first organized in Federal Hall at New York on April 1, 1789, Madison quickly demonstrated his belief that a Federal bill of rights should further protect individual liberties, rights he had declared to be "essential" and "fundamental" in a republican government. On April 8, he wrote to Edmund Pendleton that he anticipated "no great difficulty in obtaining reasonable" amendments to the Constitution.[39] Madison drafted Washington's "Address to Congress," delivered on April 30, in which the President mentioned the anticipated amendment process with the hope that "a reverence for the characteristic rights of freemen, and a regard for public harmony, will sufficiently influence your deliberations on the question of how far the former can be impregnably fortified, or the latter be safely and advantageously promoted."[40] Madison also drafted the responding "Address of the House of Representatives to the President," assuring Washington on May 5 that the amendment process "will receive all the attention demanded by its importance; and will, we trust be decided, under the influence of all the considerations to which you allude."[41] Thus, Madison skillfully framed the scene for introduction and approval of the Bill of Rights, and he quickly acted to take control of those amendments.

On May 4, 1789, Madison had given notice that he intended to propose amendments to the Constitution on May 25, but the demands of organizing the new government forced consideration to be postponed until June 8.[42] Despite opposition from members believing other matters more important, Madison addressed the House on June 8, 1789, providing the first glimpse of the words which would eventually become the First Amendment, clearly articulating his reasons and intent in proposing the measures and explaining his vision of the nexus between the proposed amendments and the underlying nature of the political community created by the Constitutional. To protect freedom of expression, Madison proposed an amendment reading, "The people shall not be deprived or abridged of their right to speak, to write, or to publish their sentiments; and the freedom of the press, as one of the great bulwarks of liberty, shall be inviolable."[43]

In addition, Madison argued for a provision that "No state shall violate the equal rights of conscience, or the freedom of the press, or the trial by jury in criminal cases." During subsequent debate on August 17, when Congressman Thomas Tucker of South Carolina moved to strike the prohibition on state government infringements, Madison called that clause "the most valuable amendment on the whole list."[44] The House voted to retain the restriction, even adding protection for freedom of *speech*, but the Senate later rejected the provision. Despite similar guarantees in many state constitutions, Madison seemed to know that freedom of expression would be frequently without any real protection in the state courts and in the face of overbearing majorities.[45]

The amendment process which resulted in the final wording of the First Amendment was rather tedious. On July 21, Madison proposed that his resolutions be debated in the Committee of the Whole; however, the House referred them, along with the changes requested by the state ratifying conventions, to a special committee on which Madison served. The committee issued a favorable report on July 28, then the House tabled the report. The report and the proposed amendments were debated in the House during the

week of August 13–17, and on August 24 the House approved and sent seventeen amendments to the Senate.

Senate action on September 2, conducted behind closed doors, resulted in both substantive and stylistic reduction of the list to twelve amendments.[46] The Senate Journal does, however, reveal that the Senate defeated a proposal to restrict protection of press freedom to the scope "as hath at any time been secured by the common law," further undermining Levy's Blackstonian thesis.[47] As passed by the Senate and referred to a conference committee on September 19, proposed Amendment Three read, "Congress shall make no law establishing articles of faith, or a mode of worship, or prohibiting the free exercise of religion, or abridging the freedom of speech, or the press, or the right of people peaceably to assemble, and petition the government for the redress of grievances." As Robert Rutland said of the Senate revision of Madison's original resolutions, "They slashed out wordiness with a free hand."[48] After several substantive and stylistic changes by the conference committee, Congress approved the revised list of twelve amendments on September 25, 1789. On December 15, 1791, Virginia became the requisite eleventh state to ratify proposals three through twelve which then were certified as adopted, becoming the ten amendments known as the Bill of Rights.

The legislative process in Congress, still in its mechanical infancy, had modified and condensed Madison's original language, usually with more concern for stylistic parsimony than for precision of meaning. As a result, the historical facts of the legislative process provide little insight into the meaning of the words beyond the evidence appearing in the language of the First Amendment; however, Madison's reasoned arguments provide a wealth of information about the intent of the author. Madison called freedom of conscience and liberty of the press "the choicest privileges of the people," and he noted that freedom of speech and conscience are natural rights existing before the governmental compact.[49]

A careful reading of Madison's speech of June 8 reveals that his primary intention was to secure the rights of the people, both natural rights and political rights arising out of the nature of the compact, against encroachments by government—national and state, executive and legislative—and by powerful and interested majorities in the community. Regardless of the specific form adopted by particular states, and equally applicable to the national government he said, "the great object in view is to limit and qualify the powers of government, by excepting out of the grant of power those cases in which the government ought not to act, or to act only in a particular mode. They point these exceptions sometimes against the abuse of the executive power, sometimes "against the legislative, and, in some cases, against the community itself; or in other words, against the majority in favor of the minority."[50] Such positive protections of fundamental rights should not be seen as enlarging the powers delegated to the government, but as limitations on them; should be seen as safeguards against the "necessary and proper" clause being abused to enforce government powers not granted; and could in no way be argued to interfere with the legitimate functions of government by their promoting the rights of individuals.[51] It would appear that Madison intended that the Bill of Rights serve as the touchstone for those trying to balance the demands of conflicting powers by giving added weight to individual liberties against the delegated powers of the government—and as a double protection against the usurpation of both enumerated and unenumerated powers retained by the people.[52]

The Demands of the Ratifying Conventions

While Madison's position regarding the need for amendments certainly evolved— prompted by Jefferson's urging, solidified by the congressional campaign, and assured by

the adoption of the Constitution—what is less clear is how the speech clause came to be included in Madison's proposals. In all of his remarks previous to introduction of the amendments, Madison stressed only freedom of conscience and liberty of the press, first mentioning freedom of speech in his address of June 8, 1789. In compiling the list of rights proposed on June 8, Congressman Fisher Ames of Massachusetts said, "Mr. Madison has introduced his long expected amendments. They are the fruit of much labor and research. He has hunted up all the grievances and complaints of newspapers, all the articles of conventions, and the small talk of their debates."[53] Of primary importance to Madison, for obvious political reasons, appear to have been the instructions and the recommended amendments from the Virginia Ratifying Convention which, in late June 1788, had requested twenty specific guarantees. Both Madison and Mason had been members of the Ratifying Convention committee which prepared those proposals, and much of the language in those instructions appears to have been borrowed from the Virginia Declaration of Rights, a document drafted primarily by Mason and supported by Madison in 1776.

The Virginia call for an amendment protecting freedom of speech, however, could not have been based upon the 1776 Virginia Declaration, because that document contained no free speech clause. In this instance at least, George Mason, Patrick Henry and the Anti-Federalist minority in Virginia, like the North Carolina convention which subsequently recommended an amendment protecting freedom of speech, borrowed the demand from the earlier language of *The Address and Reasons of Dissent of the Minority of the Convention, of the State of Pennsylvania, to their Constituents*, a document drafted by Robert Whitehill and widely reprinted and circulated among the Anti-Federalist network in other states.[54]

As early as October 5, 1787, the Pennsylvania Anti-Federalists had raised the issue of protection for freedom of speech, a right guaranteed under the state's 1776 constitution but which they thought unprotected under the proposed Federal Constitution. "Centinel" praised the Pennsylvania Declaration of Rights which, he said, "provides and declares *'that the people have a right of* FREEDOM OF SPEECH, *and of* WRITING and PUBLISH-ING *their sentiments, therefore* THE FREEDOM OF THE PRESS OUGHT NOT TO BE RESTRAINED.' The constitution of Pennsylvania is *yet* in existence, as yet you have the right to *freedom of speech,* and of *publishing your sentiments.*" Charging that the proposed Federal constitution contemplated an unaccountable aristocracy, he said that the Framers, "actuated by the true spirit of such a government, have made no provision for the *liberty of the press,* that grand *palladium of freedom* and *scourge of tyrants,* but observed a total silence on that head." Then, relying upon the force of popular political writings, he joined "the opinion of some great writers, that if the liberty of the press . . . could be rendered *sacred,* even in *Turkey,* that despotism would fly before it."[55]

During the debates of the Pennsylvania Ratifying Convention on November 30, 1787, William Findley asked that the delegates consider the necessity of a Federal declaration of rights. "Powers given—powers reserved—ought to be all enumerated. Let us add a bill of rights to our other securities," he said. John Smilie agreed and promised, "We will exhibit a bill of rights, if the Convention will receive it." Almost as if he were refuting Blackstone and rejecting the limited liberties secured by common law, he said, "Freedom [was] almost unknown in the Old World. Are we to go there for precedents of liberty? . . . Suppose Congress [were] to pass an act for the punishment of libels and restrain the liberty of the press, for they are warranted to do this. What security would a printer have, tried in one of their courts." Then, repeating Centinel's warning, Smilie said, "An aristocratical government cannot bear the liberty of the press."[56]

On December 12, Whitehill urged fifteen amendments he believed necessary before the Constitution could be safely ratified. Sixth among Whitehill's proposed amendments was one reading, "That the people have a right to the freedom of speech, of writing, and of publishing their sentiments, therefore, the freedom of the press shall not be restrained by any law of the United States."[57] There is little question that this language was drawn and adopted from Article XII of the 1776 Pennsylvania Declaration of Rights which held, "That the People have a Right to Freedom of Speech, and of writing and publishing their Sentiments; therefore, the Freedom of the Press ought not to be restrained."

After the Convention majority rejected Whitehill's motion for amendments, 23–46, he led a twenty-one member minority in drafting and publishing on December 18 their reasons for opposing ratification, once again repeating verbatim the call for an amendment protecting the freedom of speech and press. The *Dissent of the Minority* demanded "a Bill of Rights ascertaining and fundamentally establishing those unalienable and personal rights of men, without the full, free and secure enjoyment of which there can be no liberty, and over which it is not necessary for a good government to have control . . ." Among these essential rights they said, borrowing and combining the words of "Centinel" and "Cato", was "the liberty of the press, that scourge of tyrants, and the grand bulwark of every other liberty and privilege."[58]

As the Anti-Federalists learned the strategic value of calling for a Bill of Rights, the Pennsylvania minority's list of suggested amendments became a model, with other states subsequently modifying it in their own conventions based on the state declarations where such existed. In Virginia, for example, the convention proposed in June, 1788, a list of suggested amendments, the sixteenth of which read, "That the people have a right to freedom of speech, and of writing and publishing their sentiments; that the freedom of the press is one of the greatest bulwarks of liberty, and ought not to be violated."[59] Virginia's 1776 Declaration of Rights did not contain a speech clause, but declared, "That the freedom of the Press is one of the greatest bulwarks of liberty, and can never be restrained but by despotick Governments."[60] The additional language regarding the people's rights to speech, writing, and publishing their sentiments was almost certainly borrowed from the Pennsylvania *Dissent*.

In North Carolina, the Convention refused to ratify the Constitution without prior amendments, and on August 1, 1788, duplicated the call for Virginia's proposed sixteenth amendment, "That the people have a right to freedom of speech, and of writing and publishing their sentiments; that freedom of the press is one of the greatest bulwarks of liberty, and ought not to be violated." The North Carolina Declaration of Rights, adopted on December 17, 1776, held only "That the freedom of the press is one of the great bulwarks of liberty, and therefore ought never to be restrained."[61]

Thus, when Madison turned to the reports of the state ratifying conventions in search of materials for a Federal Bill of Rights, he found three states—Pennsylvania, Virginia, and North Carolina—calling for Federal guarantees of protection for both speech and press, using the free speech language first found in the 1776 Pennsylvania Declaration of Rights, and joined with the "bulwark of liberty" metaphor from the 1776 Virginia Declaration of Rights. Ironically, this fusion restored the language first used by Thomas Gordon, writing as "Cato" in 1720.[62] In Essay No. 15 of *Cato's Letters,* entitled "Of Freedom of Speech: That the same is inseparable from Publick Liberty," Gordon asserted, "Freedom of Speech is the great Bulwark of Liberty; they prosper and die together: And it is the Terror of Traytors and Oppressors, and a Barrier against them. . . . All Ministers, therefore, who were Oppressors, or intended to be Oppressors, have been loud in their Complaints against

Freedom of Speech, and the Licence of the Press; and always restrained, or endeavoured to restrain, both."[63]

While Levy recognized but discounted the influence of *Cato's Letters* upon the Framers, Anderson argued otherwise: "We know that Cato's rhetoric found its way into the antecedents of the press clause; why should we conclude that the ideas did not?"[64] As a result of his own research efforts, Clinton Rossiter concluded, "No one can spend any time in the newspapers, library inventories, and pamphlets of colonial America without realizing that *Cato's Letters* . . . was the most popular, quotable, esteemed source of political ideas in the colonial period."[65] Levy confirmed that assessment as series editor for a collection of *Cato's Letters* in 1965, and even in 1985, he said, "In the history of political liberty as well as of freedom of speech and press, no eighteenth century work exerted more influence than *Cato's Letter's*."[66] Such an admission undermines either Levy's sincerity or his conclusions with regard to Blackstone's domination of colonial thought regarding freedom of speech and press.

Drafting the Pennsylvania Declaration of Rights

Several scholars have recognized the contribution of the 1776 Pennsylvania Declaration of Rights to the Federal Bill of Rights and even to the First Amendment; however, little is known about the crafting of that document, the principal draftsmen, or the source of their ideas. Nix and Schweitzer, for example, made the connection between the 1776 Declaration and the Minority Report, but they attributed the origins of the Pennsylvania Declaration to the Virginia Declaration and Penn's Charter, a history which overlooks the Pennsylvania origin of the speech clause.[67] Certainly the form of prefacing a written constitution with a declaration of rights, and even some of the rights so declared, were to be found in the Virginia document. An early draft of the Virginia Declaration of Rights was published in the Philadelphia press in early June, and a final version was available by the time the Pennsylvania Convention met.[68] Virginia, however, had no free speech provision, no guarantee of petition and assembly, no requirement that the doors of the Assembly be open to the public, no requirement that votes of the Assembly be published, and a much more limited section on religious liberty. The 1682 Frame of Government could hardly qualify as the precedent or source of the speech provision, because that charter held "That all scandalous and malicious reporters, backbiters, defamers and spreaders of false news, whether against Magistrates, or private persons, shall be accordingly severely punished, as enemies to the peace and concord of this province."[69] The 1776 Pennsylvania declaration of Rights was breaking new ground in republican theory and planting the seeds of a concomitant theory of freedom of expression which would eventually bear fruit in the First Amendment.

Bernard Schwartz discussed the importance of Article XII, and acknowledged, "For the first time in any constitutional enactment, it guarantees freedom of speech, as well as freedom of the press (being the direct precursor of perhaps the most significant guarantee of the Federal Bill of Rights). Certainly the inclusion of the freedom of speech in the list of fundamental rights guaranteed was a seminal step in the development that led to the Federal Bill of Rights." Despite recognition of the importance of the speech clause, however, he admitted, "We unfortunately do not know how freedom of speech came to be added to the Pennsylvania Declaration. . . ."[70]

Prime authorship of the 1776 Constitution has been attributed by various writers to Benjamin Franklin, George Bryan, Thomas Paine, David Rittenhouse, Samuel Adams,

George Ross, Thomas Young, Joseph Reed, and Timothy Matlack.[71] My argument in this section is that James Cannon was the principal author of the Declaration of Rights and Frame of Government adopted in Pennsylvania in 1776, and this conclusion is generally supported by other scholars of revolutionary Philadelphia, including Hawke, Reyerson, Foner, and Rosswurm.[72] None, however, have specifically addressed authorship of the speech clause; consequently, I believe it important to examine more closely Cannon's personal background and his philosophical positions in relationship to his probable authorship of the Pennsylvania free speech clause. Such an investigation should provide a better understanding of the original intent of the constitutional provision which ultimately informed and provided the language in the speech clause of the First Amendment.

James Cannon was an experienced and skillful writer, and he was thoroughly grounded in the rhetoric of rights and revolution by the time the Constitutional Convention convened in July, 1776. Although almost completely forgotten today, Cannon was, said Stephen Lucas, "an able advocate" and among "the most effectual Radical rhetoricians." Hawke believed that "except for Sam Adams, possibly no one in colonial America was a more skilled publicist, more adept at using the press to shape men's minds, more brilliant in his timing of manipulated events," and, with regard to authorship of the constitution, concluded, "Cannon's leading role is beyond question." Reyerson called him "by far the most literate and best educated" of the radical cadre and "the most important penman in Pennsylvania after Thomas Paine," and he said that the constitution "was largely Cannon's own work." Foner agreed that Cannon was "the radical group's leading thinker aside from Paine," said that he "took the leading part in drafting the new constitution," and called him "the leading voice on the committee which drew up the Declaration of Rights."[73]

Contemporary evidence provides considerable testimony that Cannon was the leading author of the constitution. John Adams, who had worked closely with Cannon in orchestrating the overthrow of the proprietary government in Pennsylvania, discounted Franklin's role in the process and attributed its major points to the ideas of Matlack, Cannon, Young, and Paine; Alexander Graydon also disputed Franklin's contribution and named Cannon as the primary draftsman.[74] Thomas Hartley, in a letter to Anthony Wayne, complained of the radical nature of the new constitution, attributing it to "Cannon and his puritanick levelling Party."[75]

Benjamin Rush, who had also worked closely with Cannon in the early days of the revolution but later opposed the constitution, said that the constitution "was formed by a fanatical schoolmaster who had art enough to sanctify it with Dr. Franklin's name."[76] Rush also related the story of Francis Hopkinson's reaction to the constitution while they were serving together in the Confederation Congress: "In the midst of a long debate he once amused himself by drawing with a pencil a caricature of the manner in which the first Constitution of Pennsylvania was forced upon the people. A Brewer and Schoolmaster, who were the most active members of the convention that framed the Constitution, with a dray, and a Schoolboy composed the figures of this picture. The Brewer offers the boy a mug of beer, the boy attempts to thrust it from him, while the Schoolmaster with a rod, compels him to drink it."[77]

David Ramsay, the historian and future Congressman, knew Cannon well during the two years he lived in Charleston, South Carolina during the war. He wrote to his friend Benjamin Rush, telling him that "James Cannon one of the constitution makers is in this town. He is disposed to defend the whole of it on which I have had frequent disputes, particularly about the necessity of a compound legislature." Unlike Rush, Ramsay did not let this point diminish his respect for Cannon's character. When Cannon returned to

Philadelphia, he carried a letter from Ramsay to Rush, confessing, "I almost envy you the pleasure you will receive, & I will lose by the departure of the bearer from Charlestown. He has been my most intimate friend here, & one whose company was always agreeable. His benevolence is equal to his understanding. Although he differs with you on the means of securing the blessings of good government to the people, yet his wishes that those blessings may be secured are equal to those of his most zealous opposers. Carolina is indeed impoverished by the departure of Mr. Davison (sic) & himself."[78]

Cannon's own testimony also supports the proposition that he was instrumental in drafting the constitution. He defended the provisions of the constitution in a public debate against John Dickinson and Thomas McKean on October 21, 1776, and on October 30, defended both the constitution and his own character in the public press. Writing under the pseudonym, "Consideration," he said the opponents of the constitution held it as "a vile thing, because a certain Schoolmaster had a principal hand in forming it," but suggested that the author was "a learned, sensible and disinterested Patriot."[79] In a letter to Robert Whitehill, he said,

You and I appear to be the Butts of the resentment of the gentlemen who do not like the government. I only wish the people may act honestly for themselves and that every one who seeks an alteration in the Plan may do it from a sincere desire to serve his country & secure the Liberties of its Inhabitants on the safest foundation—I am to live but one Life Time—Have none to leave behind me, am not gained by any Plan; but sincerely pray God that that alone may be established which will ever secure their Liberties without future Tumults & Confusion. This I think our present form would do if once fairly submitted to. Two bodies may do well in the Legislature until our present struggle is over, afterwards they will certainly form separate Interests and breed continual Broils in the State— However I wish every friend to his country satisfied and would do anything in reason to effect it— It was a great error not to print & distribute properly 10,000 of the copies of the Frame of Government, that the People might see & judge for them selves—This and a prudent conduct would settle the Matter I believe. To God I committ it & his good Providence, I have done what I did in Sincerity & with a sincere love of my neighbours.[80]

Cannon had proven himself a skilled writer in a number of contexts. He was active in the formation of the United Company of Philadelphia for Promoting American Manufactures, "an entryway into Philadelphia politics for several important ultraradical leaders in the revolutionary movement," and was elected Secretary of the Board of Managers on March 16, 1775.[81] In September, 1775, he served as Clerk of the General Committee of Privates of the Association, and in February, 1776, he headed the Philadelphia Committee of Privates' Committee of Correspondence, drafting the Privates' major broadsides and protests leading to independence.[82] Cannon also wrote a number of essays in the local press advocating independence, most notably the "Cassandra essays" in opposition to William Smith's "Cato essays."[83] As a result of these experiences, he was prepared to assume a major role in the Constitutional Convention, and he was quickly recognized and accepted as a capable advocate and draftsman by the delegates who were familiar with his skills and activities. During the Convention, he served on nine different committees— more than any other delegate.[84] Cannon's drafting and writing skills had become so evident by the close of the Convention that he was appointed to draft the Preamble on September 25 and to the committee to revise and print the Minutes on September 28.[85]

The minutes of the proceedings of the 1776 Constitutional Convention provide little detail of the debates; however, they do provide evidence to suggest Cannon's role in drafting the Declaration of Rights. The Convention organized on July 15, and a committee, consisting of one delegate from each county and the City of Philadelphia, was appointed

on July 18 to prepare a Declaration of Rights. This Committee was given leave to prepare a draft on Monday, July 22, and it reported a draft Declaration of Rights on Thursday, July 25. On that day, the Convention tabled the draft report and, apparently dissatisfied with the work of the committee, added six new members to the committee—Timothy Matlack, James Cannon, James Potter, David Rittenhouse, Robert Whitehill, and Bartram Galbreath. On Friday, July 26, with Cannon and the radicals now in control of the drafting committee, the report was recommitted to the expanded committee, and that evening they transformed their ideas into words and formulated the text. The next morning, Saturday, July 27, the committee reported a new draft of the Declaration of Rights which was read and debated by paragraphs that day and the following Monday, July 29th. At the end of the debates on Monday, the convention ordered 96 copies printed for further consideration by the Convention. This draft contained Article XII, the speech and press clause, which was modified only in style when it was again debated on August 13, 15, and 16, and adopted on August 16th.[86]

Some insight into the convention action can be gleaned from letters sent by the Secretary of the Convention, John Morris, Jr., to John Dickinson. On July 30, as the convention entered its third week, Morris wrote, "I need not inform you how very closely the nature of my employment in the Convention employs me; Indeed I have scarce an hour that I can call my own. . . . They have done a variety of Business, but have scarce entered upon Essentials yet. You will see by the Inclosed, which is one of the copies of the Intended Bill of Rights (printed merely for the consideration of the Members) what is the present object of their Deliberation. I wish most heartily that you could have been with them on this Important Subject."[87]

One week later, Morris observed, "The further consideration of the Bill of Rights has not yet been resumed, since ye Printing—nor do I hear of any time fixed for that Purpose. The Frame of Government is yet with the Committee & we know nothing more of it, than that it is resolved that the Future Legislative Body shall consist of one Branch only & not of two, as was strenuously contended: The Debate on that point alone took up Seven hours Debate in a Committee of the whole Convention."[88]

Three days later, on Sunday, August 11, Morris noted that the convention was concentrating on militia matter and had not yet debated the Bill of Rights or the Frame of Government. At the end of the week, however, he reported, "The Convention has spent all this week in Deliberating on their Bill or Declaration of Rights, Wch with Difficulty, was last evening reported to the House by the Committee of the whole; It is altered a good deal from the printed, and yet is, upon the whole, pretty much the same."[89]

The Declaration of Rights, adopted on August 16, was published for public consideration on August 20.[90] The only surviving public comment suggests an expansive public interpretation of the speech clause, one with little regard for the Blackstonian thesis and with implicit disdain for the concept of seditious libel. The writer observed,

Freedom of speech and writing on matters of public concern, having in every free country been considered the best bulwark to preserve the spirit of liberty from degenerating into supineness and slavery, it gave me great pleasure to observe that the Convention of Pennsylvania, in their declaration of rights of the inhabitants, have made it an object of their deliberation, viz. 'That the people have a right to freedom of speech and of writing and publishing their sentiments, therefore the freedom of the press ought not to be restrained.'
. . . To those who indulge the idea, that the conduct of men in public stations are exempt from impartial scrutiny, entertain notions incompatible with the good of society, for it is not merely the men but the measures which form the good or ill of society; it is the right of examination, and to

remedy the defects, that constitute the safety of the people; and when that right is infringed, the constitution falls a sacrifice to tyranny and usurpation. . . ."[91]

In addition to the free speech clause of Article XII in the Declaration of Rights, an important provision in the Frame of Government—the text of the Constitution itself—should also be noted for a better understanding of the meaning of freedom of expression. Section 35 of the Frame declares, "The printing presses shall be free to every person, who undertakes to examine the proceedings of the legislature, or any part of government." Leonard Levy remarked that the provision "opened every branch of government to criticism and the doors of the Assembly to the public, allowing printers to publish debates without prior approval, which was necessary in the past, and without breaching parliamentary privilege. We do not otherwise know what Pennsylvania meant by 'freedom of speech' or press."[92]

A closer examination of the work of the Convention, however, reveals much about the thinking of the Committee which drafted the section. The Committee reported a draft Frame on Monday, August 19; it was debated on nine days between then and September 5, when it was ordered printed for public consideration and comment. This proposed Frame contained the provisional §36, which began with the same language, "The printing-presses shall be free to every person who undertakes to examine the Proceedings of the Legislature, or any part of the Government." However, the clause continued in language which further declared, "and the House of Representative shall not pass any Act to restrain it: Nor shall any Printer be restrained from printing any Remarks, Strictures, or Observations on the Proceedings of the General Assembly, or any Branch of Government, or any public proceeding whatever," indicating an expansive view of public commentary on the public policy process.[93]

More importantly, perhaps, the proposed §36 also extended the protection for citizen opinion regarding *"the conduct of any public Officer, so far as relates to the execution of his office."* Cannon and the drafting Committee intended, then, unrestrained and unpunished speech and writing on both policy and public officials, limited only by the final exception, "provided it does not extend to the informing an Enemy in actual war, concerning our strength, weakness, disposition, or any other thing which may serve the Enemy, and injure the State."[94] This communication to assist the enemy in an *actual war* was the only exception to complete freedom of political discourse, a limitation which clarifies the extent of protection which they intended to declare and which provides an explanation for the numerous restrictions on the speech of Loyalists during the American Revolution. This language also goes far beyond the press clause of the 1776 Virginia Declaration of Rights and does much to undermine Levy's position that the common law notion of seditious libel and the Blackstonian definition of freedom of the press maintained the hegemony he supposes.

Convention action, sometime between August 19 and September 5, deleted the last part of the Committee's proposed language, but the reason for dropping the additional language is unclear. The Journal is of no help in understanding the change, and there appears to have been no surviving public discussion on the point, so we have no documentary evidence as to whether the language of §36 was shortened by the Delegates as a matter of principle or as a matter of style.[95]

As with the speech clause in the Declaration of Rights, this second press clause was mentioned only once in the newspaper commentary during the sitting of the convention. The writer began deferentially by suggesting, "However censurable a man may become,

by differing in opinion with some part of the community, it ought not to lessen his right and his duty to communicate his sentiments, whenever he apprehends the happiness and safety of the people to be in danger." Then, warming to that right and duty, this dissenting citizen became more bold. "The right of publishing my sentiments, I claim on the general principles of liberty and self preservation." Moving beyond this abstract discussion of natural rights, however, the writer noted, "The Convention for the state of Pennsylvania have [sic] preserved this right *defensible*, by inserting of it in the Declaration of Rights, and intending to admit it in their proposed frame of government, to wit, 'that the printing presses shall be free to every person who undertakes to examine the proceedings of the legislature, or *any part* of the government,' &c." Continuing to gird the protection for critical commentary, this anonymous author said, "therefore I am induced to examine into *some* part of the proceedings of the Convention, and hope no evil tendency to the public will arise from the examination." The writer then launched a bitter attack on the Convention, criticizing its delay, its expenses, its exceeding its authority, and its passing ordinances which interfered with such fundamental rights as political speech, trial by jury, and *habeas corpus*.[96]

Even those who reprobated the constitution most severely because of its unicameral Assembly and the political loyalty oath, however, appear to have been fully supportive of the freedom of speech provisions in the Declaration of Rights. In a meeting on November 2, 1776 to select a slate to oppose the "Constitutionalist" candidates for the first Assembly, the more moderate "Republicans" declared their acceptance of such fundamental principles as freedom of press and other provisions in the Declaration of Rights.[97] Benjamin Rush later complained that the new Assembly was acting like the British Parliament and infringing upon the freedom of speech, freedom of press, and freedom of assembly and petition guaranteed by the constitution.[98] And John Adams, one of the most outspoken critics of the constitution, in preparing the draft of the Massachusetts Declaration of Rights in 1779, copied the Pennsylvania language as Article XVII, "The people have a right to the freedom of speaking, writing, and publishing their sentiments. The liberty of the press, therefore, ought not to be restrained." When the Massachusetts convention renumbered the section, deleted any reference to freedom of speech, and changed the language to read, "The liberty of the press is essential to the security of freedom in a state; it ought not, therefore, to be restrained in this commonwealth," one historian noted, "Much objection was made to it, among the people, as insufficient."[99] This language, which the people thought insufficient, Levy attributes to Blackstone's *Commentaries*.[100]

Intellectual Sources of the Pennsylvania Framers

To suggest that Cannon and the other delegates to the Pennsylvania Constitutional Convention of 1776 "invented" the concept of freedom of speech which they wrote into the Declaration of Rights is not the purpose of this paper. Rather, I hope to explicate the meaning and intention which they assigned to that clause, and that understanding is to be found in the intellectual milieu in which they operated. As Morton White stated so well,

. . . we may repeat what scholars have always known, and what most candid rebels always admitted, namely, that they did not invent a single idea that may be called philosophical in the philosopher's sense of that word. The self-evidence that the revolutionaries applied to their truths when they used an old term of epistemology, the essence or nature of man to which they appealed in their metaphysical moods, the concept of equal creation that loomed so large in their theology, the unalienable moral

rights they defended, and the happiness they were so bent on pursuing as individuals and as a people—all of these ideas were familiar to distinguished Western philosophers and jurists before they were used in the political slogans of American revolutionaries. But we cannot understand how the revolutionaries used these ideas without detailed probing of their writings and of those writings from which they borrowed.

In spite of being philosophical borrowers, the revolutionaries deserve to have their philosophical reflections read carefully because they seriously used philosophical ideas while leading one of the great political transformations of history. Though they wrote their philosophy as they ran, many of them were men of considerable intellectual power, trained in the law and fully capable of grasping most of what they read in the writings of distinguished moralists and jurists.[101]

The first state constitutions, in many ways, "stand as the fulcrum in American constitutional history," representing the experiences and ideologies of the past, articulating a political culture for their immediate time, and grounding the future and the national constitution which was to follow.[102] Pennsylvania's experience in forming a constitution was somewhat different from the other new states, giving it an especially important role in revealing the ideological currents of the moment, due to the speed with which the radicals overthrew the proprietary government and replaced it with one of their own design. "Because of the peculiar abruptness of its internal revolution," observed Gordon Wood, "Pennsylvania tended to telescope into several month's time changes in ideas that in other states often took years to work out and became in effect a laboratory for developing of lines of radical Whig thought that elsewhere in 1776 remained generally rudimentary and diffuse."[103] This situation was, indeed, recognized and seized by the radicals in Pennsylvania. They clearly knew they had, as Thomas Paine declared in *Common Sense,* "every opportunity and every encouragement before us, to form the noblest purest constitution on the face of the earth. We have it in our power to begin the world over again." Nowhere in their work was this opportunity more fully realized than in the symbiosis of republican theory and communication rights, contemplating and structuring a government based upon and powered by the informed voice of the sovereign people.[104]

While American revolutionary rhetoric began with insistence upon British liberties and "the rights of Englishmen," the radicals in Pennsylvania were now demanding more. Cannon, for one, was not especially impressed with the current state of British liberties. "I have engaged in the present political controversy with a design to be of service to my country. On an impartial inquiry into the *present* state of the British constitution, it appears to me that it is out of the power of the British legislature to give us *security* for the future enjoyment of our *rights* and *liberties*," he wrote just three months before the convention. "The point with me has ever been, *what will secure our liberties?* The question of interest is ever determined thereby. . . . It is of small consequence to America . . . whether the constitution of their government answers excellently to the inhabitants of that island, if dependence on that excellent form of government is big with *slavery* and *ruin* to America."[105]

Another important point to remember is that John Dickinson, James Wilson, Thomas McKean, and the other leading attorneys of Pennsylvania—men who were steeped in Blackstone and the common law—were not among the convention delegates who framed the Pennsylvania Constitution and the Declaration of Rights. In urging the election of delegates to the Convention, Cannon advised the voters in the militia:

A Government made for the common Good should be framed by Men who can have no Interest besides the common Interest of Mankind. It is the Happiness of America that there is no Rank above that of Freemen existing in it; and much of our future Welfare and Tranquillity will depend on its

remaining so for-ever; for this Reason, great and over-grown rich Men will be improper to be trusted. . . . Gentlemen of the learned Professions are generally filled with the Quirks and Quibbles of the Schools; . . . we would think it prudent not to have too great a Proportion of such in the Convention— Honesty, common Sense, and a plain Understanding, when unbiased by sinister Motives, are fully equal to the Task—Men of like Passions and Interests with ourselves are most likely to frame us a good Constitution.[106]

Perhaps as a result of this persuasive appeal, very few lawyers were elected to the Convention; the delegates were men more likely to have read *Cato's Letters* than *Blackstone's Commentaries* and more concerned with democracy than decorum. In assessing the character of the delegates, Selsam said, "The Convention was not composed of great men. There were few of outstanding ability, but for the most part the members were farmers and merchants, the majority of whom were Associators."[107] Francis Alison charitably characterized the majority as "mostly honest well meaning Country men, . . . but entirely unacquainted with such high matters."[108] Charles Thompson thought the political circumstances had placed "the affairs of state into the hands of men totally unequal to them," and was apprehensive about "the error, which I fear [they] will through ignorance—not intention—commit, in setting the form of government."[109] Thomas Smith, himself a delegate, remarked that "not a sixth part of us ever read a word on the subject" of government, and later complained of the influence of "a few enthusiastic members who are totally unacquainted with the principles of government. It is not only that their notions are original, but they would go to the devil for popularity, and in order to acquire it, they have embraced leveling principles, which . . . is a fine method of succeeding."[110] A newspaper satirist, writing shortly after the convention rose, charged that "our leading men have never had much experience in public affairs," and blamed the perceived defects in the constitution on "so many plain country folks being in the Convention."[111]

Cannon and the other "plain country folk" in the convention, must have drawn confidence, in the face of contemporary critics who thought only lawyers could make constitutions, from James Burgh's defense against the charge "that a private gentleman, who has never been employed in the state, is less likely to be of service to the public by writing on political subjects." Burgh countered by citing Harrington's retort that Aristotle's *Politics* was "a valuable and lasting commentary by a private man."[112] Likewise, "Junius" critiqued the constitutional doctrines of Blackstone and Mansfield with considerable effect, yet he confessed, "I am no lawyer by profession, nor do I pretend to be more deeply read than every English gentleman should be, in the laws of his country. If, therefore, the principles I maintain are truly constitutional, I shall not think myself answered, though I should be convicted of a mistake in terms, or of misapplying the language of the law." Instead, he said, "I speak to the plain understanding of the people, and appeal to their honest, liberal construction of me."[113] Cannon must have believed—and James Madison later proved— that it was not necessary to be an attorney to craft a constitution grounded in republican theory.

In one of the more thorough analyses of the 1776 Constitution, Selsam concluded that "the influence of English political thought is plainly discernible" in the Declaration of Rights, casually suggesting (without citation or demonstration) the presence of ideas from Locke, Harrington, Hume, Sydney, Montesquieu, and Blackstone.[114] A number of more libertarian views on freedom of expression, however, were also present in the political environment of revolutionary Philadelphia, and Cannon was almost certainly exposed to many of them. The newspapers regularly featured reprints of "Cato's Letters", news of the controversy over John Wilkes' "North Briton No. 45" and his subsequent trial for

seditious libel, and the "Letters of Junius" against Lord Mansfield views on seditious libel. In addition, *The Crisis* was also a popular vehicle for the propagation of Cato's views on the subject. Christopher Marshall related that Cannon brought copies of *Crisis No. 1* and *Crisis No. 2* to his home on April 21, 1775, and the next day he noted a local press report "under the London head, Feb. 7" that *Crisis No. 3* and a pamphlet entitled *The Present Crisis with Respect to America* had been burned by two sheriffs and the hangman at the Royal Exchange in London.[115] A total of twenty-seven issues of *The Crisis* were reprinted in the colonies by Benjamin Towne in Philadelphia and John Anderson in New York. The *Crisis No. 26,* on the Right of Petition, praised *Cato,* and, almost as if addressed to the colonies, said, "Freedom of speech and writing is the first, and most glorious privileges of a free people: this the authors claim as a right, and this they are firmly resolved to use and defend: for to this privilege we may again stand indebted, for another REVOLUTION."[116]

As a member of the Library Company of Philadelphia, Cannon had easy access to such holdings as *Cato's Letters* (London, 1748), *The North Briton* (London, 1764), *The Crisis, A Brief Narrative of the Case and Tryal of John Peter Zenger* (1736), as well as the Bell's Philadelphia edition of *Blackstone's Commentaries* containing rejoinders from Priestly and Furneaux on liberty of conscience and other treatises on political topics and moral philosophy.[117] Besides serving as the library for the Continental Congress during the revolution, and later for the Confederation Congress and the Federal Convention, the Library Company was frequented by a broad spectrum of readers. Jacob Duche observed with pleasure "the general taste for books, which prevails among all orders and ranks of people in this city. The librarian assures me, that for one person of distinction and fortune, there are twenty tradesmen that frequented this library."[118] The holdings of the Library Company, founded in 1731, had grown to more than 2,000 titles and more than 3,800 volumes by 1774; there was a thriving publishing industry in Philadelphia; and "pamphlets and books from Europe could be purchased in any of the seventy-seven bookshops which existed in the city between 1761 and 1776."[119]

A source which Selsam overlooked, as did Levy, is James Burgh's *Political Disquisitions*, a book with which Cannon and his contemporaries were quite familiar. Burgh requested the London publisher to send a copy of the book to John Dickinson in March 1774, and he did so with the comment that it "meets with the highest approbation from all the friends of Liberty."[120] Such an assessment could not have been far off the mark, for John Wilkes would shortly buttress his arguments in the Commons by almost casually referring his colleagues to Burgh's analysis for the detailed support.[121] *Political Disquisitions* was quickly reprinted by subscription in Philadelphia by Robert Bell and William Woodhouse, with the first two volumes appearing in June, 1775, and the final volume in October, 1775.[122]

Excerpts from Burgh were almost immediately reprinted in the Philadelphia newspapers, especially those sections which seemed to privilege the power of the people over that of Parliament (and, by implication, the Pennsylvania Assembly).[123] Burgh, in informing the reader of his political stance, borrowed *Cato's* description of an independent whig as one who "scorns all implicit faith in the state, as well as the church. The authority of names is nothing to him; he judges all men by their actions and behaviour, and hates a knave of his own party as much as he despises a fool of another. He consents not that any man or body of men shall do what they please." Rejecting the premises of seditious libel, he continued, "He claims a right of examining all public measures, and if they deserve it, of censuring them. As he never saw much power possessed without some abuse, he takes

upon him to watch those that have it; and to acquit, or expose them, according as they apply it to the good of their country, or their own crooked purposes."[124]

Almost from its first appearance, the public was aware of the utility of the principles articulated in *Political Disquisitions* for framing a new political order. One of the advertisements for the set promised that,

perusal of the work at this important period will be attended with the most salutary and certain advantages, if the inhabitants of America will be so rational as to act wisely, in taking warning from the folly of others, by permitting no ministerial extravagances to enter into their plan. They will then start fair, for laying a sure foundation that freedom shall last for many generations; and the great expense of blood and treasure, which the present grand conflict must cost, will in some measure be compensated for by the goodness and permanency of the new erection, which must be constructed, if the infatuated ministry of Britain continue to persist in the ignominious attempt of making Freemen Slaves.[125]

At the time of publication, Bell and Cannon were acting in concert as members of the Committee of Privates. They had been acquainted for almost ten years, with Cannon's former home and schoolroom in close proximity with Bell's bookstore and printing shop in Third Street, next to St. Paul's. While Cannon was not an advance subscriber for the book, there can be little doubt that he was thoroughly familiar with its contents.[126] The "encouragers" for the publication, however, did include the Library Company of Philadelphia; Cannon's close friends Francis Alison, Christopher Marshall, Benjamin Rush, and Thomas Young; and other prominent Pennsylvanians such as William Allen, Robert Aitken, Richard Bache, John Bayard, John Cadwalder, Sharp Delaney, Thomas Proctor, William Smith, Anthony Wayne, and Joshua Maddox Wallace.

Among the 96 Delegates to the 1776 Constitutional Convention were subscribers George Ross, Bartram Galbreath, James Smith of York, Samuel Smith, George Clymer, George Schlosser, John Bull, and William Coates—three of whom served on the committee which drafted the Declaration of Rights. Benjamin Franklin, President of the Constitutional Convention, and Benjamin Rush, a leader of the Provincial Conference which called the Convention, were both personally acquainted with Burgh during their time in England. This "web of personal relations between English Dissenters and American radicals undergirded the written word," said Staughton Lynd, shaping the ideas of the day by "elaborating the characteristic themes" of Trenchard and Gordon and reaching back to draw from the republican ideology of John Lilburne.[127]

At the continental level, members and officers of the Congress who were advance subscribers to the publication included George Washington, Samuel Chase, John Dickinson, John DeHart, Silas Deane, Christopher Gadsden, Robert Goldsborough, John Hancock, Michael Hilleps, Thomas Jefferson, Jared Ingersoll, William Jackson, Thomas Mifflin, Henry Middleton, Thomas McKean, Alexander McDougall, Joseph Reed, John Sullivan, Roger Sherman, Charles Thompson, James Wilson, and John Joachim Zulby.[128] James Madison, only twenty-three at the time, was not among the subscribers, but *Political Disquisitions* was among the volumes he recommended for the Congressional library in 1783, was referenced in his memorandum prepared for the Virginia Ratifying Convention, and was cited in his "Federalist 56." John Adams said it was "a book which ought to be in the hands of every American who has learned to read," and Thomas Jefferson recommended it in 1790 to Thomas Mann Randolph as essential reading for a legal education.[129]

It was neither an obscure nor an insignificant work among those who crafted the constitutions for the new states and the new nation.

A review of recent scholarship reveals that practically every historian of note—except Leonard Levy—has recognized the ideological importance of James Burgh's *Political Disquisitions* to the political culture of the American Revolution and the generation which framed the Constitution. Bernard Bailyn judged it "the key book" by which the contemporary English radicals such as Price, Priestly, and Cartwright influenced the political thought of American colonists.[130] Priestly and Price, he said, while influential, were "lesser writers, no doubt" when compared with Burgh. While the ideas of Locke and Montesquieu were known by some in every colonial assembly, it was even more important that the books of Burgh and other "transmitters of English nonconformist thought" were known by someone "in almost *every village* of every colony."[131]

Edmund Morgan said that *Political Disquisitions* "achieved instant popularity in the colonies.", and Oscar and Mary Handlin argued that it "had a widespread influence upon the revolutionary generation—not only upon the leaders, but even more upon the common folk."[132] Forrest McDonald counted Burgh's treatise among the opposition literature which was "widely known" in the colonies, and which by 1776, he said, "had been thoroughly absorbed into the American political vocabulary."[133] Isaac Kramnick believed that *Political Disquisitions* was "a veritable sourcebook for the reformers who were to plague George III and his ministers through the era of the American and French revolutions" and said it was "devoured" by the American colonists.[134] Caroline Robbins called the work "perhaps the most important political treatise which appeared in England in the first half of the reign of George III."[135] Gordon Wood, who credited Burgh with preserving the line of classical republican arguments from Trenchard and Gordon, suggested that Burgh's ideas on making a new commonwealth presented "a provocative challenge that seemed to the Americans of 1776 to be somehow providentially directed at them."[136] By this time, Burgh and the more radical Whig writers "were talking of natural rights rather than toleration, and demanding that English liberties be drastically broadened rather than merely preserved."[137]

Blackstone, on the other hand, said Paul Conkin, "was as far as anyone from anticipating imminent constitutional developments in America."[138] No one other than Leonard Levy has argued that Blackstone's views on sovereignty, power, and liberty should be dispositive for understanding fundamental political rights in a republic; in fact, most would agree with Chafee that Blackstone was "notoriously unfitted to be an authority on the liberties of American colonists, since he upheld the right of Parliament to tax them, and was pronounced by one of his own colleagues to have been 'we all know, an anti-republican lawyer.' "[139] James Burgh, however, sided with the colonists on the question of taxation. As for his opinion of Blackstone's views on rights and liberties, he confessed, "I cannot help considering judge Blackstone as one of the many among us who endeavor to lull us asleep in this time of danger. I owe I do not understand his ideas of free government."[140]

It is more than curious that Levy continues to maintain his position with regard to Blackstone's dominance in the thinking of the framers and completely ignores the influence of Burgh which is so apparent to other scholars. It is unlikely that Levy is unaware of the scholarly literature assessing Burgh's importance. It is even more unlikely that Levy is unaware of Burgh's arguments on freedom of speech and press, since Levy was general editor of the Da Capo Press reprint series which reissued Burgh's *Political Disquisitions* in 1971. He does cite the 1970 Da Capo reprint of William Bollan's *The Freedom of Speech and Writing upon Public Affairs, Considered, with an Historical View* (London, 1766), calls it "the most learned work in English on the subject of free speech" and

incorrectly pronounces it "the last restatement in English of the theory and function of free expression until 1793."[141] Curiously, Levy does not even mention Burgh in his clever and elaborate treatment of arguments in the text of *Emergence of a Free Press*.[142] To have engaged Burgh's arguments and the extent of his influence would have severely damaged the conclusions Levy persists in defending.

Many of the distinctive features of the Pennsylvania Constitution of 1776 are almost prescribed in Burgh's treatise: that the people are the source of all authority, that equal representation is necessary, that annual elections should be combined with rotation in office, that all elections should be by ballot, that representatives must be accountable to their constituents through open sessions and published journals and speeches, that freedom of petition and assembly are essential rights, that the people have the right of instruction of their representatives, that excessive luxury and wealth can be dangerous to states, that the militia is far superior to the evils of standing armies, and that precautions and punishments must be enforced to prevent corrupt elections.[143] While these arguments were not exclusive to Burgh's work, the correspondence between his chapter headings and the sections of the Pennsylvania constitution appear related by more than coincidence.

Cannon, Burgh, and the Speech Clause

Even before Congress adopted the Declaration of Independence and even before the Pennsylvania Provincial Conference had called for a Constitutional Convention, the radical rhetors in Philadelphia had called for "a fixed, free constitution, derived from the people alone, in such way that all may enjoy equal liberty, both civil and religious," specifically mentioning the need "to settle the freedom of the press by the constitution."[144] It would have been an easy task for Cannon to have borrowed the truncated language of *Cato's Letter No. 15* as it appeared in the Virginia Declaration of Rights for a press clause as he did in phrasing other rights included in the Pennsylvania Declaration of Rights.[145] However, he chose to fashion a different speech clause, just as he did with the expansive provision for religious liberty, with the new requirements that the doors of the Assembly be open and that the votes be recorded and published for public examination, and with the guarantee for the rights of assembly, petition, and instruction.

Burgh devoted twenty pages to a chapter entitled, "Of the Liberty of Speech and Writing on Political Subjects," and here, I contend, is the source of inspiration for including the "speech clause" in the 1776 Pennsylvania Declaration of Rights. Unlike other principal drafters of the new state constitutions, Cannon was formally trained in rhetoric, was especially aware of the role and power of public speaking, and was, in fact, the teacher of public speaking at the Academy and College of Philadelphia. It is not surprising, then, that he would recognize this particular nuance, find it salient, and include language specifically enumerating and protecting freedom of speech in the Declaration of Rights.

James Cannon attended the High School at Edinburgh and matriculated at the University of Edinburgh where the faculty included Adam Ferguson in Moral Philosophy, Hugh Blair, Professor of Rhetoric and Belles Lettres, and John Stevenson, Professor of Logic. Cannon came to Philadelphia in 1765 and graduated from the College of Philadelphia in 1767, having studied rhetoric with William Smith and logic and moral philosophy under Francis Alison.[146] Under Alison, Cannon studied Watts' *Logick* and absorbed Francis Hutcheson's views on natural rights and his admonition that "the power of reason and speech" were to be used to further "the general good."[147] Smith told his students that rhetoric was "one of the last accomplishments of the true Scholar and useful Citizen"

which might be seen as "the Means of propagating Wisdom and pushing our Discoveries in the Acquisition of Truth . . . or of inlarging the Understanding, exalting the Mind and dispelling the Mist of Error; or . . . as the powerful Bond of Society. . . . Without it our boasted Reason would not have its full Use." While rhetoric was certainly subject to abuse, he said, "in the possession of a good Man, the Power of Eloquence is a Blessing Indeed! It makes him the Patron of Honor, the Protector of the injured, the defender of Justice, and the great Arbiter of the most important Deliberations."[148]

Following graduation, Cannon opened a private school in Moravian Alley in January, 1768, where he taught "the English, Latin, and Greek Languages, Writing and Arithmetic, in all its Branches; likewise Algebra, Surveying, Navigation &c.," and he later moved to "his School-House in Third-Street, near the Union Library."[149] Cannon developed a solid reputation among both the public and the local educational community, and he was awarded a Master of Arts degree by the College of Philadelphia in June, 1770.[150] When the Trustees at the Academy and College of Philadelphia became concerned about the inattention to the teaching of oratory since the resignation of Professor Kinnersley in October 1772, Provost Smith advertised for a qualified replacement, Cannon applied, and he was appointed Professor of English and Mathematics in November, 1773.[151] Upon his death in 1782, one account recalled,

His well known abilities procured him an invitation to a professorship in that seminary where he had received the first honors of literary merit. In this station he acquitted himself with honour, and by his diligence, care and fidelity not only recommended himself to the esteem of those respectable gentlemen who first appointed him, but also to the notice and approbation of the present honourable board. Besides his abilities as a scholar, he possessed those amiable qualities of the mind which in different parts of the continent, both in public and private life, procured him the esteem of the virtuous and discerning. The cause of freedom and of his country lay always near his heart. . . .[152]

As master of the English School of the Academy, Cannon's duties included teaching oratory and public speaking to the students, one of the more prominent functions in the curriculum.[153] In this capacity, Cannon quite likely used Burgh's *The Art of Speaking* as a textbook in the Academy.[154] Burgh, in this volume, emphasized the role of public speaking in public affairs. He wrote and Cannon would have taught, "In *parliament*, at the *bar*, in the *pulpit*, in *committees* for managing public affairs, in large societies, and on like occasions, a competent address and readiness, not only in finding matter, but in *expressing* and *urging* it effectually, is what, I doubt not, many a gentleman would willingly acquire at the expense of half his other improvements."[155] Therefore, Cannon's educational training and his role as English Master and teacher of public speaking led him to an early acquaintance with Burgh's writing, an appreciation for the role of public discourse, and an awareness of the importance of freedom of speech. While he would not encounter any discussion of the citizen's "freedom of speech" in Blackstone's *Commentaries*, he would certainly find it in Burgh's *Political Disquisitions* and be inclined to infuse both the language and the meaning when drafting the Declaration of Rights.

Burgh's understanding of freedom of speech and press is certainly not that embraced by Blackstone. He boldly invokes the nature of sovereignty and the concept of republican representation to undermine the validity of the concept of seditious libel. He is not concerned here with protection from any licensing schemes of the government; that was hardly a concern anywhere in the empire in the 1770s. His understanding of the right was that it should immunize individual citizens against "punishment inflicted by government upon complainers." Such action, he said, "is certainly one of the most atrocious abuses,

that a free subject should be restrained in his inquiries into the conduct of those who undertake to manage his affairs." All public officials, he asserted, "are answerable for what they undertake: but if it be dangerous and penal to inquire into their conduct, the state may be ruined by their blunders, or by their villainies, beyond the possibility of redress."[156]

Underlying Burgh's argument is the important republican premise that sovereignty originates only with the people and, therefore, they retain the essential right to discuss the policies which they wish to adopt and the conduct of those temporarily vested with the responsibility to execute their wishes.[157] "In a petition to parliament, a bill in chancery, and proceedings at law, libellous words are not punishable; because freedom of speech and writing are indispensably necessary to the carrying on of business." In a true republic where the people are sovereign, the same is implicitly true with regard to the discussion of public officers and public policies. Yet, Burgh acknowledged, "it may be said, there is no necessity for a private writer to be indulged the liberty of attacking the conduct of those who take upon themselves to govern the state." Demonstrating the importance which individual freedom of speech held in his constitutional scheme, Burgh answered,

That all history shews the necessity, in order to the preservation of liberty, of every subject's having a watchful eye on the conduct of Kings, Ministers, and Parliament, and of every subjects being not only secured, but encouraged in alarming his fellow-subjects on occasion of every attempt upon public liberty, and that private, independent subjects *only* are like to give faithful warning of such attempts; their betters (as to rank and fortune) being more likely to conceal, than detect the abuses committed by those in power. If, therefore, private writers are to be intimidated in shewing their fidelity to their country, the principal security of liberty is taken away.[158]

Moreover, Burgh was prepared to go even beyond the limits on freedom of speech advocated by Gordon in *Cato's Letters*. While Gordon would draw the line in *No. 15* at private libel,[159] Burgh contended, "Punishing libels public or private is foolish, because it does not answer the end, and because the end is a bad one, if it could be answered."[160] As to unjust defamers, Burgh had observed earlier in *The Dignity of Human Nature*, they would be punished by God. When confronted by libels, he advised, "To defeat calumny, 1. Despise it. To seem disturbed about it is the best way to make it believed. And stabbing your defamer will not prove you innocent. 2. Live an exemplary life. And then your general good character will over power it."[161] Personal retribution for private libels was unwise and unnecessary; state action against citizen criticism of public officers was not only ill advised but unwarranted and illegal. Consequently, he concluded, damage to the political character of public ministers was nothing compared with the possible fate of the nation. "Therefore no free subject ought to be under the least restraint in respect to accusing the greatest, so long as his accusation strikes only at the political conduct of the accused: his private we have no right to meddle with, but so far as a known vicious private character indicates an unfitness for public power or trust."[162]

To those who would complain that it "is a grievous hardship on those who undertake the administration of a nation; that they are to run the hazard of being thus publicly accused of corruption, embezzlement, and other political crimes, without having it in their power to punish their slanderers," Burgh would answer, "It is no hardship at all, but the unavoidable inconvenience attendant upon a high station, which he who dislikes must avoid, and keep himself private. . . . If a statesman is liable to be falsely accused, let him comfort himself by recollecting that he is well paid." And if an official is, in fact, falsely accused, Burgh noted, "he has only to clear his character, and he appears in a fairer light

than before. He must not insist on punishing his accuser: for the public security requires, that there be no danger in accusing those who undertake the administration of national affairs." Moreover, he said, "The punishment of political satyrists gains credit to their writings, nor do unjust governments reap any fruits from such severities, but insults to themselves, and honour to those whom they prosecute."[163]

After an historical account of abuses of general warrants, filings by informations, and suspension of *habeas corpus,* Burgh concluded that "it seems manifest, that nothing can be imagined more inconsistent with freedom (to say nothing of the *right* which every free subject has to speak and write of public affairs), than putting a discretionary power into the hands of a set of low-bred, unprincipled, and beggarly officers or messengers, who may be expected to abuse their power. . . ." Even if the people could be protected from and indemnified for such procedural abuses, a more fundamental point remained. Again exceeding the parameters of political speech advocated in *Cato's Letters No. 32*—that of protection only for "true" charges against the government—Burgh declared, "No man ought to be hindered saying or writing what he pleases on the conduct of those who undertake the management of national affairs, in which all are concerned, and therefore have a right to inquire, and to publish their suspicions concerning them. For if you punish the slanderer, you deter the fair inquirer."[164]

Conclusion

Burgh's philosophy of freedom of speech and press, both as a term of art and as a political principle, differs significantly from that advocated by Blackstone. For the revolutionary generation, it was an increasingly familiar and easily embraced argument which supported their political world view; therefore, it would seem to have offered Cannon and his contemporaries a ready template for crafting a new constitution, and the concept of freedom of speech advanced therein seems even more likely to have supported and informed their intentions when drafting a declaration of rights. Unlike Blackstone, an officer of the King's government who was attempting to state and conserve things as they were, these were revolutionaries intent upon making the world anew, and the words of Cato and Burgh provided the grammar for their vision—not of what might have been in the past but of what a new republican government should and could be in the future.

The meaning of freedom of speech in a republic continues to be of vital concern. Issues of both prior restraint and subsequent punishment still reach the United States Supreme Court, and original intent is again gaining acceptance as an important element in the jurisprudence of the younger members of the Court. For scholars and judges seeking to understand the history of the free speech clause and to fashion an interpretive strategy based upon the intent of the framers, it is especially important to be aware of the republican theory which influenced the founders. The premises of popular sovereignty and the implicit theory of unfettered political discussion necessary in a republic, articulated so well by such writers as Trenchard, Gordon, and Burgh, provide the appropriate intellectual guide-posts for seeking the "enlightenment from the structure of the document and the government it created," as suggested by Judge Bork.[165] The latter day commonwealthmen and seventeenth century British radicals provided the political theory, and the American radicals who fomented a revolution and forged republican constitutions provided the praxis.

Freedom of speech and press, said Burgh, meant far more than absence of licensing and prior restraint; it meant complete liberty to consider and censure public officers and public policies without fear of punishment. While the people might be said to be responsible

for the abuse of that liberty, they were responsible only to themselves. Government officials must consider themselves responsible to the people, wrote Burgh, "while the people are answerable only to God; themselves being the losers, if they pursue a false scheme in politics."[166]

There were, of course, numerous political theories available to the founding generation, and, undoubtedly, all had at least a few adherents. While I have not attempted to and cannot claim to have demonstrated a complete consensus among the framers as to the exact meaning of freedom of speech, I am confident that James Cannon, author of the world's first constitutional provision recognizing the free speech rights of citizens, borrowed the language and meaning from the text of *Political Disquisitions* and grounded that provision more in Burgh's expansive view of republicanism than on Blackstone's court-crabbed view of the common law and the noxious notion that ultimate sovereignty was lodged in the government. Both the political etymology of the free speech clause of the First Amendment and the republican ideology evident in the structure of the government created by the Constitution refute Levy's disingenuous claim that the framers intended merely to codify Blackstone and preserve the concept of seditious libel. Nonetheless, to paraphrase Chafee, this Levy theory dies hard, but it ought to be knocked on the head once for all. Scholars have delivered the philosophical and historical prognosis; it is time for the Court to pull the plug.

Notes

1. Robert H. Bork, *The Tempting of America: The Political Seduction of the Law* (New York: Free Press, 1990): 165.

2. Clinton Rossiter, *1787: The Grand Convention* (New York: Macmillan, 1966): 424. See also, Leonard W. Levy, *Original Intent and the Framers' Constitution* (New York: Macmillan, 1988): xii–xiii.

3. It is beyond the scope of this paper to argue the appropriateness of original intent as a means of constitutional interpretation. For the dimensions of that controversy, see Levy, *Original Intent and the Framers' Constitution*: 322–398; Daniel A. Farber and Suzanna Sherry, *A History of the American Constitution* (Saint Paul: West, 1990): 372–398; and Mark Tushnet, *Red, White, and Blue: A Critical Analysis of Constitutional Law* (Cambridge: Harvard University Press, 1988) 21–60. Obviously, I find it *among* the valid means of interpretation.

4. Diana Peck, "Mass Media and the First Amendment," *Community Television Review*, 8, No. 2 (1985): 6.

5. Stephen Klaidman, "Cigarette Ads and Your Civil Liberties," *The New York Times*, 2 August 1986: 23.

6. Leonard W. Levy, *Legacy of Suppression: Freedom of Speech and Press in Early American History* (Cambridge: Harvard University Press, 1960); Leonard W. Levy, *Emergence of a Free Press* (New York: Oxford University Press, 1985).

7. Levy, *Emergence of a Free Press*, 281; xii. For an intriguing argument that Blackstone, having relied on Coke's erroneous transportation of Star Chamber practices into common law, was wrong about seditious libel, see Irving Brant, *The Bill of Rights: Its Origin and Meaning* (1965; New York: New American Library, 1967): 118–124.

8. Levy, *Emergence of a Free Press*, vii; David A. Anderson, "The Origins of the Press Clause," *UCLA Law Review*, 30 (1983): 493, 534.

9. Zechariah Chafee, Jr., *Free Speech in the United States* (1941; New York: Atheneum, 1969): 9. Thorough and thoughtful arguments against Levy's thesis have been provided in Richard A. Parker, "Rhetorically Reconstructing the History of the First Amendment," Speech Communication Association, Chicago, November 1990; Jeffrey A. Smith, "The Original, Absolute Press Clause," Speech Communication Association, Chicago, November 1990; Jeffrey A. Smith, *Printers and Press Freedoms: The Ideology of Early American Journalism* (New York: Oxford University Press,

1988); Richard A. Parker, "Revising Revisionist History: Consensus Theories of the Framers' Intent," *Free Speech Yearbook*, 26 (1987): 1–10; David Rabban, "The Ahistorical Historian: Leonard Levy on Freedom of Expression in Early American History," *Stanford Law Review*, 37 (1985): 795–856; William T. Mayton, "Seditious Libel and the Lost Guarantee of Freedom of Expression," *Columbia Law Review*, 84 (1984): 91–142; David A. Anderson, "The Origins of the Press Clause," *UCLA Law Review*, 30 (1983): 455–541; and J. Louis Campbell, "From Small Acorns Mighty Oaks Grow: The Legislatures and Free Speech in Colonial Connecticut and Rhode Island," *Free Speech Yearbook*, 16 (1977): 3–24.

10. James Burgh, *Political Disquisitions: Or, An Enquiry into Public Errors, Defects and Abuses* 3 Vols. (London: E. and C. Dilly, 1774–1775).

11. Levy, *Emergence of a Free Press,* 12–13; Sir William Blackstone, *Commentaries on the Laws of England,* 4: 151–152.

12. Thomas M. Cooley, *Treatise on the Constitutional Limitations Which Rest Upon the Legislative Power of the States,* ed. V. H. Lane (Boston: Little, Brown, 1903, 7th ed.): 603. While Levy cites this edition of Cooley's *Constitutional Limitations* in his bibliography (*Emergence of a Free Press*, 363), he fails to address this argument in the text. Parker's close examination of Levy's internal inconsistencies and logical fallacies raises other doubts about Levy's motives and his reputation as an objective scholar. See, Richard A. Parker, "Rhetorically Reconstructing the History of the First Amendment," Speech Communication Association, Chicago, November 1990.

13. Roscoe Pound, *The Development of Constitutional Guarantees of Liberty* (New Haven: Yale University Press, 1957) 65–67.

14. As a result, in Great Britain, this "absence of any constitutional or legislative statement of a freedom of speech means that the liberty is largely residual. In other words the freedom exists where statute or common law rules do not restrain it." Eric Barendt, *Freedom of Speech* (Oxford: Clarendon, 1987) 29. Such unlimited statutory discretion for punishment—legislative determination of what constitutes "bad sentiments" and speech that is "improper, mischievous, or illegal"—Levy argues is what was intended by the framers of the First Amendment.

15. See, John Phillip Reed, *Constitutional History of the American Revolution: The Authority of Rights* (Madison: University of Wisconsin Press, 1986) 5–7. I will argue below that the English Dissenters and the American radicals also meant natural rights which are necessarily reserved in republican governments.

16. Barendt, 23, note 73.

17. 1 W. & M. c. 2 (1689); Blackstone 1: 143. For the British origins of the right of petition and subsequent development in the United States, see Stephen A. Smith, "The Right to Petition: An Ancillary Contribution to Free Speech Theory," Southern States Communication Association, Memphis, Tennessee, April 1988.

18. See, Richard B. Morris, "Legalism versus Revolutionary Doctrine in New England," *New England Quarterly,* 4 (1931): 195–215.

19. Adam Smith, *Lectures on Jurisprudence,* ed. by R. L. Meek, D. D. Raphael, and P. G. Stein (Oxford: Clarendon, 1978): 124–125, 303.

20. "Junius," "To Sir William Blackstone, Solicitor General to her Majesty," 29 July 1769, *Woodfall's Junius: The Letters of Junius* (New York: Lovell, 1880) 116–119.

21. "Fragments on Government" cited in George H. Sabine, *A History of Political Theory* (New York: Holt, Rinehart and Winston, 1961) 676.

22. "Of the Study of Law in the United States," *The Works of James Wilson,* ed. Robert Green McCloskey (Cambridge, MA: Belknap Press, 1967) 1: 79–80. Wilson also notes the characterization of Blackstone as anti-republican by one of his colleagues. Wilson's educational and legal background is discussed in Geoffrey Seed, *James Wilson* (Millwood, NY: KTO Press, 1978) 4–5.

23. Thomas Jefferson to James Madison, 17 February 1826, *Thomas Jefferson: Writings,* ed. Merrill D. Peterson (New York: Library of America, 1984) 1513–1514. For Jefferson's general refutation of Blackstone's authority, see Julius S. Waterman, "Thomas Jefferson and Blackstone's Commentaries," in *Essays in the History of Early American Law,* ed. David H. Flaherty (Chapel Hill: University of North Carolina Press, 1969) 451–488.

24. For the most extreme stacking of sources, see Levy, *Original Intent and the Framers' Constitution*, 195–220.

25. Richard A. Parker, "Revising Revisionist Historians: Consensus Theories of the Framers' Intent," *Free Speech Yearbook,* 26 (1987): 1–10. Having served as a member of the Arkansas

General Assembly, 1971–1975, and as Vice President of the Arkansas Constitutional Convention, 1979–1980, I also find such consensus hypotheses amusing at best.

26. Robert F. Williams, "The State Constitutions of the Founding Decade: Pennsylvania's Radical 1776 Constitution and Its Influences on American Constitutionalism," *Temple Law Review*, 62 (1989): 545.

27. John Murrin, "Fundamental Values, the Founding Fathers, and the Constitution," in *"To Form a More Perfect Union": The Critical Ideas of the Constitution*, eds. Herman Belz, Ronald Hoffman, and Peter J. Alberts (Charlottesville: University Press of Virginia, in press).

28. Richard B. Morris, "Foreword," in *Law & Authority in Colonial America*, ed. George Athan Billias (New York: Dover, 1965) viii–ix.

29. Levy, *Emergence of a Free Press*, 281. Levy's argument also seems to minimize the ideological clash between inalienable and reserved rights of individuals and delegated and enumerated powers of the government. For my disagreement here, see "Of Sovereign Assumptions, Delegated Powers, and an Absolutist View of Freedom of Expression," *Free Speech Yearbook*, 27 (1989): 106–114.

30. The most popular American edition of *Blackstone*, in fact, appended vigorous refutations of his views on religious liberty by Priestly and Furneaux. Sir William Blackstone, *Commentaries on the Laws of England*, 4 Vols. (Philadelphia: Robert Bell, 1771–1772). See Bell's advertisement for Volume 3, *Pennsylvania Packet*, 20 July 1772: 3.

31. Robert A. Rutland, ed., *The Papers of George Mason*, 3 Vols. (Chapel Hill: University of North Carolina Press, 1970) 1: 278–279, 281.

32. Adrienne Koch, ed., *Notes on the Debates in the Federal Convention of 1787 Reported by James Madison* (Athens: Ohio University Press, 1966) 630.

33. Thomas Jefferson to James Madison, 31 July 1788, *The Papers of James Madison*, ed. Robert T. Hutchinson et al (Chicago and Charlottesville: University of Chicago Press and University Press of Virginia, 1962-) 11: 212–213.

34. James Madison to Thomas Jefferson, 17 October 1788, *Madison Papers*, 11: 297–299. For Jefferson's rebuttal, see Thomas Jefferson to James Madison, 15 March 1789, *Madison Papers*, 12: 13–15.

35. See George Nicholas to James Madison, 2 January 1789, and James Madison to George Washington, 14 January 1789, *The Documentary History of the First Federal Elections, 1788–1790*, ed. by Gordon DenBoer (Madison: University of Wisconsin Press, 1984) 2: 331–332; 394.

36. James Madison to George Eve, 2 January 1789, *Madison Papers*, 11: 404–405. Madison repeated his support for amendments, each time specifically mentioning the same four provisions, in a letter to Thomas Mann Randolph, Sr., 13 January 1789, and in a circular letter printed in the *Virginia Herald*, 29 January 1789, *The Documentary History of the First Federal Elections*, 2: 339–340.

37. John Leland to James Madison, 15 February 1789, and *Virginia Herald*, 12 February 1789, *The Documentary History of the First Federal Elections*, 2: 346–347.

38. George Mason to John Mason, 31 July 1789, *The Documentary History of the First Federal Elections*, 2: 348.

39. James Madison to Edmund Pendleton, 8 April 1789, *Madison Papers*, 12: 51.

40. George Washington, "Address of the President to Congress," 30 April 1789, *Madison Papers*, 12: 120–121, 123.

41. Madison Papers, 12: 133.

42. Madison Papers, 12: 125, 196.

43. Madison Papers, 12: 201.

44. Madison Papers, 12: 202, 344.

45. Robert Allen Rutland, *The Birth of the Bill of Rights, 1776–1791* (New York: Collier, 1962): 212, 215. It was not until 1925 that the Supreme Court, applying the First Amendment to the states through the Fourteenth Amendment, held that liberty of speech and press might be afforded relief from local restrictions under the United States Constitution in *Gitlow v. New York*, 268 U.S. 666 (1925). Ironically, noted Walter Berns with regard to freedom of speech and press, "The fact is, the Bill of Rights has served (and continues to serve) mainly to secure rights from abridgement by the states and not the federal government, the very opposite of the role . . . the Anti-Federalists expected them to play." Walter Berns, *Taking the Constitution Seriously* (New York: Simon & Shuster, 1987) 127.

46. Rutland, 212–216.

47. Senate Journal, 3 September 1789; *The Roots of the Bill of Rights*, ed. by Bernard Schwartz (New York: Chelsea House, 1980) 5: 1148.

48. Rutland, 215.

49. "Amendments to the Constitution," 8 June 1789, *Madison Papers*, 12: 203, 194. The reference to speech and conscience as natural rights appears in Madison's surviving speaking notes but not in the text of his remarks as reported in the press.

50. Madison Papers, 12: 204.

51. Madison Papers, 12: 201–206.

52. For an elaboration of this argument, see Stephen A. Smith, "Of Sovereign Assumptions, Delegated Powers, and an Absolutist View of Freedom of Expression," *Free Speech Yearbook*, 27 (1989): 106–111. Madison's views here seem consistent with the positions of James Wilson and Alexander Hamilton who contended that a federal Bill of Rights to protect freedom of the press was unnecessary, since the federal government was one of only delegated powers and was without any power whatsoever to infringe upon liberty of the press. "James Wilson's Speech in the State House Yard," 6 October 1787, *The Documentary History of the Ratification of the Constitution*, ed. by Merrill Jensen (Madison: State Historical Society of Wisconsin, 1976)2: 167–168; [Alexander Hamilton], "No. 84," *The Federalist Papers*, intro. Clinton Rossiter (New York: New American Library, 1961) 512–515.

53. Fisher Ames to Thomas Dwight, 11 June 1789, *Works of Fisher Ames*, ed. W. B. Allen (1854; Indianapolis: Liberty Classics, 1983) 1: 642.

54. *Documentary History of the Ratification of the Constitution*, 2: 618–639. Levy, *Emergence of a free Press*, 238, incorrectly attributes authorship to George Bryan.

55. [Samuel Bryan], "Centinel I," *Independent Gazette*, 5 October 1787; *Documentary History of the Ratification of the Constitution*, 2: 158, 166. Emphasis in the original. The reference to great writers appears to be based upon Jean Louis de Lolme's *The Constitution of England, or an Account of the English Government* (London, 1775). "Junius" cites the same passage in the Preface of *Woodfall's Junius: The Letters of Junius*, xxiii–xxiv. The appearance of the Centinel essay was answered by James Wilson's "Speech in the State House Yard," 6 October 1787, denying that the federal government had *any* power to infringe liberty of the press.

56. *Documentary History of the Ratification of the Constitution*, 2: 439, 441.

57. *Documentary History of the Ratification of the Constitution*, 2: 597.

58. "The Address and Reasons of Dissent of the Minority of the Convention of the State of Pennsylvania to their Constituents," *Documentary History of the Ratification of the Constitution*, 2: 623, 630–631.

59. *Roots of the Bill of Rights*, 4: 482

60. *Roots of the Bill of Rights*, 2: 235.

61. *Roots of the Bill of Rights*, 4: 968; 2: 287.

62. Anderson, 491–492.

63. David L. Jacobson, ed., *The English Libertarian Heritage* (Indianapolis: Bobbs-Merrill, 1965): 40. Gordon's *No. 32* and John Trenchard's *No. 100* and *No. 101* also elaborated their conception of free speech and press.

64. Levy, *Emergence of a Free Press*, 109–118; Anderson, 524–527.

65. Clinton Rossiter, *Seed Time of the Republic: The Origin of the American Tradition of Political Liberty* (New York: Harcourt, Brace, 1953) 141.

66. Leonard W. Levy and Alfred Young, "Foreword," in *The English Libertarian Heritage: From the Writings of John Trenchard and Thomas Gordon in The Independent Whig and Cato's Letters*, ed. David L. Jacobson (Indianapolis: Bobbs-Merrill, 1965) viii; Levy, *Emergence of a Free Press*, 114.

67. Robert N. C. Nix and Mary M. Schweitzer, "Pennsylvania's Contributions to the Writing and the Ratification of the Constitution," *Pennsylvania Magazine of History and Biography*, 112 (1988): 3–24. Levy acknowledges the extent to which the Pennsylvania Declaration of Rights surpassed that of Virginia. Levy, *Original Intent and the Framers' Constitution*, 144, 185. Robert F. Williams, "The Influence of Pennsylvania's 1776 Constitution on American Constitutionalism During the Founding Decade," *Pennsylvania Magazine of History and Biography*, 112 (1988): 48, notes that the 1776 Constitution "has almost been forgotten. Its important place in the evolution of constitutional ideas in this country, however, should not continue to be overlooked." For an expanded version of this argument, see Robert F. Williams, "The State Constitutions of the Founding Decade:

Pennsylvania's Radical 1776 Constitution and Its Influences on American Constitutionalism," *Temple Law Review*, 62 (1989): 541–585.

68. *Pennsylvania Evening Post*, 6 June 1776: 1–2; *Pennsylvania Ledger*, 8 June 1776: 2; Samuel Adams to Richard Henry Lee, 15 July 1776, and Samuel Adams to James Warren, 16 July 1776, in *The Writings of Samuel Adams*, ed. Harry Alonzo Cushing (Boston: 1904–1908) 3: 298–299.

69. "Laws Agreed Upon in England" (1682), *Roots of the Bill of Rights*, 1: 143.

70. *Roots of the Bill of Rights*, 2: 262–263.

71. While it is not necessary to address each of these assertions in this essay, each claim can be generally refuted. Neither Bryan, Adams, Paine, Reed, nor Young were delegates. Franklin and Ross were soon elected to represent the state in Congress and participated only minimally in the work of the Convention. Reed was in the army during the time of the convention and later refused to serve as Chief Justice because of his objections to the Constitution. See, Joseph Reed to the Executive Council of Pennsylvania, 22 July 1777, *Life and Correspondence of Joseph Reed*, ed. William B. Reed (Philadelphia: Lindsay and Blackstone, 1847) 1: 301–303. Paine said he was at camp with the Army during the sitting of the Pennsylvania Convention; furthermore, he said, "I held no correspondence with either party, for, or against, the present constitution. I had no hand in forming any part of it, nor knew any thing of its contents until I saw it published." *Common Sense*, "To the People," *Pennsylvania Packet*, 18 March 1777.

72. David Hawke, *In the Midst of a Revolution* (Philadelphia: University of Pennsylvania Press, 1961): 170–200; Richard Alan Reyerson, *The Revolution is Now Begun: The Radical Committees of Philadelphia , 1765–1776* (Philadelphia: University of Pennsylvania Press, 1978): 112–114, 241; Eric Foner, *Tom Paine and Revolutionary America* (New York: Oxford University Press, 1976): 115, 133; and Steven Rosswurm, *Arms, Country, and Class: The Philadelphia Militia and the "Lower Sort" during the American Revolution* (New Brunswick, NJ: Rutgers University Press, 1987): 107.

73. Stephen E. Lucas, *Portents of Rebellion: Rhetoric and Revolution in Philadelphia, 1765–1776* (Philadelphia: Temple University Press, 1976) 160–161; Hawke, 170, 186; Reyerson, 134, note 53, 112–114, 241; Foner 115, 131, 133. For other secondary attributions of Cannon's role in authorship of the 1776 Constitution and Declaration of Rights, see J. Thomas Scharf and Thomas Westcott, *History of Philadelphia, 1609–1884*, 3 Vols. (Philadelphia: L. H. Everts, 1884) 1: 322–323; Burton Alva Konkle, *George Bryan and the Constitution of Pennsylvania, 1731–1791* (Philadelphia: W. J. Campbell, 1922) 121, 124; Allan Nevins, *The American States During and After the Revolution, 1775–1789* (New York: Macmillan, 1924): 149–152; Elisha P. Douglass, *Rebels and Democrats: The Struggle for Equal Political Rights and Majority Rule During the American Revolution* (1955; New York: Quadrangle, 1965) 263–266; and Carroll C. Arnold, "Early Constitutional Rhetoric in Pennsylvania," in *American Rhetoric: Context and Criticism*, ed. Thomas W. Benson (Carbondale: Southern Illinois University Press, 1989) 134.

74. Charles Francis Adams, ed., *The Works of John Adams*, (Boston: Little, Brown, 1851), 9: 623; Alexander Graydon, *Memoirs of a Life, Chiefly Passed in Philadelphia, Within the Last Sixty Years* (Edinburgh: Blackwood, 1822) 302–305. Graydon appears to be the only contemporary to consider George Bryan as a primary contributor to the ideas behind the Constitution, and based upon his comments, Konkle advanced the unconvincing argument that Bryan guided the delegates drafting the document. Bryan's obituaries in 1790 make no mention of his role in shaping the 1776 Constitution.

75. Thomas Hartley to Anthony Wayne, 21 November 1776, Anthony Wayne Papers, Historical Society of Pennsylvania, Philadelphia.

76. Benjamin Rush to Charles Nisbet, 27 August 1784, *Letters of Benjamin Rush*, ed. Lyman H. Butterfield, 2 Vols. (Princeton: Princeton University Press, 1951) 1: 336. Rush also suggests that George Bryan and Joseph Reed opposed the Constitution when it was first adopted. Benjamin Rush to John Adams, 24 February 1790, *Letters of Benjamin Rush*, 1: 532.

77. George W. Corner, ed., *The Autobiography of Benjamin Rush* (Princeton: Princeton University Press, 1948) 147–148. The brewer represented Matlack and the schoolmaster Cannon.

78. David Ramsay to Benjamin Rush, 3 July 1779, and David Ramsay to Benjamin Rush, 8 April 1780, Rush Manuscripts, Historical Society of Pennsylvania, Philadelphia. Cannon and Robert Davidson had moved with their families to Charleston to teach in a local school after the British occupied Philadelphia, returning just before the fall of Charleston and carrying sealed papers from General Benjamin Lincoln to the Confederation Congress.

79. Christopher Marshall Diaries, 21 October 1776; "Consideration," *Pennsylvania Gazette*, 30 October 1776: 1. For evidence of the attacks on Cannon's character by opponents of the Constitution, see William Hopper to Joseph Hewes, 5 November 1776, and William Hopper to Joseph Hewes and Samuel Johnston, 6 November 1776, *Letters of Delegates to Congress, 1774–1789*, ed. Paul H. Smith (Washington, DC: Library of Congress, 1979) 5: 440, 443.

80. James Cannon to Robert Whitehill, 9 April 1777, Robert Whitehill Papers, Cumberland County Historical Society, Carlisle, Pennsylvania. Cannon's relationship with Whitehill during the 1776 Convention is especially important in view of Whitehill's having demanded an amendment protecting freedom of speech and press during the Pennsylvania Ratifying Convention of 1787. For an extended discussion of their personal and political relationship see Stephen A. Smith, "Religious Test Oaths and Republican Revolutionaries: The Ordeal of the Pennsylvania Constitution of 1776," Transformation of Philadelphia Project, Philadelphia, Pennsylvania, 9 May 1990.

81. Reyerson, 112; Christopher Marshall Diaries, 17 March 1775, Historical Society of Pennsylvania; Lucas, 300, note 21; *Pennsylvania Evening Post*, 18 March 1775: 3. See also, Minute Book of the United Company of Philadelphia for Promoting American Manufactures, Samuel Weatherill Papers, Van Pelt Library Special Collections, University of Pennsylvania, Philadelphia. The list of members, a copy of Benjamin Rush's presidential address, and the manuscript minutes are in Cannon's handwriting.

82. *Pennsylvania Evening Post*, 28 September 1775: 3; *Pennsylvania Gazette*, 7 February 1776.

83. See Cassandra, "On Sending Commissioners," *Pennsylvania Evening Post*, 2 March 1776: 1–2; "Cassandra to Cato," *Pennsylvania Gazette*, 20 March 1776: 1, and *Pennsylvania Packet*, 25 March 1776: 1; "Cassandra to Cato II," *Pennsylvania Packet*, 8 April 1776: 1–2, and *Pennsylvania Ledger*, 13 April 1776: 2, and 20 April 1776: 4; "Cassandra to Cato III," *Pennsylvania Ledger*, 27 April 1776: 2.

84. Rosswurm 107.

85. *Minutes of the Proceedings of the Convention of the State of Pennsylvania, held at Philadelphia the 15th day of July, 1776, and continued by adjournments to the 28th September following*, The version cited is in *The Proceedings Relative to Calling the Convention of 1776* (Harrisburg, Pa.: John S. Wiestling, 1825): 53, 66. The preamble committee included Rittenhouse and John Jacobs; the minutes committee included Rittenhouse, Matlack, and John Bull.

86. *Minutes of the Proceedings of the Convention of the State of Pennsylvania, held at Philadelphia the 15th day of July, 1776*, 45–51. The slight stylistic changes to Article XII are evident from the emendations in Franklin's hand on a broadside copy of the draft printed for consideration of the members. *An Essay of a Declaration of Rights, Brought in by the Committee appointed for that Purpose, and now under the Consideration of the Convention of the State of Pennsylvania*, Library Company of Philadelphia.

87. John Morris, Jr. to John Dickinson, 30 July 1776, R. R. Logan Collection, Historical Society of Pennsylvania, Philadelphia. Dickinson noted in the margins of his copy of the proposed Declaration of Rights "that the Freedom of the Press is one of the great bulwarks of liberty." Milton E. Fowler, *John Dickinson: Conservative Revolutionary* (Charlottesville: University Press of Virginia, 1983) 176. This language was probably taken from the Virginia Declaration and could have been made when Dickinson replied to Samuel Chase's request for assistance in preparing a Bill of Rights for Maryland's Constitution. See, Samuel Chase to John Dickinson, 29 September 1776, and Samuel Chase to John Dickinson, 19 October 1776, R. R. Logan Collection, Historical Society of Pennsylvania.

88. John Morris, Jr., to John Dickinson, 8 August 1776, R. R. Logan Collection, Historical Society of Pennsylvania, Philadelphia.

89. John Morris, Jr., to John Dickinson, 11 August 1776, and John Morris, Jr., to John Dickinson, 16 August 1776, R. R. Logan Collection, Historical Society of Pennsylvania, Philadelphia.

90. *Pennsylvania Evening Post*, 20 August 1776: 3.

91. "D", "For the Pennsylvania Evening Post," *Pennsylvania Evening Post*, 7 September 1776: 1.

92. Levy, *Emergence of a Free Press*, 185. Levy incorrectly cites the provision as Section XXV.

93. *The Proposed Plan or Frame of Government for the Common-wealth or State of Pennsylvania [Printed for Consideration]*: 9. Library Company of Philadelphia.

94. *The Proposed Plan or Frame of Government for the Common-wealth or State of Pennsylvania [Printed for Consideration]*: 9. Emphasis added. The italicized language regarding strictures on the

conduct of public officers comports with the position maintained in Burgh's *Political Disquisitions*, 3: 250.

95. The only scholarly article to address this change did not discover any public comment challenging the implicit political philosophy in the provision and seems to suggest that the change was merely stylistic rather than political. Specifically, the author discounted the idea that the deletion was intended to suggest protection for communication with the enemy during actual war. See John N. Shaffer, "Public Consideration of the 1776 Pennsylvania Constitution," *Pennsylvania Magazine of History and Biography*, 98 (1974): 426–427.

96. "F", *Pennsylvania Evening Post*, 28 September 1776: 1.

97. *Pennsylvania Packet*, 12 November 1776; Robert Levere Brunhouse, *The Counter-Revolution in Pennsylvania, 1776–1790* (Philadelphia: University of Pennsylvania Press, 1942) 20.

98. Hampden, "To the Citizens of Philadelphia," *Pennsylvania Evening Post*, 13 March 1777: 1. Cannon responded by asking, "Wherein is liberty of the press restrained?" "To Hampden," *Pennsylvania Evening Post*, 15 March 1777: 3. See Brunhouse 27, note 41.

99. *The Works of John Adams*, 4: 215–216, 226.

100. Levy, *Emergence of a Free Press*, 184.

101. Morton White, *The Philosophy of the American Revolution* (New York: Oxford University Press, 1978): 3–4.

102. Donald S. Lutz, *The Origins of American Constitutionalism* (Baton Rouge: Louisiana State University Press, 1988) 97. See also, George Anastaplo, *The Constitution of 1787: A Commentary* (Baltimore: Johns Hopkins University Press, 1989) 149–166; and Albert P. Blaustein and Jay A. Sigler, *Constitutions that Made History* (New York: Paragon House, 1988) xiii, 9–69.

103. Gordon S. Wood, *The Creation of the American Republic, 1776–1787* (New York: W. W. Norton, 1969) 85.

104. Thomas Paine, *Common Sense and Other Political Writings*, ed. Nelson F. Adkins (Indianapolis: Bobbs-Merrill, 1953) 51. See also Williams, "The State Constitutions of the Founding Decade," 554–558, 562–563. Walter Berns credits Paine with articulating the relationship between popular sovereignty and written constitutions to fix rights and, conversely, the incompatibility of parliamentary sovereignty, a key tenet of Blackstone's treatise. Berns, *Taking the Constitution Seriously*, 77.

105. "Cassandra to Cato, Number III," *Pennsylvania Ledger*, 27 April 1776: 2.

106. "To the several Battalions of Military Associators in the Province of Pennsylvania," Robert Whitehill Papers, Cumberland County Historical Society, Carlisle, Pennsylvania. The notation on the back of the broadside, in Whitehill's handwriting, indicates that this is "Mr. Cannons & others Circular letter."

107. J. Paul Selsam, *The Pennsylvania Constitution of 1776: A Study in Revolutionary Democracy* (Philadelphia: University of Pennsylvania Press, 1936): 148.

108. Francis Alison to Robert _____, 20 August 1776, *Pennsylvania Magazine of History and Biography*, 28 (1904): 379.

109. Charles Thompson to John Dickinson, 16 August 1776, *Pennsylvania Magazine of History and Biography*, 35 (1911): 500.

110. Thomas Smith to Arthur St. Clair, 3 August 1776, and Thomas Smith to Arthur St. Clair, 22 August 1776, cited in Hawke, 190–191; Selsam 149.

111. "Orator Puff," *Pennsylvania Evening Post*, 10 October 1776, 19 October 1776.

112. James Burgh, *Political Disquisitions*, 3 Vols. (Philadelphia: Robert Bell and William Woodhouse, 1775) 1: xvii-xviii.

113. *Woodfall's Junius: The Letters of Junius*, xii.

114. Selsam, 176.

115. Christopher Marshall Diaries, 21–22 April 1775, Historical Society of Pennsylvania, Philadelphia. Rossiter, *Seedtime of the Republic*, also notes the significance of *The Crisis* in informing the popular political theory of liberty during the era.

116. *The Crisis. Number XXVI* (New York: Anderson, 1775), Evans 13992, p. 220.

117. Minute Book, Library Company of Philadelphia, 2: 42, 44; Library Company of Philadelphia, Record Book A:102,197; *The Charter, Laws, and Catalogue of Books of the Library Company of Philadelphia* (Philadelphia: Joseph Crukshank, 1770); Robert Bell advertisement for Third Volume of Blackstone's *Commentaries on the Laws of England*, *Pennsylvania Packet*, 20 July 1772: 3. The College of Philadelphia was a subscriber for this edition, and Cannon would have had access in the College library.

118. Caspipina, "To the Right Honourable Lord Viscount P_____, at Oxford," *Pennsylvania Packet*, 16 March 1772: 1.

119. Typescript on flyleaf of Library Company of Philadelphia copy of the 1770 catalog, *The Charter, Laws, and Catalogue of Books of the Library Company of Philadelphia*; Lucas, 8–9. See also, E. V. Lamberton, "Colonial Libraries of Pennsylvania," *Pennsylvania Magazine of History and Biography*, 42 (1918): 192–234.

120. Edward Dilly to John Dickinson, 7 March 1774, John Dickinson Papers, Historical Society of Pennsylvania, Philadelphia. Volume Three, containing Burgh's arguments on freedom of speech and press, was sent to Dickinson in proof sheets before binding but complete except for the title page in early 1775. Edward Dilly to John Dickinson, 28 January 1775, John Dickinson Papers, Historical Society of Pennsylvania, Philadelphia.

121. "Speech of John Wilkes in Favour of Parliamentary Reform, 1776," *The Eighteenth Century Constitution: Documents and Commentary*, comp. E. N. Williams (Cambridge: Cambridge University Press, 1960) 216. John Adams employed the same rhetorical shorthand in "Novanglus," 30 January 1775, *Tracts of the American Revolution*, ed. Merrill Jensen (Indianapolis: Bobbs-Merrill, 1976) 307.

122. *Pennsylvania Evening Post*, 3 June 1775: 4; 5 October 1775: 1.

123. "Of Exclusion by Rotation," *Pennsylvania Evening Post*, 23 November 1775: 1.

124. Burgh, *Political Disquisitions*, 1: xvi-xvii. These sentiments and the identical language were attributed to a "young lady" and printed as a letter to the editor in a local newspaper. "A Reasonable Whiggess," *Pennsylvania Evening Post*, 2 January 1776: 3.

125. *Pennsylvania Evening Post*, 14 November 1775: 1.

126. The inventory of Cannon's property in 1782 included 195 books valued at £28, but only *Buchanan's Syntax*, used in his courses at the University, is mentioned by title. "An Inventory of Goods and Chattels belonging to the Estate of Mr. James Cannon, deceased, taken by Mess. James Davidson and William Oliphant, February 23, 1782." Will Book S, File 73, Page 75 (1782), Registrar's Office, City Hall, Philadelphia.

127. Staughton Lynd, *Intellectual Origins of American Radicalism* (New York: Vintage, 1969) 26–27.

128. The list of encouragers for the American edition is at the front of volume three.

129. Carla H. Hay, *James Burgh, Spokesman for Reform in Hanoverian England* (Washington, DC: University Press of America, 1979): 42–43. Hay's study is the best available assessment of Burgh's entire career and literary contributions. The best analysis of Burgh's political theory is Isaac Kramnick's chapter, "James Burgh and 'Opposition' Ideology in England and America," in Kramnick, *Republicanism and Bourgeois Radicalism* (Ithica, NY: Cornell University Press, 1990) 200–259.

130. Bernard Bailyn, *The Ideological Origins of the American Revolution* (Cambridge: Harvard University Press, 1967): 41

131. Bernard Bailyn, *Faces of Revolution: Personalities and Themes in the Struggle for American Independence* (New York: Knopf, 1990): 190. Emphasis added.

132. Edmund S. Morgan, *Inventing the People: The Rise of Popular Sovereignty in England and America* (New York: W. W. Norton, 1988): 232. Morgan suggested that Volume III (which contained Burgh's explicit statement on Freedom of Speech and Press) was especially popular. Oscar and Mary Handlin, "James Burgh and American Revolutionary Theory," Massachusetts Historical Society *Proceedings*, 73 (1961): 38.

133. Forrest McDonald, *Novus Ordo Seclorum: The Intellectual Origins of the Constitution* (Lawrence: University Press of Kansas, 1985) 78.

134. Kramnick, 235, 237.

135. Caroline Robbins, *The Eighteenth-Century Commonwealthman* (Cambridge: Harvard University Press, 1961): 365.

136. Gordon S. Wood, *The Creation of the American Republic, 1776–1787* (1969; New York: W. W. Norton, 1972): 16, 127. For additional assessments of Burgh's importance see, Lance Banning, *The Jeffersonian Persuasion: Evolution of a Party Ideology* (Ithica, NY: Cornell University Press, 1978) 61; J. G. A. Pocock, *Virtue, Commerce, and History: Essays on Political Thought and History* (New York: Cambridge University Press, 1985) 257, 260–261; Carl B. Cone, *The English Jacobins: Reformers in Late 18th Century England* (New York: Scribner, 1968) 45–50; Clinton Rossiter, *Seed Time of the Republic: The Origin of the American Tradition of Political*

Liberty (New York: Harcourt, Brace, 1953): 141; Wilson Ober Clough, *Intellectual Origins of American National Thought* (1955; New York: Corinth, 1961) 282; and Page Smith, *A New Age Now Begins: A People's History of the American Revolution* (New York: McGraw-Hill, 1976) 1: 144, 255–256, 676.

137. Henry F. May, *The Enlightenment in America* (New York: Oxford University Press, 1976) 157. This point, with direct application to the Pennsylvania Constitution of 1776, is also made by Kramnick 244, and J. R. Pole, *Political Representation in England & the Origins of the American Republic* (Berkeley: University of California Press, 1971) 269–270, 274, 276, 429, 465–466. May's view, which I find convincing, is not, however, uncontroverted. In addition to Levy's argument regarding a static vision of liberty of speech and press, see generally, John Phillip Reid, *The Concept of Liberty in the Age of the American Revolution* (Chicago: University of Chicago Press, 1988) 8–17, 98–122.

138. Paul K. Conkin, *Self-Evident Truths* (Bloomington: Indiana University Press, 1974) 24.

139. Zechariah Chafee, Jr., *Free Speech in the United States* (1941; New York: Atheneum, 1969): 9. The contemporary assessment is from Willes, J., in *Dean of St. Asaph's Case*, 4 Doug. 73, 172 (1784).

140. Burgh's attack on Parliament's unwarranted taxation of the American colonies is in *Political Disquisitions* 2: 274–340. The quote is from Burgh, *Political Disquisitions* 3: 275; additional criticism of Blackstone on liberties is found at 1: 371, 2: 39, 345, 3: 283–286, 305.

141. Levy, *Emergence of a Free Press*, 154.

142. Levy does give Burgh's *Political Disquisitions* a single "see also" footnote in support of a proposition which Burgh would find too narrow. Levy, *Emergence of a Free Press*, 160, note 59.

143. This view of Burgh's direct influence is supported by Willi Paul Adams, *The First American Constitutions: Republican Ideology and the Making of State Constitutions in the Revolutionary Era* (Chapel Hill: University of North Carolina Press, 1980) 213, 246. The most direct evidence of the treatise on Cannon's invention concerns §16 in the draft proposal of the Declaration, reading: "That, an enormous Proportion of Property vested in a few Individuals is dangerous to the Rights, and destructive of the Common Happiness, of mankind; and therefore every free State hath a Right by its Laws to discourage the possession of such Property." Hawke suggests that "Cannon's Bill of Rights failed to meet acceptance of an item he must have regarded with affection, since it was one of the few distinctive differences between his document and that passed by Virginia a few weeks earlier." Hawke, 190. Adams traces this provision to Burgh's *Political Disquisitions,* 3: 186, and finds an instance of its being excerpted in the *Providence Gazette,* 9 December 1775, shortly after the American edition was distributed. Adams, *The First American Constitutions,* 213. The property limitation was replaced in the final draft with another provision drawn from Burgh—the associated rights of petition, instruction, and assembly.

144. "A Protestor," *Pennsylvania Evening Post,* 15 June 1776: 1. This evidence contradicts John Phillip Reid's assertion that the political theory and constitutional right of freedom of the press "was not a factor in the revolutionary controversy between Great Britain and the colonies." Reid, *Constitutional History of the American Revolution: The Authority of Rights,* 7–8.

145. See, Samuel Eliot Morison, Ed., *Sources & Documents Illustrating the American Revolution, 1764–1788, and the Formation of the Federal Convention* (1923; New York: Oxford University Press, 1965) 163–164, for an indication of the other clauses incorporated from the Virginia document. For the argument that Mason drew upon Burgh's *Political Disquisitions* in preparing the Virginia Declaration see Hugh Blair Grigsby's comments cited in Kate Mason Rowland, *The Life of George Mason, 1725–1792* (New York: G. P. Putnam's Sons, 1892) 247.

146. Scharf and Westcott, 1: 322; Edinburgh University Matriculation Roll, 1 (Arts, Law and Divinity, 1623–1858), typescript copies in the Special Collections, Edinburgh University Archives, were attached with a letter from Jo Currie to Louis M. Waddell, 6 February 1990, indicating that Cannon matriculated in Greek under Robert Hunter in 1762 and in Natural Philosophy under Jacob Russel in 1764. Dr. Waddell kindly provided me with copies of this information. *Pennsylvania Gazette,* 19 November 1767: 3.

147. Francis Alison, Lectures on Moral Philosophy, [MSS Notes of Jasper Yeates,1761], Archives of the University of Pennsylvania, Philadelphia; Francis Hutcheson, *A Short Introduction to Moral Philosophy* (Glasgow: Foulis, 1753) 134–135, 185.

148. William Smith, Lectures on Rhetoric, 1759, MSS, University of Pennsylvania Archives, 8–10.

149. *Pennsylvania Gazette*, 14 January 1768: 3; *Pennsylvania Gazette*, 5 October 1769: 1. The school appears to have been quite successful. John Dickinson paid the tuition of William Hicks to attend from March–November, 1773, "Receipt," Logan Papers, 41:27, Historical Society of Pennsylvania; and John Heffernan advertised that he had "removed his school to that noted room over Mrs. Richardson's, near St. Paul's, in Third-street, lately occupied by Mr. Cannon, now of the college. . . ." *Pennsylvania Evening Post*, 14 October 1775: 1.

150. *Pennsylvania Gazette*, 14 June 1770: 1.

151. Trustees' Minutes, 15 October 1772, 2 February 1773, A2: 55, 60, MSS, University of Pennsylvania Archives; *Pennsylvania Gazette*, 13 October 1773: 3, 10 November 1773: 4; Trustees Minutes, 17 November 1773, MSS, A2–69, University of Pennsylvania Archives.

152. *Pennsylvania Packet*, 7 February 1782: 3.

153. For examples of the emphasis placed upon public speaking in the curriculum and details of how it was taught, see [Benjamin Franklin], "Proposals Relating to the Education of Youth in Pennsylvania, 1749," *Papers of Benjamin Franklin*, 3: 405–410; [William Smith], "Account of the College, Academy, and Charitable School in Philadelphia in Pennsylvania," *The American Magazine*, October 1758; Graydon 16–17; J. A. Leo Lemay, *Ebenezer Kinnersley: Franklin's Friend*. (Philadelphia: University of Pennsylvania Press, 1964) 93–94; [Jacob Duche], Caspipina, "To the Right Honorable the Lord Viscount P_____, at Oxford," *Pennsylvania Packet*, 16 March 1772: 1; Trustees Minutes, 2 February 1773, A2: 60, MSS, University of Pennsylvania Archives.

154. Burgh's *The Art of Speaking* was originally published in London in 1761, but the 4th Edition was also published in Philadelphia by Robert Aitken in 1775, and the market was such that Aitken also published the 5th Edition in 1780. For a discussion of the extensive use of the text in colonial America and the early years of the Republic, see Donald E. Hargis, "James Burgh and *The Art of Speaking*," *Speech Monographs*, 24 (1957): 275–284. Additional discussion and specific evidence that the book was used at the University of Pennsylvania (formerly College of Philadelphia), see William Parrish, "The Burglarizing of Burgh, or The Case of the Purloined Passions," *Quarterly Journal of Speech*, 38 (1952): 431–434.

155. Burgh, *The Art of Speaking* (Philadelphia: Aitken, 1775) 5. This first of eight American editions was available in early 1775. *Pennsylvania Packet*, 3 April 1775. The Library Company of Philadelphia already held the 1761 London edition.

156. Burgh, *Political Disquisitions*, 3: 246. Burgh can be counted—although he was not mentioned by Blasi—among those premising the value of freedom of speech on its utility in detecting and curbing the abuses of government power. See, Vincent Blasi, "The Checking Value in First Amendment Theory," *American Bar Foundation Research Journal*, Summer 1977: 521–649.

157. This premise is more fully articulated in Burgh, *Political Disquisitions*, 1: 4–5.

158. Burgh, *Political Disquisitions*, 3: 247.

159. The implications and limitations of *Cato's Letters* for free speech theory are closely examined in David S. Bogen, "The Origins of Freedom of Speech and Press," *Maryland Law Review*, 42 (1983): 444–450.

160. Burgh, *Political Disquisitions*, 3: 247.

161. James Burgh, *The Dignity of Human Nature*, 2 Vols. (1754; London: Johnson & Payne; Cadell, 1767) 2: 183–86, 287. This is the edition held by the Library Company of Philadelphia.

162. Burgh, *Political Disquisitions*, 3: 250

163. Burgh, *Political Disquisitions*, 3: 250–251.

164. Burgh, *Political Disquisitions*, 3: 254.

165. Bork, 165. For detailed arguments on the implicit republican theory of political communication, see Stephen A. Smith, "Promoting Political Expression: The Import of Three Constitutional Provisions," *Free Speech Yearbook*, 27 (1989): 1–32.

166. Burgh, *Political Disquisitions*, 1: 4.

The Free Speech Jurisprudence
of the Rehnquist Court

Nadine Strossen

Introduction

Although the free speech clause has been a part of our Constitution since the Bill of Rights was ratified in 1791, Supreme Court doctrine regarding the contours of that clause has a substantially shorter life span, commencing in the second decade of this century with decisions arising out of the World War I context. The general trend of judicial decisions during most of that period has been toward greater protection for speech, through two interrelated developments: expanded judicial definitions of protectible speech, and stricter judicial scrutiny of measures restricting such speech.[1]

Recently, however, under the leadership of Chief Justice Rehnquist, with the support of his so-called "conservative" block,[2] the tide has begun to turn in important respects. Although these trends have deeper roots, they have most prominently come to the fore during the 1988–89 and 1989–90 Supreme Court terms, the first two in which Justice Kennedy participated throughout, thus consolidating Chief Justice Rehnquist's majority. Accordingly, the present essay concentrates on free speech decisions issued during this period, showing how they have reversed prior patterns of judicial interpretation.

Some observers who criticize the Rehnquist Court's jurisprudence for cutting back on individual rights generally have qualified their criticism by noting that free speech has fared relatively well.[3] To be sure, two of the most heralded decisions of both relevant terms—the two that invalidated statutes prohibiting desecration of the U.S. flag—did adhere to earlier understandings of constitutionally protected expression.[4] However, it should be stressed that both decisions were issued by a narrow 5–4 majority and authored by Justice Brennan,[5] who has since resigned from the Court. Moreover, in terms of both their analysis and their rulings, these two decisions stand sharply apart from many others in the free speech area. Although the recent speech-eroding cases received less attention than the widely publicized flag-burning controversies, their long-range impact on First Amendment jurisprudence is equally significant.

In fundamental—albeit relatively subtle—respects, the Rehnquist Court has reversed the rights-expanding trend of the Warren and Burger Courts regarding freedom of speech, much as it has done regarding other individual rights. Given the often indirect methods by which these decisions have achieved their long-range effect of altering—and truncating—our conceptions of judicially protectible expression, it is especially important to analyze them closely and to contrast them with prior precedents.

As is generally the case regarding the Court's interpretation of constitutional rights, its speech-restricting cases have two dimensions: one of process—*i.e.*, the standards that the

The author gratefully acknowledges the research assistance of Jennifer Colyer and Marie Newman.

Court employs in reviewing claims that these rights have been violated—and one of substance. This essay analyzes both sets of speech limiting rulings. Although the Rehnquist Court's substantive holdings more directly and clearly have contracted the scope of free speech, its process rulings have achieved the same effect indirectly.

Process Rulings Restricting Free Speech

As is true regarding many Rehnquist Court holdings constraining individual rights, the Court's recent free speech decisions have been important in terms of not only the particular results reached on the facts at issue, but also the judicial process that led to such results— *i.e.*, the analytical or methodological standards employed.[6] Although Court watchers have decried substantive incursions that recent decisions have made on a spectrum of civil liberties, they have been less alert to this more subtle but ultimately more invidious aspect of the recent rulings.

No doubt the commentators' relatively sanguine attitude toward the Court's recent speech decisions is explained in part by this distinction between the bottom-line disposition of a case and the analysis leading to it. In many recent speech cases, the Court's specific substantive holdings, in terms of resolving particular factual controversies, were substantially less significant—and hence less alarming—than the general analytical processes by which the Court reached such results. Yet the Court's resolutions of process issues will have long-range significance that transcends differing factual contexts. Justice Marshall noted this phenomenon in his dissenting opinion in *Ward v. Rock Against Racism*. There, in the context of upholding regulations on musical performances in a public park, the Court transformed the criteria for permissible "time, place, and manner" regulations on expression generally: "Today's decision has significance far beyond the world of rock music. Government no longer need balance the effectiveness of regulation with the burdens on free speech. After today, government need only assert that it is most effective to control speech in advance of its expression."[7] In addition to being couched in relatively unnoticed language regarding methodological or analytical issues, the adverse long-term impact of many of the Rehnquist Court's speech-restrictive rulings is camouflaged in two additional ways as well. First, these decisions routinely assert that they are not reversing prior decisions that had been more rights-protective.[8] In fact, however, the Rehnquist Court has significantly limited and, in effect, overruled much prior precedent in the free speech area. Often, the Court has achieved this result by relying on distinguishable cases or on *dicta*, concurring opinions, and even dissenting opinions from past cases.[9] By purporting to follow past precedent, the Court masks the actual significance of its new "interpretations."[10]

Second, as its vehicles for enunciating new, weakened judicial review standards, the Court often employs cases in which the particular speech claims may not be sympathetic to many people: for example, *Ward v. Rock Against Racism* involved the speech rights of rock musicians performing outdoors in a public park, and *Thornburgh v. Abbott*[11] involved prisoners' communications. It is likely that relatively few people are concerned specifically about the free speech rights of either loud musicians or convicted felons. No doubt, more would be concerned if they realized the negative implications that the Court's limitations on these rights will have upon other forms of expression. Justice Marshall described this facet of the *Ward* ruling:

[T]he majority plays to our shared impatience with loud noise to obscure the damage that it does to our First Amendment rights. Until today, a key safeguard of free speech has been government's

obligation to adopt the least intrusive restriction necessary to achieve its goals. By abandoning the requirement that time, place, and manner regulations must be narrowly tailored, the majority replaces constitutional scrutiny with mandatory deference.[12]

The Rehnquist Court's application of a relaxed judicial review standard to speech-limiting measures is squarely inconsistent with the traditional view that free speech is a "preferred freedom,"[13] and consequently that any infringements on it are subject to the most exacting judicial scrutiny.[14] Nevertheless, in several recent speech cases, the Rehnquist Court jettisoned crucial elements of this traditional strict scrutiny and instead deferred to speech-limiting decisions by executive and legislative branch officials.

One key element of the strict judicial scrutiny traditionally applied to speech-abridging measures is the demand that any such measure be *necessary* for promoting the government's countervailing interest.[15] By contrast, the Rehnquist Court has upheld speech-abridging measures that clearly were not necessary to advance the asserted government ends but rather were at most reasonable or desirable. For example, in *Thornburgh v. Abbott*, the Court held that regulations restricting prisoners' receipt of incoming materials would survive a First Amendment challenge so long as they are "reasonably related to legitimate penological interests." The Court further held that a prison may exclude materials even if they are not "likely" to lead to violence, so long as the warden determines that they create an "intolerable risk of disorder."[16] As another example, in *Ward*, the Court held that the government could impose "time, place, and manner" restrictions on speech or expressive conduct so long as they are not "substantially broader than necessary" to achieve the government's interest.[17]

In allowing the government to regulate speech on a ground short of necessity, both *Thornburgh* and *Ward* defied earlier precedents which enforced the necessity requirement generally with respect to any speech regulations. Moreover, both cases defied earlier Supreme Court rulings that had enforced the general necessity requirement in the specific factual contexts at issue.[18]

Closely related to the Court's increasing refusal to demand that speech-limiting measures be necessary to promote a government interest is its growing refusal to enforce the established requirement that the government promote its interest through the measure that least restricts speech.[19] In both *Thornburgh*[20] and *Ward*,[21] the Court expressly disavowed this "least restrictive alternative" requirement, although it previously had been enforced in the specific contexts involved in those cases. Furthermore, the Rehnquist Court expressly repudiated this requirement in two other free speech cases, which also involved contexts in which it previously had been enforced: regulations of commercial speech;[22] and limitations on freedom of association.[23]

The Court's reasoning in all these cases is typified by *Ward*, which ruled that content-neutral regulations on the time, place, or manner of speech should be sustained even if the government's goals could have been served through less speech-restrictive alternatives.[24] *Ward* upheld New York City's regulations requiring that any musical performance at the Central Park bandshell had to use city furnished sound equipment run by a city employed sound technician. The city's asserted justification for this regulation was to control sound volume.[25] The city's sound technician controlled not only the sound's volume, however, but also its "mix," which is an essential aesthetic element of rock music.[26] For this reason, the Second Circuit Court of Appeals invalidated the regulations. Applying the least intrusive alternative approach, the Court of Appeals found that there were various alternative means of controlling volume without also intruding on performers' ability to control the sound mix.[27]

In *Ward*, as in the other cases where the Court discarded the least restrictive alternative test, it substituted a requirement that the challenged measure be "narrowly tailored" to promote the relevant interest. The term "narrowly tailored" suggests a test resembling the least restrictive alternative approach. The Court's explanation of the term, however, makes clear that it is a nebulous, deferential criterion, which will result in upholding most government measures.

In *Ward*, the Court said that the narrow tailoring requirement would be satisfied "so long as the . . . regulation promotes a substantial government interest that would be achieved less effectively absent the regulation.[28] In other words, the regulation may not "burden substantially more speech than is necessary to further the government's legitimate interests."[29] But, as the dissent noted, "this means that only those regulations that 'engage in the gratuitous inhibition of expression' will be invalidated."[30] Moreover, even this attenuated tailoring requirement probably would not be enforced under the majority's analysis, because the majority criticized the Second Circuit for evaluating the comparative efficacy and intrusiveness of the alternative means for achieving noise reduction.[31]

Until recently, the fact that a challenged government measure was the least restrictive alternative for pursuing a government goal did not insulate it from invalidation. In addition, the extent to which the measure advanced the relevant government goal had to be proportional to and not outweighed by the extent to which it inhibited individual freedom. In other words, the government's end did not necessarily justify its rights-infringing means.[32]

Now, however, the Rehnquist Court has inverted these previous holdings: A challenged measure need not be the least intrusive alternative for advancing the government's goal; if it effectively promotes the goal, that alone validates it. Nor is the government required to show that its interest is promoted proportionately to and not outweighed by the curbing of individual rights. Justice Marshall captured this point in *Ward* when he said, "the majority enshrines efficacy but sacrifices free speech."[33]

This inversion also characterized the Court's 1990 decision in *United States v. Kokinda*,[34] which upheld a U.S. Postal Service regulation that banned all solicitation on public sidewalks adjoining Post Office buildings. *Kokinda* repeatedly stressed that "[t]he purpose of the [sidewalk] . . . is to enable the postal service to accomplish the most efficient and effective postal delivery system."[35] According to *Kokinda*, not only is the government entitled to utilize the most efficient and effective measures for pursuing its goals, but also individuals have no rights to government measures that are less restrictive of their free speech.[36]

Ward, *Kokinda*, and other Rehnquist Court decisions constitute striking reversals of classic principles governing speech on public property. Under the established approach, the government could be required to make some sacrifice in the efficiency with which it pursued its goals, because it had to utilize the measures that least restricted individual expression. For example, in the venerable decision of *Schneider v. State*,[37] the Court held that the government could not pursue its goal of maintaining litter-free streets by banning leafletting. Rather, the Court held, the government had to utilize a measure that was less intrusive on speech, such as punishing those who engaged in littering, even if that measure was less effective in accomplishing the government's goal. In short, free speech was deemed more important that government efficiency.

Another aspect of the Rehnquist Court's drift toward relaxed scrutiny of government action curtailing speech is its failure to require that any such action be undertaken pursuant to clearly delineated standards, in order to circumscribe official discretion. In two recent cases, the Court expressly permitted the government to limit speech pursuant to open-

ended, broadly worded standards that left much room for the exercise—and hence for the abuse—of governmental discretion.

In *Ward*, the Court upheld New York City's guidelines for regulating outdoor music performances even though it recognized that the standards were "undoubtedly flexible," and that "the officials implementing them will exercise considerable discretion."[38] As Justice Marshall noted in dissent, this broad discretion was particularly problematic for two reasons. First, it would afford officials leeway to engage in content-based regulation under the guise of making ostensibly neutral judgments about volume.[39] He pointed out that, throughout history, newer styles of music generally have been perceived as "noisier" than older styles, with the result that content could be censored on the pretext of regulating volume.[40]

A second reason why the detailed legal standards requirement should have been enforced especially zealously in *Ward*, Justice Marshall explained, is that the guidelines constituted a prior restraint on expression.[41] Prior restraints long have been considered especially threatening to free speech values. Thus, they are viewed as presumptively unconstitutional and upheld only if they satisfy several prerequisites that the Court has enunciated. These prerequisites are so strictly enforced that almost no prior restraints have passed constitutional muster.[42]

Yet, despite the fact that the regulations upheld in *Ward* imposed prior restraints on expression, the Rehnquist Court did not subject them to the strict scrutiny appropriate for such serious invasions of First Amendment liberties. In particular, it failed to enforce one established prerequisite for validating a prior restraint: that it regulate speech only pursuant to "narrowly drawn . . . and definite standards for the [administering] officials to follow."[43] Notwithstanding the general and vague terms of the *Ward* guidelines, however, the Court upheld them.[44] The Court did not insist that the regulations themselves explicitly limit official discretion. Instead, it was content to rest its approval upon the officials' testimony that, in practice, they interpreted the regulations' broad standards relatively narrowly.[45] This rationale is at odds with the Court's established stance toward prior restraints. It had consistently ruled that a regulation whose terms were insufficiently narrow could not be saved by allegedly limiting interpretations that were consigned to the discretion of official enforcers.[46]

Thornburgh v. Abbott also abandoned the previous requirement that government action limiting speech may be undertaken only pursuant to specific, detailed standards. There, the Court upheld regulations that gave prison officials broad discretion to control prisoners' receipt of publications and other materials if they determined that such materials might be "detrimental to the security, good order, or discipline of the institution or if they might facilitate criminal activity."[47] As the dissent noted, these "standards" are so ambiguous that they give prison officials virtually free rein to censor incoming materials.[48]

Yet another aspect of the strict scrutiny that the Court traditionally has applied to speech-infringing measures, which it recently has jettisoned, is the requirement that the government interest promoted by such measures must be very important. To capture this concept, the Court has said that such an interest must be of "compelling" significance.[49] Recently, however, the Rehnquist Court has displayed a tendency to approve speech infringements on the rationale that they advance government interests that are merely "legitimate" rather than "compelling."

Alternatively, the Court achieves the same result by conclusorily labeling as "compelling" government interests that traditionally have not been considered to rise to that level of importance. For example, in *Thornburgh*, the Court sustained prison regulations that significantly abridged prisoners' speech rights on the basis of administrative convenience,[50]

a government interest that never before had been deemed sufficiently important to justify limiting speech.[51] Indeed, the Court previously had ruled that administrative convenience did not justify limiting even less fundamental rights.[52]

The foregoing specific respects in which the Rehnquist Court has reduced the strict degree of judicial scrutiny traditionally applied to speech-limiting measures constitute manifestations of its general proclivity to defer broadly to the challenged determinations of executive and legislative branch officials who adopt such measures. The Court essentially presumes such decisions to be correct and imposes substantial burdens of proof upon individuals who challenge them. As previously noted, the two recent flag-burning decisions reaffirmed traditional free speech principles and thus stand as important counter-examples to the other cases discussed in this essay as well. In holding that legislation criminalizing flag desecration violates free speech principles regardless of the fact that a majority of Americans apparently support such legislation, Justice Brennan's majority opinions rejected Chief Justice Rehnquist's dissenting view of the Court's appropriate role. In urging judicial deference to majoritarian decisions, the Chief Justice declared: "Surely one of the high purposes of a democratic society is to legislate against conduct that is regarded as evil and profoundly offensive to the majority of people. . . ."[53]

This statement is starkly inconsistent with prior Supreme Court pronouncements regarding the Court's role in reviewing speech-abridging measures.[54] Nonetheless, it is consistent with the weakened judicial scrutiny that the Court recently has applied to other speech-restricting measures, aside from statutes banning flag desecration, Such a deferential stance was maintained, for example, in *Kokinda*, which upheld regulations of speech on public property adjoining Post Offices;[55] in *Thornburgh*, which upheld prison regulations of inmates' correspondence and their receipt of publications;[56] in *Ward*, which upheld municipal regulations controlling the volume and sound mix of musical performances in a public park;[57] and in *Board of Trustees of the State University of New York v. Fox*, which upheld a public university's regulations on commercial speech.[58] This aspect of the foregoing decisions was aptly summarized by Justice Marshall when he stated that "the majority replaces constitutional scrutiny with mandatory deference."[59]

Substantive Rulings Restricting Free Speech

Paralleling its invocation of weakened judicial review standards in free speech cases, the Rehnquist Court's substantive holdings have diminished the scope of protectible free speech. One important way in which the Court achieves this reduction is that, construing the free speech clause, it increasingly overemphasizes notions of formal equality. The Court reads this constitutional provision as securing for every individual opportunities to engage in expressive activities that are formally equal to other persons' opportunities. The Court has retreated from previous readings of the clause as absolutely guaranteeing the right to engage in some expressive activities.

The equal protection clause bars governmental discrimination regarding specific constitutional rights, including freedom of speech. Therefore, to read those guarantees as merely assuring non-discrimination is to render them superfluous, devoid of independent, substantive content.

The tendency of the Rehnquist Court's free speech jurisprudence to exaggerate egalitarian concepts of relative protection, at the expense of libertarian concepts of absolute protection, is graphically illustrated by its decisions concerning the "public forum doctrine," governing speech on public property. This essay will focus on one such decision

from the Court's 1989–90 term, *United States v. Kokinda*.[60] The *Kokinda* case construes the First Amendment as guaranteeing only that invasions of free speech will not be made on an overtly or intentionally discriminatory basis. It does not, however, construe the First Amendment either as prohibiting all such invasions outright or as prohibiting any such invasions that are discriminatory in effect.

In *Kokinda*, the Court continued its recent application of the public forum doctrine to allow the government to deny access or to terminate previously granted access to public property for expressive purposes. The only limitation on the government's prerogatives in this area is that it must not deny or terminate the expressive use of its property solely for reasons that overtly discriminate against particular speakers or messages.[61]

To be sure, the free speech clause protects against discriminatory as well as unjustified denials of expressive opportunities. Yet, in its public forum decisions, the Rehnquist Court has overemphasized the First Amendment's relative guarantee of equal access to public property for expressive purposes and ignored its absolute guarantee of some such access. In effect, the Court has said that the *only* right an individual has is not to be given *less* protection than other individuals, but that all may be equally unprotected.[62] Furthermore, the Court employs a formalistic notion of equality, which prohibits facially discriminatory government regulations but tolerates other regulations that are discriminatory in effect. Therefore, the Court does not even ensure *equal* non-protection, let alone equal *protection*, of free speech rights on public property.

Ironically, the public forum doctrine—which the Rehnquist Court has applied to diminish speech rights—initially was introduced into First Amendment jurisprudence as a vehicle for expanding expressive liberties.[63] The basic idea was that on certain types of public property, such as streets, parks, and sidewalks, the government had to grant access to speech and other expressive activities. As originally enunciated, the public forum doctrine encapsulated a basic libertarian proposition: *i.e.*, that all individuals have an absolute right of access to certain government property for expressive purposes (subject to neutral "time, place and manner restrictions").[64] Early on, the Court recognized an egalitarian corollary to that basic libertarian proposition: that the government could not deny access to its property, for expressive purposes, on the basis of the speaker's identity or message.[65]

Recently, the Court has distorted the public forum doctrine into guaranteeing not *any* absolute, minimal degree of free speech access to government property, but instead only an *equal* or *relative* degree of access. The government has no absolute obligation to make its property available for expressive purposes to any speaker, the Court says. Rather, the government's sole obligation arises only if it voluntarily chooses to open a particular piece of property for some expressive purposes. Then and only then, says the Court, does government incur the obligation not to discriminate among speakers or messages. In other words, the government must simply treat all would-be speakers alike. If it grants access to some, it must not deny access to others on a manifestly discriminatory basis. But it need not grant access to any.[66] Moreover, government may deny access on a basis that effectively discriminates against certain speakers or ideas.

The Court's regression in construing the public forum doctrine can be schematically outlined as follows:

Libertarian proposition: The government must grant access to its property for expressive purposes.

Egalitarian corollary: The government must not deny access to its property for expressive purposes on discriminatory bases.

Reductionist redefinition: The government may deny access to its property for expressive purposes on non-discriminatory bases.

Kokinda epitomizes the Court's "equal non-protection" approach to the public forum doctrine. In what Justice Brennan aptly labelled a "farce" of the intendedly speech-protective public forum doctrine,[67] the *Kokinda* opinion twisted that doctrine into a basis for denying speech rights on a type of government property that—along with streets and parks—traditionally had been deemed a "quintessential" or "inherent" public forum: a public sidewalk.[68]

In a model of a boot-strapping argument, the Court "reasoned" that because the U.S. Postal Service had issued a regulation prohibiting any solicitation on sidewalks adjoining Post Office buildings, such sidewalks should be classified as "nonpublic forums," where the government could freely enforce almost any restriction on access for expressive purposes. In other words, the government *could* deny access to speech because it *had* denied such access![69]

The *Kokinda* Court imposed only two minimal limitations on the government's power to impose speech restrictions on sidewalks adjoining Post Offices or other public property classified as nonpublic forums: such restrictions had to be "reasonable," and they could not constitute "an effort to suppress expression *merely* because public officials oppose the speaker's view."[70] Thus, the government apparently *may* "suppress expression" on such property "because public officials oppose the speaker's view," so long as that is not the officials' *only* motivation.

Not only did the *Kokinda* opinion relegate the precious free speech liberty to the minimal degree of protection afforded by rational basis review, but also, even worse, it applied that standard in a particularly lackluster fashion, manifesting substantial deference to the determinations of the U.S. Postal Service and effectively presuming those determinations to be constitutionally correct. Thus, *Kokinda* also demonstrates the integral interconnection between the Court's weakened review standards and its diminished substantive concept concerning free speech.

As the *Kokinda* dissent noted, even assuming *arguendo* that the Postal regulations were appropriately reviewed under a rational basis standard, it still should have been invalidated, because it was unreasonable. Of particular significance, the regulation was unreasonable in its discrimination among types of speech and speakers. In contrast with its categorical ban on solicitation, the Postal Service "does not subject to the same categorical prohibition many other types of speech presenting the same risk of disruption . . ., such as soapbox oratory, pamphleteering, distributing literature for free, or even flag-burning."[71] In fact, as the dissent observes, those who solicit money may well be less likely to cause disruption in the Post Office Services than those who engage in permitted types of speech.[72]

This irrational inconsistency in the Postal Service rule upheld in *Kokinda* illustrates how the Court's sterile overemphasis on formal equality strips constitutional guarantees of real meaning. The Court purports to preserve in the public forum doctrine at least the protection against the discriminatory exclusion of *some* speech, if not a more absolute protection against the exclusion of *any* speech. Yet, by deferring to government regulators and presuming their speech restrictions to be "reasonable," the Court approves restrictions that, in actual effect, *do* discriminate against certain categories of speakers and certain types of messages, without any rational justification.

In other recent public forum cases, the Court even has gone so far as to sustain restrictions that discriminated against certain viewpoints, the central evil that the free

speech clause guards against.[73] For example, in *Cornelius v. NAACP Legal Defense and Educational Fund*,[74] the Court held that an annual charitable fund-raising drive conducted in the Federal workplace during working hours was not a limited public forum, although for almost 20 years it had been open to any tax-exempt, nonprofit, charitable organization that was supported by public contributions and provided direct health and welfare services to individuals. The Court therefore applied only minimal scrutiny to a 1983 Executive Order, which for the first time excluded from the fund-raising drive "[a]gencies that seek to influence the outcomes of elections or the determination of public policy through political activity or advocacy, lobbying, or litigation on behalf of parties other than themselves."[75] The Court held that the exclusion of advocacy groups survived the low-level scrutiny it deemed applicable, reasoning that the avoidance of controversy is a valid ground for restricting speech in a nonpublic forum.[76] As the *Cornelius* dissenters maintained, this exclusion was patently viewpoint-based.[77]

Another case in which the Court permitted the government to discriminate against particular viewpoints in regulating speech on public property is *Perry Education Association v. Perry Local Educators' Association*.[78] In *Perry*, the Court held that public school mail facilities did not constitute a limited public forum, even though they were open to a union that had been certified as the teachers' exclusive bargaining representative, had previously been open to a rival union, and had periodically been open to civic and church organizations.[79] Because of its conclusion that these facilities constituted a nonpublic forum, the Court held that the school could bar the rival union from using them. Yet, as the dissenters noted, this selective exclusion constituted viewpoint discrimination which should be prohibited even in a nonpublic forum.[80]

It seems incredible that the intendedly speech-protective public forum doctrine was applied in the two foregoing cases, which allowed the government to restrict speakers' access to government property based on their viewpoints. This dramatically demonstrates the Court's recent distortion of the doctrine. Although the Rehnquist Court has reduced the public forum doctrine to a guarantee of formal non-discrimination or equality, the Court is not even adequately protecting equality values. It tolerates arbitrary and discriminatory restrictions on speech as well as unjustified restrictions.

Conclusion

"Not with a bang, but a whimper,"[81] the Rehnquist Court has reversed the momentum of previous Courts toward expanded protection for speech. To be sure, the Court has issued some significant decisions that are consistent with that previous protective trend, and its speech-restricting decisions have received relatively little attention. Nevertheless, it is important to analyze the rulings that undermine free speech precisely because so many are issued in contexts designed to obscure their import.

These speech-limiting rulings have far reaching consequences beyond the factual settings directly involved, since they have eviscerated the strict scrutiny traditionally applied to measures encroaching on speech. Eschewing the Supreme Court's established role as the guarantor of individual liberties—including the paramount liberty of free expression—the Rehnquist Court increasingly has deferred to judgments of majoritarian governmental branches in support of speech-limiting measures.

Paralleling its deferential scrutiny—or, more accurately, "non-scrutiny"[82]—of government measures abridging speech, the Rehnquist Court has constricted its conception of

the scope of protected speech. *Kokinda* and other recent public forum decisions abandon established views of the free speech clause as ensuring some absolute level of protection for expression. Rather, they espouse a diminished view of this constitutional provision as ensuring only that individuals will not be subjected to patent, intentional discrimination in the level of protection—or lack of protection—they receive. Thus, after *Kokinda*, none of us has the right to engage in expressive activity on government property. Instead, we must be content in the knowledge that the government may not single us out in denying expressive access to its property *solely* because it disagrees with our ideas.

Notes

1. *See generally* K. Greenawalt, *Speech, Crime, and the Uses of Language* (1989) 186–218.

2. The term is in quotation marks to signify both its indeterminacy and also the fact that basic canons of judicial restraint, an approach usually associated with judicial conservatism, are not consistently followed by Chief Justice Rehnquist and the Justices who often vote with him (Justices White, O'Connor, Scalia, and Kennedy). *See* Strossen, *Introduction to Symposium on Recent Supreme Court Civil Rights Decisions*, N.Y.L.S. J. Hum. Rts. (1990) (forthcoming).

3. *See, e.g.*, American Civil Liberties Union, *The 1989 Supreme Court Term: Mixed Signals*, June 28, 1990, at 1 ("The Court's decisions on free speech . . . can best be described as a mixed bag."); Supreme Court Watch, *Good News, Bad News: The Supreme Court's 1989–1990 Term*, July 1990, at 11 ("Supreme Court decisions this term gave strong protection to the right of free speech for individuals while rendering a troubling decision on freedom of the press.").

4. *See United States v. Eichman*, 48 U.S.L.W. 4744 (1990); *Texas v. Johnson*, 109 S. Ct. 2533 (1989).

5. Justice Brennan also authored the other major free speech victory of the past two Terms: *Rutan v. Republican Party of Illinois*, 58 U.S.L.W. 4872 (1990) (holding that promotions, transfers, and recalls based on political affiliation or support constitute an impermissible infringement on public employees' First Amendment rights).

6. For a discussion of this aspect of the Court's individual rights decisions beyond the free speech sphere, *see* Strossen, *Recent U.S. and International Judicial Protection of Individual Rights: A Comparative Legal Process Analysis and Proposed Synthesis*, 41 Hasting L.J. 805, 866–67 (1990).

7. 109 S. Ct. 2746, 2762, 2765 (1989) (Marshall, J., dissenting).

8. Regarding this aspect of the Rehnquist Court's individual rights jurisprudence more generally, *see* Strossen, *supra* note 7, at 876–77.

9. For examples of the Rehnquist Court's reliance on previous dissenting opinions in a case cutting back on free speech, *see Ward*, 109 S. Ct. at 2753; *id.* at 2755. *Ward* also provides an example of the majority's reliance on distinguishable cases. *See id.* at 2761 n. 1(Marshall, J. dissenting).

10. *See Webster v. Reproductive Health Services*, 109 S. Ct. 3040, 3077 (1989) (Blackmun, J., concurring in part and dissenting in part):

Never in my memory has a plurality . . . gone about its business in such a deceptive fashion. At every level of its review . . . the plurality obscures the portent of its analysis. With feigned restraint, the plurality announces that its analysis leaves *Roe* "undisturbed" . . . But this disclaimer is totally meaningless. The plurality opinion is filled with winks, and nods, and knowing glances to those who would do away with *Roe* explicitly. . . .

Thus, "not with a bang, but a whimper," the plurality discards a landmark case of the last generation.

11. 109 S. Ct. 1874 (1989).

12. 109 S. Ct. 1746, 1760 (Marshall, J., dissenting) (1989).

13. *See, e.g., Kovacs v. Cooper*, 336 U.S. 77, 88, 93 (1949); *Saia v. New York*, 334 U.S. 558, 561, 562 (1948).

14. *See, e.g., Pacific Gas & Electric Co. v. Public Utilities Commission of California*, 475 U.S. 1, 17, 19, 21 (1986); *Widmar v. Vincent*, 454 U.S. 263, 270 (1981); *First National Bank of Boston v. Bellotti*, 435 U.S. 765, 786, 787, 792, 795 (1978).

15. *See, e.g., Widmar*, 454 U.S. at 270 (government "must show that its [speech] regulation is necessary to serve a compelling state interest and that it is narrowly drawn to achieve that end.").

16. 109 S. Ct. 1874, 1876, 1883 (1989).

17. 109 S. Ct. at 2578.

18. *See Procunier v. Martinez*, 416 U.S. 396, 413 (1974) (censorship of prison mail would be permitted only if "the limitation of First Amendment freedoms [was] no greater than . . . necessary or essential").

19. *See, e.g., Martin v. City of Struthers*, 319 U.S. 141, 147 (1943).

20. *See* 109 S. Ct. at 1880–81. *Compare Procunier v. Martinez*, 416 U.S. 396, 413 (1974).

21. *See* 109 S. Ct. at 2758. *Compare, e.g., Frisby v. Schultz*, 487 U.S. 474 (1988); *Boos v. Barry*, 485 U.S. 312, 329 (1988); *United States v. O'Brien*, 391 U.S. 367, 377 (1968).

22. *See Board of Trustees of the State University of New York v. Fox*, 109 S. Ct. 3028, 3033–34 (1989). *Compare, e.g., Shapero v. Kentucky Bar Association*, 486 U.S. 466, 472 91988); *San Francisco Arts & Athletics, Inc. v. United States Olympic Committee*, 483 U.S. 522, 539 (1987).

23. *See Dallas v. Stanglin*, 109 S. Ct. 1591, 1596, 1597 (1989). *Compare Shelton v. Tucker*, 364 U.S. 479, 488 (1960).

24. 109 S. Ct. 2746, 2757 (1989).

25. *Id.* at 2756.

26. *Id.* at 2751–52 & n. 1.

27. *See id.* at 2752–53. The Second Circuit opinion is reported at *Rock Against Racism v. Ward*, 848 F. 2d 367 (2d Cir. 1988).

28. 109 S. Ct. at 2758 (quoting *United States v. Albertini*, 472 U.S. 677, 689 (1985).

29. *Id.*

30. *Id.* at 2762 (Marshall, J., dissenting) [quoting Ely, *Flag Desecration: A Case Study in the Roles of Categorization and Balancing in First Amendment Analysis*, 88 Harv. L. Rev. 1482, 1485 (1975)].

31. *Id.* at 2757.

32. *See, e.g., Olmstead v. United States*, 277 U.S. 438, 485 (1928) (Brandeis, J., dissenting) ("To declare that in the administration of the criminal law the end justifies the means—to declare that the Government may commit crimes in order to secure the conviction of a private criminal— would bring terrible retribution. Against that pernicious doctrine this Court should resolutely set its face").

33. 109 S. Ct. at 2763 (Marshall, J., dissenting).

34. 58U.S.L.W. 5013 (1990).

35. *Id.* at 5016. *Accord, Id.* at 5017 (Postal Service restrictions on speech may "ensure the most effective and efficient distribution of the mails.").

36. *See* 58 U.S.L.W. at 5016 (citation omitted) ("'The Government's decision to restrict access to a nonpublic forum need only be *reasonable*; it need not be the most reasonable or the only reasonable limitation.'") (emphasis in original).

37. 308 U.S. 147, 162 (1939).

38. 109 S. Ct. at 2755.

39. *Id.* at 2764 (Marshall, J., dissenting).

40. *See id.* at 2764 n. 7 (Marshall, J., dissenting).

41. *Id.* at 2763.

42. *See* Tribe, L., *American Constitutional Law* (1988) sec. 12–34.

43. *Niemotko v. Maryland*, 340 U.S. 268, 271 (1951).

44. 109 U.S. at 2760.

45. *Id.* at 2756.

46. *See* Tribe, L., *supra* note 43 at sec. 12–38, 1056–57.

47. 28 C.F.R. sec. 540.71(b) (1985).

48. 109 S. Ct. at 1889 (Stevens, J., concurring in part and dissenting in part).

49. *See, e.g., Pacific Gas & Electric Co.*, 475 U.S. at 17, 19, 21.

50. 109 S. Ct. at 1884; *see id.* at 1891–92 (Stevens, J., dissenting).

51. *See Bullock v. Carter*, 405 U.S. 134, 149 (1972) (administrative convenience or cost savings

cannot justify burdens on fundamental rights); *Shapiro v. Thompson*, 394 U.S. 518, 633–34 (1969) (same); *Terminiello v. Chicago*, 337 U.S. 1, 4 (1948) ("freedom of speech . . . is . . . protected . . . unless shown likely to produce a clear and present danger of a serious substantive evil that rises far above public inconvenience, annoyance, or unrest.").

52. *See Craig v. Boren*, 429 U.S. 190, 198 (1976) (involving right to non-discrimination on the basis of gender, which the Court treats as less important than "fundamental" right such as free speech; measures invading the latter are subject to strict judicial scrutiny, whereas measures invading the former are subject to "intermediate" scrutiny).

53. *Texas v. Johnson*, 109 S. Ct. 2533, 2555 (1989) (Rehnquist, C.J., dissenting).

54. *See West Virginia State Board of Education v. Barnette*, 319 U.S. 624, 638 (1943): "The very purpose of a Bill of Rights was to withdraw certain subjects from the vicissitudes of political controversy, to place them beyond the reach of majorities and officials and to establish them as legal principles to be applied by the courts. One's . . . fundamental rights may not be submitted to vote; they depend on the outcome of no elections."

55. *See* 58 U.S.L.W. at 5016–18.

56. *See* 109 S. Ct. at 1883–84.

57. *See* 109 S. Ct. at 2759 (1989).

58. *See* 109 S. Ct. at 3035 (1989).

59. *Ward*, 109 S. Ct. at 2760 (Marshall, J., dissenting).

60. 58 U.S.L.W. 5013 (1990).

61. *See, e.g.*, *Perry Education Association v. Perry Local Educators' Association*, 460 U.S. 37, 46 (1983) (outside public property that the government voluntarily opens to expressive use, government may impose on its property any speech-restrictive regulations that are reasonable and that are "not an effort to suppress expression merely because public officials oppose the speaker's view").

62. *See Kokinda*, 58 U.S.L.W. at 5016.

63. Justice Brennan noted this development in his *Kokinda* dissent, 58 U.S.L.W. at 5019.

64. This notion is eloquently expressed in Justice Roberts' oft-quoted dictum in *Hague v. CIO*, 307 U.S. 496, 515 (1939):

> Wherever the title of streets and parks may rest, they have immemorially been held in trust for the use of the public and, time out of mind, have been used for purposes of assembly, communicating thoughts between citizens, and discussing public questions. Such use of the streets and public places has, from ancient times, been a part of the privileges, immunities, rights, and liberties of citizens.

65. *See, e.g.*, *Police Department of Chicago v. Mosley*, 408 U.S. 92, 95–96 (1972): "[A]bove all else, the First Amendment means that government has no power to restrict expression because of its message, its ideas, its subject matter, or its content."

66. *See Kokinda*, 58 U.S.L.W. at 5016.

67. 58 U.S.L.W. at 5025 (Brennan, J., dissenting).

68. *See Frisby v. Schultz*, 487 U.S. 474, 480 (1988); *United States v. Grace*, 461 U.S. 171, 177, 180 (1983).

69. *See* 58 U.S.L.W. at 5016 (citations omitted): "The Postal Service has not expressly dedicated its sidewalks to any expressive activity. . . . To be sure, individuals or groups have been permitted to leaflet, speak, or picket on postal premises . . . but . . . a practice of allowing some speech activities on postal property do[es] not add up to the dedication of postal property to speech activities. We have held that '[t]he government does not create a public forum by . . . *permitting* limited discourse, but only by intentionally opening a nontraditional forum for public discourse.'"

70. 58 U.S.L.W. at 5016, *quoting Perry Education Association v. Perry Local Educators' Association*, 460 U.S. 37, 47 (1983) (emphasis supplied).

71. 58 U.S.L.W. at 5024 (Brennan, J., dissenting).

72. *See id.*

73. *See, e.g.*, *First National Bank v. Bellotti*, 435 U.S. 765, 785 (1985); *Madison Joint School District No. 8 v. Wisconsin Employment Relations Commission*, 429 U.S. 167, 175–76 (1976).

74. 473 U.S. 788 (1985).

75. *Id.* at 795.

76. *Id.* at 811.

77. *See id.* at 814 (Blackmun, J., dissenting); *id.* at 835 (Stevens, J., dissenting).

78. 460 U.S. 37 (1983).

79. *Id.* at 47–48.

80. *See id.* at 65 (Brennan, J., dissenting).

81. *See supra* note 11.

82. *See Webster v. Reproductive Health Services*, 109 S. Ct. 3040, 3077 (1989) (Blackmun, J., concurring in part and dissenting in part).

Freedom of Speech and the Flag
Anti-Desecration Amendment:
Antinomies of Constitutional Choice

William W. Van Alstyne

Introduction

On June 21, 1989, in *Texas v. Johnson*, the Supreme Court held that the First Amendment does not permit imprisonment for burning a flag in the course of an open political demonstration.[1] The Court's decision was widely featured on all major television networks the same day it came down, replaying film footage of the original incident as it had occurred in front of the Dallas City Hall. The Supreme Court decision came within three weeks of the shooting of students for demonstrating in Tiananmen Square in Beijing, events also replayed on television sets here at home. It was a summer unusually full of tumultuous events, even as one-party Communist regimes continued to come apart in eastern Europe and totalitarianism elsewhere continued to crack and break up.

In response to the Court's decision in *Texas v. Johnson*, however, President Bush did not speak to the contrast of these events. Rather, speaking from a flag-rimmed rostrum constructed for the occasion in front of the famous Iwo Jima flag memorial in Washington, the President called on Congress to protect the flag. He did not contrast the freedom of political demonstration the Court had affirmed with the shootings and jailings even then still ongoing in the People's Republic. Instead, he proposed the following amendment to the Constitution of the United States for prompt passage by two-thirds of both Houses in Congress and for prompt ratification by the states: "The Congress and the States Shall Have Power to Prohibit the Physical Desecration of The Flag of the United States."

The amendment was at once introduced in Congress where, however, it became temporarily sidetracked when Democratic majorities in both houses rushed to propose a new "Flag Protection Act," rather than the proposed amendment. At the time, it was clear they were not eager to approve an amendment, but by offering a new act—to do by redrafted statute what the President proposed to do by amendment—they hoped to avoid any political blame for being less patriotic than president Bush and the Republicans.[2] In turn, the President allowed the new act to become law without his signature, even while indicating that he believed it to be an insufficient substitute for the proposed amendment he continued to support as the appropriate response.

The new act of Congress was swiftly tested by political demonstrators in Washington, D.C., and in Seattle, Washington. The two Federal district courts quickly vindicated the

This essay is adapted from Notes submitted in opposition to the proposed 27th Amendment—the anti-flag desecration amendment—when it was under consideration in the House and Senate in 1989 and 1990.

President's view. Each held that the cosmetic difference between the redrafted Federal statute and the original Texas statute struck down in *Texas v. Johnson* was of insufficient constitutional significance to make a difference under the First Amendment.[3] Each, therefore, on facts similar to those in *Texas v. Johnson*, held the new Federal act unconstitutional as applied. On June 11, 1990, on further and final review of these two new cases under the revised Federal statute, the Supreme Court agreed.[4]

The proposed 27th Amendment was at once re-introduced in Congress. After a flurry of debate in the House, it was approved by a clear majority but not by the extraordinary two thirds required by Article V of the Constitution. As it failed to carry the House, the debate in the Senate collapsed. It carried the President's strong support to the end, however, and at least one national poll indicated that a substantial number of Americans clearly felt it to be a good measure for the country to enact.

What did the proposed 27th Amendment to the Constitution mean? How would it have worked? What kind of flag uses would it have covered? What kind of legislation would it have insulated from review under the First and Fourteenth Amendments? What impact on our understanding of free speech might it have had? And what would it have meant, if anything, in other countries where freedom of political dissent remains under attack? These are some of the questions one should want to think about before adding a provision to the Constitution of the kind the President proposed. It is entirely proper to take their measure even now, moreover, though the momentum for the amendment has passed away. For it is in reflecting on these things that we may better understand the meaning of freedom of speech under our First Amendment today. A review of the amendment is also worthwhile because it will help one come to terms with the original decision in *Texas v. Johnson*. It may help one sort out what made *Texas v. Johnson* a welcome and truly important case.

There were, broadly speaking, two kinds of issues raised by the proposed amendment. First, there was the question of the amendment's scope in terms of the kind of legislation it would authorize. Just what would it have empowered Congress and the states to do? Second, there was also the question of the extent to which the amendment would affect the First Amendment as interpreted and applied by the Supreme Court. How much of that amendment, if any, would the proposed amendment have set aside?

After exposing this hitherto unexplored feature of the amendment in Part I, I shall suggest in Part II of this brief review why the amendment would have been a source of uncertainty regarding the kinds of legislation it would and would not sustain, and what a profound mistake its adoption as part of our constitution would have been. In proceeding in this fashion, I hope we may also see how events associated with this amendment and with *Texas v. Johnson* also bear on events in other places such as those in Tiananmen Square.

Did the Proposed 27th Amendment Purport to Alter or Affect Any Interpretation of the First Amendment?

It is a seemingly odd thing that, although the amendment was introduced to overcome a decision of the Supreme Court based squarely on the First Amendment, the proposed amendment left the First Amendment intact and said nothing to suggest that the First Amendment was to be deemed inapplicable to any legislation adopted pursuant to its own provisions. In this singular aspect, moreover, the proposed amendment was wholly *unlike* past amendments that had been proposed and ratified to overcome other controversial

decisions by the Supreme Court.[5] Indeed, nothing on the face of the proposed amendment actually purported to mandate a different outcome in a case like *Texas v. Johnson*, as one may see from reviewing the actual case itself.

In *Texas v. Johnson*,[6] the Texas State Court of Appeals did not reverse Gregory Johnson's conviction on the basis that the State of Texas lacked some general power to forbid the desecration of venerated objects—the crime for which Gregory Johnson was convicted. Rather, it reversed his conviction solely on the basis of the First Amendment where the facts of the case placed Johnson's particular conduct within the protection of the First Amendment as part of an open, public political demonstration and where his acts were protected as a recognized form of free speech. Concretely, this is what the Texas Court of Criminal Appeals held:[7] "We hold that section 42.09(a)(3) [the state flag antidesecration act] may not be used to punish acts of flag desecration when such conduct falls within the protection of the First Amendment. We express no view as to whether the State may prosecute acts of flag desecration which do not constitute speech under the First Amendment."[8] So the state court itself distinguished acts of demonstrative flag use in a political setting from unprotected acts of vandalism, theft, or defilement (e.g., throwing paint on a flag being carried by another), in drawing its own clear First Amendment lines. And the Supreme Court affirmed just that decision, as it likewise decided the two later cases, under the redrafted congressional statute, on the same First Amendment grounds.

In order to forestall a decision like that reached solely on First Amendment grounds by both the state court and the Supreme Court in *Texas v. Johnson*, moreover, one might suppose that an amendment seeking that effect would need to read something much more like this: "The First Amendment shall not be deemed applicable to Federal or state legislation prohibiting the physical desecration of any American flag." But the proposed amendment did not say anything like this. Nor did it propose anything like the following terms: "Neither the First nor the Fourteenth Amendment shall be construed to forbid the conviction of any person who physically desecrates any flag of the United States." Far from saying anything that suggests the First Amendment should be deemed inapplicable to any state or national law providing penalties for what the government may regard as the physical desecration of some facsimile of the flag (whether or not the government's property and whether or not used in protest of or dissent from some policy of the United States), however, the amendment simply tracked the form of other clauses vesting certain ordinary affirmative powers in Congress. It tracked the form of such routine constitutional provisions, that is, as these:

The Congress shall have power to regulate Commerce with foreign Nations, and among the several states, and with the Indian tribes[9]

The Congress shall have Power to establish Post Offices and post Roads[10]

Indeed, the comparison with other clauses of this sort is so striking that the proposed amendment should be examined again, virtually side by side: "The Congress and the States Shall have Power to Prohibit the Physical Desecration of The Flag of The United States."

But we know, of course, that the First Amendment fully applies to any act adopted by Congress pursuant to any of its previously enumerated express powers, whether it is an act regulating commerce among the several states or an act establishing post offices and post roads.[11] And we know, too, that the proposed amendment stated no exception in respect to any law adopted pursuant to the particular power ("to prohibit the physical

desecration of the flag") to which it speaks. If, then, though an action of the sort that Johnson participated in were subsequently to be prosecuted pursuant to some state or national law based on this amendment,[12] if the act were also an act within the First Amendment in light of the circumstances involved in the particular case (like those involved in *Johnson* itself[13]), when called upon to show why no First Amendment claim should be heard, what can one point to in the proposed amendment to make good any such claim?

The origin of the proposed amendment doubtless did lie in the felt dissatisfaction of those who sponsored it with the manner in which the Supreme Court had construed and applied the First Amendment. But to have their way in this matter, if they did mean to oust the First Amendment from further consideration in this matter, it was incumbent upon them to say so. An amendment that would do so is quite different from the amendment that was introduced and endorsed by President Bush. It is different, moreover, because on its face it would declare that this nation does not want or does not deem the First Amendment to be appropriate to one particular kind of symbolic expression despite its own Supreme Court's view that the First Amendment does apply to such conduct and that it applies unexceptionably. It is also different in the important sense that the very process of confronting the issue in those terms would have made the debate in Congress and elsewhere very different. When put that way, I think it much less likely that any amendment, so proposed and so understood, would have rallied much support. The events from Tiananmen Square would have been drawn on powerfully to show the blow any such amendment would deliver against our own Constitution. It would never have gotten off the ground.

Suffice it to say, however, that this amendment did not do so. Indeed, it addressed none of these matters at all. And why not? Because, no doubt, it would have been seen even more clearly for what it was and would itself doubtless have led to the amendment's defeat. We know that any such amendment would, in all likelihood, not pass. Such an amendment would, thus framed, in all likelihood not, in fact, be approved by many who otherwise may not approve every Supreme Court decision but who nonetheless would not want so to amend the Constitution of the United States.

Behind *Texas v. Johnson*, there lay a significant history. Over the years, the Supreme Court had reviewed more than a half-dozen criminal convictions involving flag use, and the results were not all of a piece. On the one hand, the Court has found little difficulty sustaining regulations restricting the commercialization of flags or flag facsimiles as an incident of hawking goods or promoting commercials ales.[14] On the other hand, like many ordinary citizens in this country, the Court had experienced genuine problems in sorting out other events involving flag uses in keeping faith with the First Amendment, in noncommercial settings. And, overall, it had drawn significant, useful First Amendment lines strongly protecting rights of political dissent. For example, an individual who, believing a national policy to be wrong and unworthy of the United States, may signal his or her message even in the manner of an international distress signal, i.e., by flying the flag on his car antenna or in his own front window, upside down. Another may emboss it with taped superimposition of a peace sign.[15] Generally, both kinds of acts would be regarded as forms of political expression clearly protected by the First Amendment to our Bill of Rights, not just under the Court's decision in *Texas v. Johnson*, but also because they were already so regarded by the Court prior to that decision.

A case may instead involve a black citizen and war veteran, grief-stricken by the news account he receives by radio of the purported shooting in the South of a civil rights figure.

Weeping, he takes his own flag to the street beside his apartment. Cradling it, he burns it in despair.[16] Is this a crime? Shall it be constituted a crime? Does one see no First Amendment issue at stake? A very large number of Americans certainly might, even as the Supreme Court did.

So the proposed amendment rather willfully said nothing of these matters. It spoke no word as to how the Supreme court should construe and apply the First Amendment in cases involving acts of flag "desecration:" where—as is typically the case—the flag is not government property but may be a personal facsimile made of paper or other material and is used in some demonstrative way to express dissent from some policy or position of the government of the United States. Indeed, on its face, the proposed amendment affected no previous application of the First Amendment in any way at all. Insofar as it meant nonetheless to do so, it hid that purpose (to such extent that it harbored that purpose) underneath calculated language. It hoped, thereby, to slide easily into place.

If the proposed amendment did mean to exempt from First Amendment review all such legislation as would fit within the power vested in Congress and the states, then, of course, one would want to have a very clear picture of that power because, by hypothesis, the First Amendment would be cut off from any act otherwise bearing on things one may do in respect to the flag.[17] So, just what would the amendment, thus understood, have done?

The Unravelling of an Ill-Considered Amendment

The choice of language restricting the amendment to allow punishment only of acts of "physical" desecration was deliberate. At one stage, before it became somewhat unravelled (as we shall see), it was meant to represent some serious concession to First Amendment concerns—to keep the amendment itself within reasonable bounds. It initially reflected an intention to reach only forms of actual *physical* disfigurement of a flag, whether by mutilation, burning, tearing, spitting on a flag, or some other physical besmirching of it in some other way. It expressly did not mean to reach mere words of contempt or verbal expressions of derision about the flag or about anything which, in the opinion of the offending speaker, the flag allegedly represents. So much as this seemed quite clear. In short, as long as the flag (no matter whose flag) is not itself physically desecrated, i.e., as long as it is intact, unaltered, unmutilated, unburnt, physically unsullied, the amendment is still in its sheath. Certainly an ordinary citizen's posting of a flag, on a standard angled from his own porch in the usual way, was not meant to be affected by any legislation possibly based on this amendment.

But likewise, then, assuredly the amendment would not reach the flying of any *intact* flag, even giant size, say, from a flagpole outside a Hardee's Fast Food Restaurant? Possibly, but somehow the example becomes contentious insofar as some might regard this to be an inappropriate (because commercial) use, even one in their view that is physically desecrative because it seeks to identify the commercial product of the entrepreneur with the national flag. Still, in keeping with the emphasis solely on "physical" desecration, perhaps there is no reaching such a use by legislation connected with this amendment. The flag's use may be objectionable to some, even conceivably mildly "desecrative" in some sense, but "physically" desecrative, perhaps not.

But if that much is so, then similarly the amendment ought to be equally inapplicable as addressed to an American Nazi Party march, otherwise protected by the First Amendment, a parade involving the carrying of a sound, unaltered, intact American flag at the

head of the march. It—i.e., this use—likewise involves no mutilation, no alteration, no burning, spitting on, rending, etc. of the standard itself. There is no more "physical" desecration of the flag here, any more than in the presupposed Hardee's Restaurant case.

What, then, however, of another who is not a Nazi and who does not engage the use of the flag as part of a political assembly or parade, but who merely displays the flag upside down, e.g., as a member of a group protesting some U.S. military engagement abroad they believe to be an undeclared war and an immoral use of force? Is there any physical desecration in this act? Evidently, some think there may be, and, indeed, those purporting to speak for the administration in support of the amendment testified that, in their view, the amendment would sustain legislation of exactly this prohibitory kind.[18] But if one is inclined to stretch the word "physically" to include the mere manner of displaying an intact flag (e.g., displaying it upside down—as a physically desecrating manner of display) on the reasoning that such a manner of display is inappropriate and disrespectful of appropriate flag display, one needs to reconsider *all* the cases previously posed. If the amendment can be stretched in this way, many may equally well conclude that for an American Nazi Party to parade with the flag at all is equally to "desecrate" the flag because of the infamous auspices of those who would so parade with it publicly. May Congress and state legislatures therefore also confine use of the flag to certain political parties in the United States? If it were to do so, e.g., to disallow the flag to be displayed under political auspices other than by the Republican, Democratic, and other "mainstream" parties, would such a law be (a) valid by force of this proposed amendment, or would it instead be (b) invalid either under the First Amendment or invalid (c) under the Fifth Amendment's implied equal protection clause (e.g., Socialists, Environmentalists, Communists, Libertarians)?

Next, then, to the different case of another who carefully affixes removable tape in the shape of a peace symbol and displays the flag in his home front window, albeit quite properly and respectfully, i.e., right side up?[19] Is this an act of "desecration" at all? To be sure, the flag thus displayed has a superimposed figure temporarily affixed; yet, the flag itself is not mutilated, burned, rent, dirtied, or soiled. In what respect, then, may it fairly be said that this is an act of "physical desecration" of the flag?[20]

There is, moreover, a related problem of interpretation raised by the proposed amendment. The related problem is that of proposing and understanding some baseline definition of the phrase "*the flag* of the United States." Assuming one gets control of what it is to commit an act of "physical desecration," still, consistent with the proposed terms of the amendment, it is not subject to prohibition unless it is physical desecration of "the flag of the United States;" i.e., it must be such a flag for the amendment to apply at all.

Initially, to be sure, the term seems perfectly clear. One starts with a standard flag of the United States, then one does something with it or to it that "physically desecrates" *that flag*. And that understanding dovetails with the background from which this proposed amendment arose, i.e., *Texas v. Johnson*, involving, as it did, the burning of and spitting on a flag.

But suppose one does *not* start with a flag which one "physically desecrates." Rather, suppose one starts with a mere idea, e.g., a stars-and-stripes motif. The simplest example, perhaps, would be proposed by a swim suit designer who designs a bikini using the stars-and-stripes motif. Raquel Welch has been previously photographed in just this way. In this instance, unlike *Texas v. Johnson*, there never was "a flag" that is altered, disfigured, torn, or modified. There was no flag "physically desecrated" in the construction of this

suit. Neither did Ms. Welch physically desecrate any flag of the United States. Accordingly, may we suppose that laws adopted pursuant to the amendment would not apply to a case of this sort?

But if that is so in Ms. Welch's case, what, then, of any other original constructions that never were a flag, whether a flag bought commercially or a flag made at home? Will a law adopted pursuant to this amendment apply—or not apply—to a sculptor who, wishing to make a political point, constructs displays an original work that never was a flag of the United States, i.e., neither the sculptor's own "flag" or anyone else's? What he or she makes is nonetheless very "flaglike" and highly offensive in a number of respects. It has a projecting part in the shape of a swollen phallus, closely spiraled with alternate red and white stripes. The grotesque red-and-white striped barrel of this cannon sculpture rests on a gun carriage shaped to suggest a misshapen, oversized scrotum, painted blue, superimposed with white stars. The message of this work is loud, clear, and confrontational. Many may think it a physical desecration of the flag of the United States. But what "flag" was physically desecrated, since the artist never used a flag as such at all?[21] How does one want to conclude in this case? That the artist can be sent to prison because his or he work violates a law duly enacted by Congress or some state, deemed authorized by the proposed amendment, or that the display of the work is, instead, fully protected by the First Amendment?

And if we but continue this new turn of emphasis, i.e., from the express requirement of some kind of physical sullying or physical changing (mutilation, burning, etc.) of a flag, to the emphasis on the additional idea of "desecration," how much further along do we get? Consider again the case of the person who, grief-stricken with the news of the reported assassination of a civil rights figure, weeps over his flag and cradles it in his arms, even while burning it on the sidewalk beside the tenement where he lives. What does one say?[22] Is this an act of "flag desecration" or is it a cry of despair? Does the regret, the anguish, the whole posture of the person provide an insight and also a new First Amendment perspective we had not properly stopped to consider? Yet, here we have put an instance of an actual flag burning, no less! Yet again, the question of First Amendment freedom presses heavily in upon us from the outside as we come to terms with this case. Would legislation applied by some state to this case be deemed exempt from First Amendment review if the proposed amendment is adopted? But assuming that it might be, just why would we desire that this be so?

In the end, of course, it is ultimately this kind of question that must be asked more generally by Congress, whether in the case last put or in any other case. It is, in fact, just this very question we have actually been asking all along. The point has never been the trivial point of putting merely vexing hypothetical questions. That question is, rather, why would Americans who watched the grim events two summers ago in Tiananmen Square not want their First Amendment to apply? Who, really, now wants to rise up and condemn what the Court did in these cases? And who among the sponsors of the proposed amendment can say whether this is what the amendment would or would not do?

Concluding Thoughts on the Proposed Amendment: What Do We Value in the United States?

These last several observations bring us full circle. The object of the proposed 27th Amendment was avowedly to protect the flag as a symbol of national unity. Virtually all agree that this was its main point. But it must be obvious that neither this nor any other

amendment can advance that aspiration effectively, because unity is in the heart and in the mind of what people feel and clearly not in the model of a totalitarian law consecrating state symbols including our own. The fact is that in all the debates on the redrafted Federal statute and the proposed constitutional amendment, no one ever once gave a good reason why we should, as a people, desire to strip citizens of such right as they may otherwise have under the First Amendment, to try to reverse the Supreme Court in *Texas v. Johnson*. When we consider the protection Gregory Johnson received in the Supreme Court of the United States during the same summer we watched the "protection" of the students in Tiananmen Square in China, which example did we respond to? And how now do we want ourselves to be known?

In his first inaugural address as President of the United States, Thomas Jefferson—who had much to do with our First Amendment—spoke feelingly on the subject of patriotism, the subject that animates this proposed amendment. Jefferson spoke soberly on that occasion of those then seeking to dissolve the Union itself. "Let them stand undisturbed as monuments of the safety with which error of opinion may be tolerated when reason is left free to combat it," Jefferson declared. In most of the world, there are no real monuments of safety for dissent. Here at home, in *Texas v. Johnson*, however, our own Supreme Court reminded us that there is. The real monument of safety for dissent in the United States abides in the First Amendment in our Bill of Rights. We should take care to leave that amendment alone. In an odd way, moreover, we are unified in the freedom the First Amendment provides us. It is a freedom too little of this world is able to share.

Notes

1. *Texas v. Johnson*, 491 U.S. _____, 109 S.Ct. 2533 (1989). The breakdown of votes on the Supreme Court confounded many Court watchers when the decision came down. Justices Kennedy and Scalia, Reagan appointees who had been regarded disparagingly by a number of observers at the time of their ascension to the Court, were crucial in providing the majority of five votes (including Brennan, Marshall, and Blackmun). Justice Stevens, the more warmly regarded appointee by President Ford, on the other hand, joined the dissent (including White, Rehnquist, and O'Connor).

2. The President's proposal followed not long after his successful presidential campaign against Michael Dukakis in 1988. In the course of that campaign, Mr. Bush repeatedly faulted Mr. Dukakis for his failure, as Governor of Massachusetts, to have signed a mandatory pledge of allegiance act applicable to all public school teachers—an act the Massachusetts Supreme Court had formally advised Dukakis could not constitutionally be enforced. [*See* the opinion of the Justices, 372 Mass. 874 (1977).] Without doubt, in promptly proposing the amendment following the Court's decision in *Texas v. Johnson*, Mr. Bush had again taken the initiative on a highly charged issue where the Democrats appeared most vulnerable, i.e., the issue of patriotism and love of country.

3. *United States v. Eichman*, 58 U.S.L.Wk. 2538 (D.C. Dis. Ct. March 5, 1990); *United States v. Haggerty*, 58 U.S.L.Wk. 2498 (Dis. W. Wash. 1990).

4. *United States v. Eichman et al.*, No. 890–1438, June 11, 1990, 110 S.Ct. 2404 (affirming lower court, five to four). (The division within the Supreme Court was unchanged from the division in *Texas v. Johnson* itself.) The original act of Congress, 18 U.S.C. Section 700 (1968), provided that the offense was committed by "cast[ing] contempt upon any flag of the United States by publicly mutilating, defacing, defiling, burning, or trampling upon it." The new act, 18 U.S.C. Section 700 (Supp. 1990), made it nominally a matter of indifference whether one was or was not "casting contempt" on the flag, and whether one was or was not acting in public, i.e., it eliminated such language so that proof of purpose would no longer be of statutory consequence. Rather, the Federal crime was complete insofar as one "knowingly mutilates, defaces, physically defiles, burns, maintains on the floor or ground, or tramples upon any flag of the United States." In theory, therefore, the offense would be punishable wherever it occurred and without reference to the circumstances (if one "mutilated" a flag while alone in one's bedroom, or maintained a flag on the floor of one's locked attic, the statute would apply).

5. *Compare* the wording of the Eleventh Amendment which *is* in this form as an amendment. The Eleventh Amendment was proposed and ratified in reaction to a particular Supreme Court decision (*Chisholm v. Georgia*, 2 Dall. 419 (1793). The Eleventh Amendment is reflexive—i.e., it expressly refers to language found in the Constitution in Article III of the Constitution (namely, "the judicial power of the United States") and provides expressly how that language shall not be construed—that it "shall not be construed to extend to" a case brought against a state by a citizen of another state. In contrast, the proposed 27th Amendment is *unlike* the Eleventh Amendment; i.e., it does not purport to say how the First or Fourteenth Amendments shall be construed or interpreted to apply to such acts of Congress as may forbid acts of physical desecration of the flag of the United States.

The proposed amendment is also *unlike* the Sixteenth Amendment, an amendment likewise proposed in reaction to a particular decision by the Supreme Court [*Pollock v. Farmers' Loan & Trust Co.*, 157 U.S. 429 (1895)]. The Sixteenth Amendment expressly authorizes income taxes to be levied by Congress "without apportionment." It thus makes clear that to whatever extent such taxes might previously have been valid only if apportioned by population according to the Supreme Court's interpretation and application of the Constitution's express apportionment requirement found in Article I, Section 9, Clause 4, income taxes would not hereafter be subject to judicial review on grounds of failing to conform to the apportionment clause.

6. The decision in *Texas v. Johnson* is at 109 S.Ct. 2533 (1989). The State Court of Appeals decision, affirmed in the Supreme Court, is *Johnson v. State*, 755 S.W.2d 92 (Tex. Cr. App. 1988).

7. *Johnson v. State*, 755 S.W.2d 92, 97 (Tex. Cr. App. 1988). (Emphasis added.)

8. E.g., where the flag were government owned and the statute forbade defacing it either as government property or (in a suitable instance) as the property of another person, Johnson's demonstrative conduct would not be protected by the First Amendment from prosecution for the destruction of that property. (Interestingly in the actual case, the flag was a flag Johnson seized from government premises—but the prosecution wasn't brought for his act of arson or his act of theft but for his act of expressing contempt as such.)

9. Article I, Section 8, Clause 3.

10. Id. Clause 7.

11. E.g., an act of Congress may be fully constitutional as an affirmative exercise of Congress's express "power to regulate commerce among the several states," but, if the "commerce" is commerce in books (for instance) and if the regulation is one that seeks to restrict their free circulation, it may be invalid on pure First Amendment grounds. In turn, the power to establish post offices and post roads is separate from the power vested in Congress to regulate commerce among the several states; but every act providing for the treatment of the mail as such is also subject to full First Amendment review. [Indeed, the first decision of the Supreme Court to invalidate an express act of Congress on First Amendment grounds involved an act regulating the use of the mails, *Lamont v. Postmaster General*, 381 U.S. 301 (1965).] The express power granted to Congress to provide for post offices and post roads contains no provision excluding any exercise of that power from First Amendment review, of course; and again, neither does the proposed 27th Amendment contain any such exempting provision or clause.

12. E.g., an act making it a state or Federal offense for any person "physically to desecrate the flag of the United States. . . ."

13. E.g., an arrest and prosecution of one who tears in half his own flag to demonstrate, in a public way across the street from the White House, his view that the government is acting wrongly in assisting the suppression of land reform movements in El Salvador or somewhere else. See *also* the numerous actual kinds of cases presented *infra*, in this review.

14. *See*, e.g., *Halter v. Nebraska*, 205 U.S. 34 (1907).

15. *See*, e.g., *Spence v. Washington*, 418 U.S. 405 (1974).

16. *Cf. Street v. New York*, 394 U.S. 576 (1969). For other significant Supreme Court cases on flag use and First Amendment protected dissent, see, e.g., *Smith v. Goguen*, 415 U.S. 566 (1974); *Radich v. New York*, 401 U.S. 531. *aff'g*, 26 N.Y.2d 114 (1970), *on habeas corpus* in U.S. ex rel. *Radich v. Criminal Court*, 459 F.2d 754 (2d Cir. 1972), *cert. den.* 409 U.S. 115 (1973); *Bd. of Educ. v. Barnette*, 319 U.S. 624 (1943); *Stromberg v. California*, 283 U.S. 359 (1931).

17. By stipulation, flag uses *not* covered by this amendment would remain fully subject to First Amendment protection in circumstances where that protection would otherwise be deemed mandated by the Supreme Court, although flag uses covered by this amendment would be stripped of such First Amendment protection.

18. There was express testimony on behalf of the Department of Justice that the amendment *would* authorize legislation reaching this kind of act, so the matter is not some lawyer's contrived case. [*See* Hearings Before the Subcommittee on Civil and Constitutional Rights, House Judiciary Committee, 101 Cong. 1st Sess. 188–89 (Statement of Wm. Barr, Office of Legal Counsel), July 13, 18, 19, 20, 1989.]

19. The case [*Spence v. Washington*, 418 U.S. 405 (1974)] is briefly noted at note 15 *supra*. The Supreme Court applied the First Amendment and reversed a criminal conviction on very similar facts.

20. But surely some will regard this as an act of "physical" disfigurement—that the tape is temporary or removable will surely not be of any point. (In *Spence*, Justice Rehnquist noted to sustain the criminal conviction, though the tape was removable without damage to the fabric of the flag.)

21. [This case is modeled on an actual case it closely resembles, see *Radich v. New York*, 401 U.S. 531 (1971), *aff'g*, 26 N.Y. 2d 114 (1970), *on habeas corpus* in *U.S. ex rel. Radich v. Criminal Ct.*, 459 F.2d 754 (2d Cir. 1972), *cert. den.* 409 U.S. 115 (1973).]

22. The case is but a slight variation of *Street v. New York*, 394 U.S. 576 (1969) (reversing a state criminal court flag burning conviction on First Amendment grounds).

The Supreme Court and the First Amendment: 1989–1990

William A. Linsley

Toward Conservative Dominance

Court watchers pessimistically have described a range of fundamental issues such as free speech, civil rights, and abortion to be "one vote from devastation."

Based on the number of 5–4 rulings, 37 out of 129, the age of the ailing Justice Marshall (82) combined with the resignation of liberal Justice Brennan assures the solidification of conservative dominance over the Court. Although Brennan has led an occasional victory, the loss of his influence virtually ends any reversal of the steady movement toward conservative control over all Court decision-making.

Chief Justice Rehnquist, Brennan's conservative counterpart, opposed Brennan in 36 out of the 37 rulings which split the Court 5–4 and was on the prevailing side in 25 of these. In cases divided along ideological lines, the liberals prevailed only when Justice White voted with them on issues such as affirmative action and patronage. But White sided with the conservatives when ruling on the death penalty and most criminal law decisions and cannot be counted on for consistent free-speech support.

This past term, even when a 5–4 decision did not produce the predictable ideological lineup (Rehnquist, O'Connor, Scalia, Kennedy vs. Brennan, Marshall, Blackmun, Stevens), Justice White was unable to find a free speech violation in the Flag Protection Act which would have positioned him with a more liberal interpretation of the First Amendment.

In the flag case, Scalia and Kennedy were attracted to Brennan's majority opinion which overturned the Act by prohibiting the government from suppressing expression of an idea because society finds that idea offensive. Although Scalia found support for his position in this case, ten times when he dissented he often found no other justice subscribing to his views.

Two First Amendment cases, which did not experience the 5–4 split but found harmony in philosophical thought, occurred when the Court ruled (1) that states cannot prohibit grand jury witnesses from ever making public their own testimony and (2) that expressions of opinion are not shielded automatically from being libelous but are protected if they do not contain "approvably false factual connotation."

The "Veil of Secrecy" Slips a Bit

The United State Supreme Court consistently has recognized that the proper functioning of our grand jury system depends upon the secrecy of those proceedings which are undertaken to determine if a case should go to trial.[1] Citizens, therefore, meet in secret to determine if there is enough evidence to bring charges.

The administration of criminal justice historically has depended on a tradition of grand jury secrecy to ensure that an impartial hearing protects against abusive government, unfounded accusations, and undue influence.

The distinct interests served by safeguarding the confidentiality of grand jury proceedings repeatedly have been set forth by the Court:

First, if pre-indictment proceedings were made public, many prospective witnesses would be hesitant to come forth voluntarily, knowing that those against whom they testify would be aware of that testimony. Moreover, witnesses who appeared before the grand jury would be less likely to testify fully and frankly, as they would be open to retribution as well as to inducements. There also would be the risk that those about to be indicted would flee, or would try to influence individual grand jurors to vote against indictment. Finally, by preserving the secrecy of the proceedings, we assure that persons who are accused but found innocent by the grand jury will not be held up to ridicule.[2]

While these reasons have discouraged the courts from lifting the "veil of secrecy" from the grand jury, select portions of transcripts taken in secrecy nevertheless have been made available for use in subsequent judicial proceedings.[3] Indeed, the Federal Rules of Criminal Procedure now provide that disclosure of grand jury transcripts may be made "when so directed by a court preliminary to or in connection with a judicial proceeding."[4] Also, the Supreme Court in *Dennis v. United States* found inapplicable the reasons traditionally advanced to justify nondisclosure of grand jury testimony where defendants claimed it unlikely that the witnesses' testimony at trial was consistent with their prior grand jury testimony.[5]

Consequently, a standard for breaking grand jury secrecy has emerged from cases such as *Proctor & Gamble* and *Dennis* which requires parties seeking grand jury transcripts to show that the material sought is needed to avoid possible injustice in another judicial proceeding, that the need for disclosure is greater than the need for continued secrecy, and that the request covers only material pertinent to the need for disclosure. Clearly then, disclosure has been found appropriate where the need for it outweighs the public interest in secrecy. The state interest in grand jury secrecy, now less than absolute, has been forced to yield to other constitutional rights. Most recently, another justification for pre-empting testimonial secrecy occurred during the 1989–1990 Court term when a Florida law prohibiting a witness from ever disclosing testimony before a grand jury was held to violate the First Amendment right to reveal such testimony.[6]

Smith, a reporter, testified before a state grand jury about alleged improprieties committed by certain public officials. He was warned that any revelation of his testimony would subject him to criminal prosecution under Florida statutes. After the grand jury completed its inquiry, Smith wanted to write about the subject of the investigation and include his grand jury testimony. Consequently, he brought suit in Federal District Court to obtain an injunction prohibiting the state from prosecuting him for what he claimed was an unconstitutional abridgement of his speech rights.

The District Court, rejecting Smith's claims, recognized that Florida was entitled to assure the proper functioning of the grand jury even if it means "a severe infringement" on First Amendment rights. However, the United States Court of Appeals reversed the District Court by holding the Florida law unconstitutional to the extent that it restrained witnesses from speaking about their own testimony after the grand jury investigation is terminated.

Chief Justice Rehnquist delivered the opinion for a unanimous Court which sided with the appellate court and declared unconstitutional the prohibition of a grand jury witness

from disclosing his own testimony after the term of the grand jury has ended. Rehnquist took special note of the fact that the Court only was protecting communication of information which Smith possessed before he testified before the grand jury, not information obtained from participation in the grand jury proceedings. Such finding was deemed consistent with the notion that where a person lawfully obtains truthful information about a matter of public significance, the state may not punish the publication of the information "absent a need to further a state interest of the highest order."[7]

Rehnquist expressed concern that Florida was attempting to punish the publication of information relating to alleged governmental misconduct—"speech which has traditionally been recognized as lying at the core of the First Amendment." To justify this punishment, Florida relied on the traditional reasons for preserving grand jury secrecy which the court found either not served at all by the Florida ban on disclosure or, even if served, then insufficient to sustain the statute.

The Court reasoned that once the investigation ends, the subject of the grand jury probe is either exonerated or charged and thus there is no need to keep information from him; that fears of a witness about retribution are not affected by the disclosure ban since any witness need not divulge his own testimony and witnesses remain protected from having their testimony revealed by anyone else; that present-day criminal procedure generally results in the disclosure of state witnesses by name before trial anyway; that there are substantial penalties for perjury and witness tampering; and that although Florida has a substantial interest in protecting from public ridicule those who are exonerated, this interest alone is insufficient to justify restricting truthful speech.

Rehnquist concluded for the Court by observing the dramatic impact of a ban on disclosure of pre-existing truthful comments introduced by self-testimony. Smith, who before testifying, was free to speak out about matters of public concern, would lose this freedom when the same material was presented to a grand jury. Fear about the ban was founded in its potential for abuse as a device to silence those who know of wrongful conduct by public officials and, for reasons not overridden by a substantial state interest, still cannot freely express themselves.

Court Voids Flag Protection Law

In a decision involving the message content of venerated symbols such as a U.S. flag, the court courageously ventured into far more troubled waters than grand jury secrecy. By ruling the new Federal law against flag burning to be unconstitutional, the court majority introduced the possibility that, for the first time, the Bill of Rights might be amended to achieve what the Flag Protection Act of 1989 could not.

U.S. v. Eichman (1990)[8] was the consequence of two combined cases which upheld rulings of two Federal district courts which diminished the prosecutions of protestors who knowingly had burned American flags while protesting the government's domestic and foreign policy and while protesting the Act's passage. The Supreme Court, in a majority opinion written by Justice Brennan and joined in by Justices Marshall and Blackmun and the more conservative Scalia and Kennedy, held the Federal law unconstitutional under the principles the Court had announced in *Texas v. Johnson* (1989).[9]

While the Texas law was faulted for referring to the offensive message conveyed by flag desecration, the Federal law sponsors sought to avoid the Court's objections by prohibiting mutilation of the flag while omitting reference to the flag burner's message or

motive. The Flag Protection Act provided punishment for anyone who "knowingly muti-
lates, defaces, physically defiles, burns, maintains on the floor or ground, or tramples
upon any flag of the United States."[10]

The effort to distinguish the Federal law from the shortcomings of the unconstitutional
Texas statute failed when Brennan argued that "the Act still suffers from the same
fundamental flaw: it suppresses expression out of concern for its likely communicative
impact. Despite the Act's wider scope (to punish disrespectful treatment of the flag), its
restriction on expression cannot be justified without reference to the content of the regulated
speech." Symbolic meaning as evidenced by the communicative impact of flag desecration
rather than physical protection of the flag was found to define clearly the government's
interest despite any effort to mask the message-based objections to the Texas statute.

Although Brennan's opinion does not dwell on the political controversy certain to arise
from the deeply offensive nature of tolerance for flag desecration, he rejected consideration
of the national consensus underlying the Flag Protection Act. "Even assuming such a
consensus exists," Brennan said, "any suggestions that the Government's interest in
suppressing speech becomes more weighty as popular opposition to the speech grows is
foreign to the First Amendment."

Brennan, after noting that virulent epithets, vulgar repudiations, and scurrilous carica-
tures also may offend people, declared a bedrock principle underlies the First Amendment:
"The government may not prohibit the expression of an idea simply because society finds
the idea offensive or disagreeable."

The Flag Protection Act of 1989 became law without President Bush's signature. His
refusal to sign because he felt the law would be declared unconstitutional proved prophetic.

Justice Stevens' dissenting opinion, joined in by Justices Rehnquist, O'Connor, and
White, contended that the case comes down to "whether allowing every speaker to choose
the method of expressing his or her ideas that he or she deems most effective and
appropriate outweighs the societal interest in preserving the symbolic value of the flag."
This societal or governmental interest in preserving the flag's symbolic value, Stevens
declared, remains essentially the same regardless of which of many different ideas may
motivate flag burning.

Stevens stressed that expression may be prohibited if there are legitimate societal
interests unrelated to the suppression of the ideas the speaker desires to express, if the
prohibition does not interfere with the freedom to express the same ideas by other means,
and if the freedom to choose among alternative methods of expression is less important
than the societal interest supporting the prohibition.

The prevailing and outweighing interest cited by Stevens for allowing suppression of
action as opposed to free expression is the overriding importance of governmental interest
in protecting the symbolic value of a flag which inspires personal sacrifice to achieve those
"ideals that characterize our society."

A Provably False Factual Connotation Is Not "Fair Comment"

The common law long has afforded redress for damage to a person's reputation by the
publication of false and defamatory statements. Originally, such statements were action-
able whether they were deemed statements of fact or of opinion. Later, so that fear of a
defamation suit resulting from an expressed opinion would not stifle valued public debate,
the privilege of "fair comment" became an available defense to an action for defamation.

In *Philadelphia Newspaper v. Hepps* (1986), the Supreme Court even fashioned "a constitutional requirement that the plaintiff bear the burden of showing falsity, as well as fault, before recovering damages."[11]

The *Hepps* case result, which strengthened the freedom of expressing opinion, seemed to follow naturally from dictum recited in *Gertz v. Welch* (1974) which held that "under the First Amendment there is no such thing as a false idea."[12] Now Chief Justice Rehnquist in *Milkovich v. Lorain Journal* (1990) has taken another look at the ruling and concluded that the Court did not intend to create "a wholesale defamation exemption for anything that might be labeled 'opinion.'"[13] Rehnquist rejected the notion that in every defamation case the First Amendment requires that a statement be categorized as "opinion" or "fact" with only the latter being actionable. Instead, he held that newspaper columns and other forms of commentary may be libelous if they "imply an assertion of objective fact" that the plaintiff can prove is false. Rehnquist reserved protection only for that opinion which related "to matters of public concern" and "does not contain a provably false factual connotation." He concluded: "We think the breathing space which freedoms [sic] of expression require in order to survive is adequately secured by existing constitutional doctrine without the creation of an artificial dichotomy between 'opinion' and fact." Nevertheless, more opportunity for artificiality may have been created than discharged.

The identification of actionable "opinion" remains elusive. Rehnquist's use of examples to distinguish protected from unprotected "opinion" portends what could easily confuse any jury: "In my opinion Mayor Jones is a liar" would be actionable while "in my opinion Mayor Jones shows his abysmal ignorance by accepting the teachings of Marx and Lenin" would be protected expression. "Loose, figurative or hyperbolic language" supposedly, according to Rehnquist, would "negate the impression" that any serious factually based allegation was made.

Apparently, opinions expressed through outrageous statements would be safer than carefully constructed ones which appear predicated on objectively derived but nevertheless disputable facts.

The Court ruling, that the First Amendment no longer exempts expressions of opinion from being libelous, reinstated a libel suit brought 15 years ago by an Ohio high school wresting coach against a sportswriter who implied in a newspaper article that the coach had lied under oath during an investigation into a gymnasium incident.[14] At his trial, while the coach will have to prove the statements about him to be false, he will not be precluded from winning the suit because of a special protected category for "opinion" which previously had been widely recognized by most state and all Federal appellate courts.

The reality of this case is apparent. Where to draw the line between "pure" opinion and opinion that incorporates actionable assertions of fact will have to be determined on a case-by-case basis. Clearly, more libel suits are headed for trial rather than dismissal because the Court has restored the possibility of a false opinion and narrowed the availability of "fair comment" as a defense.

Justices Brennan and Marshall found themselves in essential agreement with the Court majority but dissented because they could not detect implied defamatory facts about the wresting coach in the sportswriter's opinion column.

Other Opinions Rendered

In opinions affecting matters other than secrecy, the flag, and fair comment, the Court heard arguments and reported findings about the use of dues to finance disapproved speech

activities, a licensing scheme to regulate sexually oriented businesses, the nondisclosure of faculty-tenure records to an investigating agency, the expressive component of a boycott, the advertising of lawyer competency, the possession of child pornography in the privacy of the home, political patronage as First Amendment infringement, and sidewalk solicitation by an advocacy group.

Keller v. State Bar of California[15]

The use of dues to finance political and ideological activities with which members of a state bar association disagree violated the members' free speech rights unless such expenditures help regulate the legal profession or improve legal services.

The State Bar of California uses member dues not only to formulate rules of professional conduct but to lobby the legislature and other government agencies, file briefs in pending cases, hold conferences for the debate of current issues, and engage in educational programs.

Members of the Bar brought suit to restrain the Bar from expending mandatory dues payments to advance political and ideological causes to which they do not subscribe in violation of their First Amendment rights to freedom of speech and association. The state court granted summary judgment to the Bar on the grounds that it is a governmental agency and therefore permitted under the First Amendment to engage in the disputed activities. The Court of Appeals reversed, finding the Bar's regulatory activities to be similar to those of a government agency but its "administration of justice" functions to resemble more closely the activities of a labor union. Using *Abood v. Detroit Board of Education*[16]— which prohibited dues of dissenting nonunion employees from being used to support political and ideological union causes—the Court held "that the Bar's activities could be financed from mandatory dues only if a particular action served a state interest important enough to overcome the interference with dissenter's First Amendment rights." The state supreme court reversed by claiming that subjecting the Bar's activities to First Amendment scrutiny would place an "extraordinary burden" on their statutory mission as a government agency.

Chief Justice Rehnquist reversed the state supreme court and delivered the opinion for a unanimous Court which held:

1. The Bar's use of compulsory dues to finance political and ideological activities with which members disagree violates free speech rights when such expenditures are not for the purpose of regulating the legal profession or improving the quality of legal service.

2. There is a substantially valid comparison between the Bar's relationship to its members and that of a union to its members. Just as union members benefit and pay their fair share for union negotiations with their employer, Bar members also pay their fair share for those costs incurred for regulating their profession. However, *Abood* prohibited a union from expending a dissenting member's dues for ideological activities not "germane" to the collective bargaining purpose of the association. Therefore, similarly, the Bar may not fund activities of an ideological nature which fall outside that which is "germane" to its goals of regulating the profession and improving the quality of legal services.

3. Where the line is drawn between permissible and impermissible dues-financed activities is not always clear. But "the extreme ends of the spectrum are clear: Compulsory dues may not be used to endorse or advance a gun control or nuclear freeze initiative but

may be spent on activities connected with disciplining Bar members or proposing the profession's ethical codes."

 For: Unanimous

FW/PBS, Inc. v. City of Dallas[17]
A constitutionally valid licensing scheme for sexually oriented businesses must provide for a prompt decision and judicial review.

The city of Dallas adopted an ordinance regulating sexually oriented businesses through a scheme incorporating zoning, licensing, and inspections. After individuals involved in the adult entertainment industry challenged the ordinances, the district court upheld the bulk of them, and the Court of Appeals affirmed, holding that the regulatory scheme did not violate the First Amendment despite procedural safeguards set forth in *Freedman v. Maryland*.[18]

In a complex result, the Supreme Court reversed in part, affirmed in part, and vacated in part the lower court findings and remanded the case for further proceedings consistent with this opinion. The First Amendment issues were primarily dealt with in an opinion written by Justice O'Connor and joined in by Justices Stevens and Kennedy which held the ordinance's licensing scheme to constitute prior restraint upon protected expression because it failed to set a time limit within which the licensing authority must act and because it failed to provide prompt judicial review so as to minimize suppression of speech in the event of a license denial.

The Court likened the Dallas licensing scheme to the procedural safeguards for censorship necessary to ensure expeditious decision-making by a motion picture censorship board as described in *Freedman*. Although the license for a First Amendment protected business must be issued in a reasonable amount of time and the safeguards to assure this be built into the ordinance as required by *Freedman*, one requirement of *Freedman* need not be met. Unlike the *Freedman* censor, Dallas does not engage in presumptively expressive material but simply performs the ministerial function of reviewing the general qualifications of each license applicant. Therefore, Dallas, unlike the motion picture censors in *Freedman*, need not on each occasion go to court to justify a decision to suppress speech.

 For: O'Connor, Kennedy, Scalia, Brennan, Marshall, White, Stevens, Rehnquist,
 Scalia (each dissented in part)

University of Pennsylvania v. EEOC[19]
The First Amendment provides no special privilege to refuse disclosure of faculty peer review materials to facilitate an EEOC investigation into a tenure decision.

When the University of Pennsylvania denied tenure to Associate Professor Rosalie Tung, she filed a charge with the Equal Employment Opportunity Commission (EEOC) alleging race, sex, and national origin discrimination in violation of Title VII of the Civil Rights Act of 1964. The EEOC subpoenaed Tung's tenure-review file and the files of five male faculty members who allegedly received more favorable treatment than Tung.

The university declined to produce certain tenure-file documents and asked the EEOC to exclude from its subpoena "confidential peer-review information." The EEOC refused

and successfully sought enforcement of the subpoena by the District Court. The Court of Appeals supported the validity of the subpoena and rejected the University's claim that the First Amendment principles of academic freedom "required the recognition of a qualified privilege [to withhold] or the adoption of a balancing that would require the EEOC to demonstrate some particularized need, beyond a showing of relevance, to obtain peer review materials."

The Supreme Court unanimously affirmed the lower court. Justice Blackmun's opinion held:

1. Congress, by extending Title VII's coverage to educational institutions in 1972 and in granting the EEOC access to any evidence relevant to a charge under investigation, balanced institutional discrimination against academic autonomy and did not create a privilege for peer-review documents.

The Court is not persuaded that it should go further than Congress thought necessary to safeguard confidentiality. In fact, the compromise of any presumed confidentiality may be necessary for the EEOC to determine whether illegal discrimination has occurred.

The requirement that the EEOC demonstrate, beyond a showing of relevance, a special reason for disclosure "would place a substantial litigation-producing obstacle in the EEOC's way and give universities a weapon to frustrate investigations."

2. Reliance by the University on academic freedom cases is misplaced since those cases dealt with content-based control of speech that constituted a direct infringement on the right to determine on academic grounds who could teach. The University does not allege any content-based regulation but only that the "quality of instruction and scholarship [will] decline" because of the burden EEOC subpoenas place on the peer-review process. Besides, "the subpoena at issue does not provide criteria that petitioner [the University] must use in selecting teachers or prevent it from using any such criteria other than that prescribed by Title VII, and therefore it respects legitimate academic decision-making." Thus, the First Amendment does not, based on the academic freedom cases, support expansion of academic freedom rights to protect confidential peer-review materials from exposure.

The claimed injury to academic freedom is speculative anyway since confidentiality is not the norm in all peer-review systems and since some disclosure would take place even if the "special category" test were adopted.

Further, this Court will not assume that most evaluators will become less candid if the possibility of disclosure increases.

Blackmun concluded that the EEOC subpoena process does not infringe any First Amendment right enjoyed by the University. Thus, the EEOC need not demonstrate any special justification of Title VII as applied to tenure peer-review materials or to the subpoena used to obtain these materials.

For: Unanimous

FTC v. Superior Court Trial Lawyers Association[20]
First Amendment protection for the expressive component in a horizontal boycott does not bar action for trade restraint.

District of Columbia lawyers who served as court-appointed counsel for indigent defendants agreed at a meeting of the Superior Court Trial Lawyers Association (SCTLA)

to cease representation until they received increased compensation. The Federal Trade Commission (FTC) filed a complaint against SCTLA for conspiracy to fix prices and commit unfair methods of competition. Although an administrative law judge concluded that the complaint should be dismissed, the FTC ruled the boycott illegal per se and prohibited future such boycotts. The Court of Appeals vacated the FTC order, noting that, although the boycott was a "classic trade restraint," it was meant to convey a political message to the public, and this element of expression warranted First Amendment protection.

The SCTLA successfully argued before the appellate court that if its conduct was prohibited by Federal antitrust law, it is protected, nevertheless, by First Amendment rights recognized in *NAACP v. Claiborne Hardware*.[21] This case resulted when white merchants sued to recover losses from a Black boycott of their services. The Supreme Court, citing protection of First Amendment activity, found that the "right of the States to regulate economic activity could not justify a complete prohibition against a nonviolent, politically motivated boycott designed to force governmental and economic change and to effectuate rights guaranteed by the Constitution itself.

The SCTLA contended that like the boycotters in *Claiborne Hardware* sought to exercise similar First Amendment rights, so too should SCTLA attorneys enjoy similar protection.

Justice Stevens wrote the majority opinion for a divided Court which considered, among other issues, whether the *Claiborne* case offered precedent for an exception to what appeared to be a boycott that was illegal per se.

Stevens disagreed with SCTLA by holding that *Claiborne* was not applicable to a boycott conducted by business competitors who "stand to profit financially from a lessening of competition in the boycotted market." The clear objective of the lawyers was to gain an economic advantage for those who agreed to participate while those who joined the *Claiborne* boycott sought no special advantage for themselves. The Black citizens who boycotted in *Claiborne* sought only "the equal respect and treatment to which they were constitutionally entitled."

Stevens acknowledged that SCTLA's effort to publicize its boycott, to explain the merits of its cause, and to lobby public officials to enact favorable legislation, like similar activities in *Claiborne*, were fully protected by the First Amendment. But nothing in the FTC order to cease the boycott either curtailed or prohibited any of these activities.

There was nothing unique about the expressive component of SCTLA's boycott, said Stevens. "A rule that requires courts to apply the antitrust laws 'prudently and with sensitivity' whenever an economic boycott has an expressive component would create a gaping hole in the fabric of those laws."

Stevens reversed the lower court because the SCTLA boycott had "no special characteristics meriting an exemption from the per se rules of antitrust law."

Justice Brennan's dissent objected to subjecting expressive political boycotts to presumptive illegality without inquiry into whether they actually cause any of the harms antitrust laws are designed to prevent. Brennan found the majority decision to be insensitive to the tradition of expressive boycotts which serve as an important means of political communication.

For: Stevens, Rehnquist, White, O'Connor, Scalia, Kennedy; Brennan, Marshall and
 Blackmun (in part)
Against: Blackmun, Brennan, Marshall (in part)

Peel v. Attorney Registration and Disciplinary Commission of Illinois[22]
The First Amendment does not permit a state to prohibit categorically a lawyer from advertising that he is certified as a "specialist" by a private organization.

The Illinois Supreme Court censured Peel, an attorney licensed to practice in Illinois, because his letterhead states that, in addition to being licensed in Illinois, he is certified as a civil trial specialist by the National Board of Trial Advocacy (NBTA).

Illinois' Code of Professional Responsibility specifies that "no lawyer may hold himself out as 'certified' or a 'specialist.'"

The Illinois Supreme Court concluded that the First Amendment did not protect the letterhead because the public could confuse the NBTA, an unofficial private source of certification, with a state authorized source for the right to practice law and because this kind of certification could be read as a claim of superior quality.

The U.S. Supreme Court granted certiorari to consider whether the statement on the letterhead is protected by the First Amendment. The Court agreed that the issue is whether a lawyer has a constitutional right, under the standards applicable to commercial speech, to advertise certification as a trial specialist by NBTA.

Justice Stevens reversed the Illinois court in an opinion written on behalf of the majority of a divided court. Stevens held that truthful advertising of lawful activity is protected; and while a state may prohibit misleading advertising, it may not absolutely prohibit potentially misleading information if the information also may be presented in a non-deceptive way.

Peel's letterhead was found to be truthful and verifiable with no finding of actual deception or misunderstanding. No empirical basis was presented for the belief that Peel's NBTA representation would be associated wrongly with government action; and public confusion of private certification as a specialist with formal state licensing is unlikely, according to Stevens.

Stevens offered a remedy rather than a prohibition: screen certifying organizations or require a disclaimer about the certifying organization or set forth the standards of a specialty. What a state may not do, he concluded, is "completely ban statements that are not actually or inherently misleading, such as certification as a specialist by bona fide organizations such as NBTA."

Justice Marshall joined by Justice Brennan, although agreeing that Peel has a right to advertise as a certified NBTA trial specialist, nevertheless found the letterhead potentially to be misleading and therefore subject to state regulation, other than total ban, to ensure the public is not misled by the representations. Marshall supported a requirement that the letterhead include a disclaimer that NBTA is not state sanctioned or include NBTA's requirements for certification so consumers would have more complete knowledge of NBTA certification.

Justice White's dissent affirmed the lower court judgment because the state, while being denied enforcement of its flat ban on any and all forms of certification, nevertheless should be able to prohibit circulation of the letterhead in its present form. White would require Peel "to clean up his advertisement" to eliminate the potential to mislead.

For: Stevens, Brennan, Blackmun, Kennedy, Marshall
Against: White, O'Connor, Rehnquist, Scalia

Osborne v. Ohio[23]
 *The First Amendment does not prevent a state from prohibiting possession of child
 pornography in the privacy of the home.*

 Ohio police found photographs of nude males in Osborne's home. Appellate courts
upheld Osborne's conviction for violating a state statute which prohibits possession of
material showing a minor, not one's child, in a state of nudity. Osborne's contention that
the First Amendment prohibits banning the private possession of child pornography was
rejected.
 The majority opinion of the U.S. Supreme Court written by Justice White endorsed the
constitutionality of Ohio's prohibition of possession and viewing of child pornography.
Stanley v. Georgia,[24] which out of paternalism struck down a law outlawing the private
possession of obscene material, was distinguished from this Ohio law which sought to
protect the physical and psychological well-being of minors and destroy the market for
their exploitation. Further, Ohio's ban encouraged destruction of the permanent record of
the victim's abuse and deprived pedophiles of materials with which to seduce other
children.
 White found that, by limiting the statute's application to nudity that constitutes lewd
exhibition or focuses on the genitals, the statute did not prohibit constitutionally protected
depictions of nudity and thus was not unconstitutionally overbroad, at least as construed,
if not on its face.
 White dismissed Osborne's view that an overbroad statute is void as written and a court
may not narrow it, affirm a conviction based on the narrowed construction, and leave the
statute in full force. This thinking, requiring that a statute be facially invalidated whenever
overbreadth is perceived, would require, according to White, radical reworking of Ameri-
can law.
 Nevertheless, Osborne's conviction was reversed and the case was sent back to Ohio
for a new trial which might demonstrate better that the conviction was based on a finding
that each element of the offense had been proved.
 Justices Brennan, Marshall, and Stevens' dissent contended that the state law, even as
construed, was fatally overbroad, and the possession of the photographs in the privacy of
the home was protected as enunciated in *Stanley v. Georgia.*

 For: White, Rehnquist, Blackmun, O'Connor, Scalia, Kennedy
 Against: Brennan, Marshall, Stevens

Rutan v. Republican Party of Illinois[25]
 *Promotion, transfer, recall, and hiring decisions based on political party affiliation
 and support infringe on a public employee's First Amendment rights.*

 The Governor of Illinois ordered state officials not to hire any employee, fill any
vacancy, create any new position or take any similar action without his express permission.
 An applicant for employment, employees who had been denied promotions or transfers,
and former employees who had not been recalled after layoffs brought suit alleging that
the Governor was operating a political patronage system, that they were discriminated
against because they had not been Republican Party supporters, and that this discrimination
violates their First Amendment rights.

The District Court dismissed the complaint and the Court of Appeals affirmed in part and reversed in part this decision. The appellate court took note that *Elrod v. Burns*[26] and *Branti v. Finkel*[27] found that discharging public employees because of their political affiliation violates the First Amendment but other patronage practices would only be violative similarly if they are the "substantial equivalent of a dismissal." The appellate court dismissed the hiring claim because rejection of an employment application did not impose a hardship comparable to loss of a job. The other claims were remanded for further proceedings.

Justice Brennan, writing for the majority, extended *Elrod* and *Branti* to cover promotion, transfer, recall, and hiring decisions which, when based on party affiliation, were found to infringe on employee's First Amendment rights. These decisions, when tied to patronage considerations, were found to impair the elective process by discouraging free political expression by public employees and by serving no vital government interest.

Brennan rejected restricting *Elrod* and *Branti* to the discharge of public employees. This fails to recognize that deprivations less harsh than dismissal can nevertheless cause public employees "to conform their beliefs and associations to some state-selected orthodoxy." Patronage hiring, Brennan concluded, places a burden on free speech similar to those imposed by patronage promotion, transfer, and recall. He found it unnecessary for the Court to consider whether not being hired is less burdensome than being discharged "because the government is not pressed to do either on the basis of political affiliation."

For: Brennan, White, Marshall, Blackmun, Stevens
Against: Scalia, Rehnquist, Kennedy, O'Connor (in part)

United States v. Kokinda[28]
To prohibit solicitation for advocacy purposes on a sidewalk that lies on postal service property does not violate the First Amendment.

A political advocacy group set up a table on a sidewalk near the entrance to a United States Post Office to solicit contributions, sell books and subscriptions to the organization's newspaper, and distribute literature about various political issues. For postal customers, the sidewalk, which was entirely on Postal Service property, was the only means to travel from the parking lot to the Post Office. Kokinda and other group members were arrested and convicted eventually for violating a law which prohibits solicitation on postal premises. The District Court upheld the convictions by finding the ban on solicitation to be reasonable and the sidewalk not to be a public forum. The Court of Appeals reversed by holding the sidewalk to be a protected public forum for which the government showed no significant interest in being able to ban solicitation. Besides, the regulation was not tailored narrowly in a way that would accomplish the asserted government interest.

Justice O'Connor, writing for a divided Court, reversed the appellate court and found the regulation not to violate the First Amendment. She recognized solicitation as a protected form of speech but supported permissible government regulation of the solicitation based on the nature of the forum utilized. Since this forum, she claimed, is a sidewalk for passage of postal patrons and not a traditional public forum and since the government has not expressly dedicated its property to expressive activity, the regulation need only be tested for reasonableness in its application to the forum in question.

O'Connor held the prohibition of this solicitation to be reasonable because it sought to control significant interference with Congress' mandate to ensure the most effective and efficient distribution of the mails. It was not unreasonable for the Postal Service to prohibit that which inherently disrupts its business by impeding the normal flow of traffic. There was no evidence of discrimination against the solicitors based on content or viewpoint, said O'Connor, but merely a Postal Service concern about losing customers because of the potentially unpleasant situation created. Assuring the flow of pedestrian customer traffic revealed no effort to discourage one viewpoint or advance another.

Justice Kennedy, in a concurring opinion, agreed that the regulation does not violate the First Amendment but stressed that it is unnecessary to determine whether the sidewalk in question is a non-public forum since the regulation satisfies the traditional time, place, and manner restrictions permitted without First Amendment infringement. Kennedy found a reasonable government interest in protecting the integrity of the purposes to which the postal property had been dedicated.

Justice Brennan's dissent took exception with Kennedy's reasoning since he contended that the sidewalk in question is a public forum and the Postal Service regulation does not qualify as a content-neutral time, place, and manner restriction. Brennan found that the postal regulation drew an unreasonable distinction between solicitation and virtually all other kinds of speech. He concluded: "It is only common sense that a public sidewalk adjacent to a public building to which citizens are freely admitted is a natural location for speech to occur, whether that speech is critical of government generally, aimed at the particular government agency housed in the building, or focused upon issues unrelated to the government. No doctrinal pigeonholing, complex formula, or multipart test can obscure this evident conclusion."

For: O'Connor, Rehnquist, White, Scalia, Kennedy
Against: Brennan, Marshall, Stevens, Blackmun (in part)

Cases Disposed Without Hearings

In most of the following cases, the action taken by the Supreme Court allowed the holding of the lower court to prevail.

Media

Lower court: A private-figure-plaintiff met the proper burden of proof to allow punitive damages by presenting evidence that a newspaper published a story with actual malice. *Issues*: When the defendant has not published a false statement of fact, does the First Amendment protect against damages for defamation involving a matter of public concern? Are punitive damages based on a jury finding of actual malice prohibited when the defendant neither intends nor is aware that its publication "is susceptible of false and defamatory implications"? Review denied.[29]

Issue: Does a state criminal statute violate the First Amendment when it imposes strict civil liability on a newspaper which publishes truthful information lawfully obtained from state records made public by a state official? Dismissed.[30]

Lower court: Statements about an anti-pornography activist were protected opinions of public concern and thus not lacking the serious value required to make them obscene. *Hustler* magazine's derogatory comments about a feminist author appeared in a magazine known for its pornographic content and thus did not produce defamatory harm. *Issues*: Is

every publication, no matter how vile, protected by the First Amendment when it is labeled "opinion"? What are the tests of constitutionally protected opinion? Should proof of actual malice be required of a public figure plaintiff who claims to have been defamed about private matters where no constitutionally protected purpose is involved in the publication? Review denied.[31]

Lower court: Since a wiretap did not involve public interest in the scrutiny of governmental functions and since the wiretap contents were not made publicly available with intent to do so, the Court declined to imply a media exception to a non-disclosure statute which barred release of a wiretap transcript. *Issue*: Does a state law allowing civil action for publishing truthful information obtained from public court files violate the First Amendment? Judgment vacated.[32]

Lower court: A rape victim's identity and details of her rape were newsworthy and such disclosure in a television report concerning possible innocence of the rape suspect did not constitute public disclosure of embarrassing private facts under Texas law. *Issue*: Does negligent disclosure of a rape victim's identity and details of her rape per se constitute non-newsworthy information which becomes protected by the First Amendment when the facts "bear [a] reasonably intriguing relationship to [a] matter of legitimate public concern"? Review denied.[33]

Lower court: Statements considered in the context of debate on a public issue and made in a newspaper editorial that a certain person is a "quack, hoke artist, fearmonger," etc. are hyperbole and privileged opinion. *Issue*: Does the First Amendment provide an absolute constitutional privilege for expression of opinion? Review denied.[34]

Lower court: A magazine publisher is not obligated under a state negligence law to decline publication of an ambiguous advertisement that might, in the context presented, be construed as an offer to commit crimes. *Issue*: Does the decision of an appellate court that a publisher was not grossly negligent in disseminating commercial speech related to illegal activity conflict with prior commercial speech decisions? Review denied.[35]

City/County/State

Lower court: An ordinance requirement that must be met in order for an adult bookstore to continue to operate properly regulated time, place, and manner. Ordinance amendments which meant to combat urban blight and safeguard minors were found unrelated to suppression of particular speech. The ordinance legitimately used police power to limit use of private property for public welfare, protect minors from exposure to sexually explicit materials, and prevent adverse effects on surrounding areas, all unrelated to suppressing free expression with only incidental restrictions on First Amendment freedoms. *Issue*: Is this zoning ordinance on adult bookstores prohibited prior restraint because it grants discretion to those who might object to the contents of materials sold in the bookstores? Judgment vacated.[36]

Lower court: A city ordinance requiring towing services to post certain signs around a business place is valid and constitutes a reasonable exercise of a city's authority to regulate businesses. *Issue*: Does a city ordinance requiring a posting of a sign stating towing fee and storage rate and regulating the sign's location, size, and color constitute an infringement on protected commercial speech? Review denied.[37]

Issue: Is the First Amendment violated by a department rule which requires a deputy sheriff to consult the sheriff's office before complaining to the FBI about treatment of her son during his arrest? The lower court had found that any intrusion upon the employee's

right of expression was slight compared to the sheriff's interest in the efficiency of his employees and department. Review denied.[38]

Lower court: Disciplinary action against a fireman for communicating to the press about the cause of another fireman's injury violated First Amendment free speech rights. *Issue*: Is government prohibited from disciplining an employee for breaching an agreement to limit public statements even when issues are not of public concern? Review denied.[39]

Issue: Is a city ordinance which bans uninvited door-to-door solicitation by merchandise peddlers properly invalidated by the lower court because it is not the least restrictive means of achieving privacy protection for the home? Judgment vacated.[40]

Lower court: A city work rule which punishes employees for making "an unwarranted or imprudent statement . . . of a sexual, racial, ethnic, or religious nature" properly prohibits well-known pejoratives unacceptable in the workplace and is not impermissibly overbroad or void for vagueness. *Issue*: Is a work rule that prohibits unwanted or imprudent statements facially unconstitutional and an overbroad restriction on speech? Review denied.[41]

Lower court: A regulation barring signs within 500 feet of an interstate highway interchange advances a substantial governmental interest in highway safety and does not infringe on a sign owner's free speech rights. *Issue*: Does the lower court err in concluding that the regulation was not violative of the First Amendment since it was content-neutral and treated commercial and non-commercial on-premise signs equally? Review denied.[42]

Lower court: A statute authorizing public employee payroll deductions for membership dues to a state employees' association but not to a state teachers' union does not violate the First Amendment *Issue*: Is the First Amendment violated by a legislative act which deprives specific organizations of valuable economic benefits because they take positions on controversial public issues? Review denied.[43]

Lower court: A state employee's alleged denial of promotion was not involved with abridgement of speech rights. *Issues*: Does denial of promotion to a public employee due to political beliefs or political affiliation or does making a promotion dependent upon political support or financial contribution violate the First Amendment? Pending.[44]

Telecommunications

Lower court: A state statute that requires licensing of telephone solicitors who arrange visits for the sale of pre-arranged funeral services does not constitute a content-based restriction on a First Amendment right to engage in commercial speech. *Issue*: May a statute consistent with the First Amendment impose restrictions on only one type of commercial telephone solicitation without justifying discrimination against the speech selected for regulation or without showing that the banned speech is harmful? Review denied.[45]

Lower court: Free speech rights are not violated by a court order which requires a telephone company in its monthly billing envelopes to place a notice of a pending class action suit against it. *Issue*: Can a class action defendant, against its will and contrary to First Amendment rights, be forced to distribute in its billing envelope a notice that it is being sued? Can a court, to reduce First Amendment protection, characterize a transaction as commercial speech when the notice proposes no commercial transaction? Review denied.[46]

Armed Forces

Lower court: An Army regulation that prevents admitted homosexuals from re-enlisting does not violate free speech rights. *Issue*: Is speech freedom chilled by the mandated

denial of re-enlistment of those who admit to a homosexual orientation but have never been found to have committed a homosexual act? Review denied.[47]

Issue: Does the First Amendment protect a Navy officer from dismissal from active duty for stating his gay orientation and nonsexual association with gay men? Review denied.[48]

Schools

Lower court: The area in which defendant distributed anti-abortion literature, a sidewalk inside a school campus near where students disembarked from buses, was not a public forum. Speech at this location could be regulated provided that expression was not suppressed because of opposition to the speaker's views. *Issue*: Is there a First Amendment right to speak and distribute literature to public high school students under the circumstances of this case? Review denied.[49]

Lower court: The First Amendment protects an assistant principal for criticism of his superior over a matter of public concern and for advocating student's and parent's rights. *Issues*: Is conduct which includes calling an immediate supervisor "incompetent," both in public and in private, protected expression? Must a public school employer permit conduct of a subordinate whose job philosophy differs from that of the employer's? Review denied.[50]

Lower court: The First Amendment was not violated by school officials who exercised control over the style and content of a student speech which was reasonably related to legitimate pedagogical concerns. *Issue*: Does the First Amendment protect a high school student's personal campaign speech which, although critical of the school administration, does not interfere with operation of the school? Review denied.[51]

Obscenity

Lower court: A state obscenity statute was found not to be unconstitutional because it required that any obscenity definition consider the context in which the matter was used to determine the absence of serious artistic, literary, political, or scientific value. *Issue*: Does the statutory requirement to consider the context of use violate the First Amendment, especially if the statute applies only to matter used for profit-making purposes? Review denied.[52]

Lower court: Punishment for an obscenity violation which requires forfeiture of a license to run a video center is an invalid restraint on protected expression. *Issue*: Is license forfeiture, as required by state law for any felony conviction, prohibited by the First Amendment when applied to an obscenity felony violation? Review denied.[53]

Miscellaneous

Lower court: A physician's claim that his medical staff privileges were suspended for engaging in protected speech was disallowed. *Issue*: Did the court of appeals commit error by reversing the trial court's findings that hospital privileges were denied in retaliation for speech which criticized hospital officials? Review denied.[54]

Lower court: Mandatory bar membership does not violate First Amendment rights. *Issue*: Does Wisconsin's mandatory bar membership violate a lawyer's First Amendment rights of association and speech where the Bar no longer supports those educational, ethical, and regulatory interests which once justified the mandatory requirement? Review denied.[55]

Lower court: The Beef Promotion and Production Act, which requires all cattle farmers to finance beef industry advertising, does not violate the farmers' free speech rights. *Issue*:

Does the obligation to pay for advertising and promotion, based on the power of Congress to stimulate interstate commerce, violate the First Amendment rights of cattle producers who have the freedom not to associate, not to speak, and the freedom of thought and belief? Review denied.[56]

Lower court: A state law that regulates funeral contracts does not violate the First Amendment by banning uninvited door-to-door and telephone solicitation. *Issues*: In regard to protected speech, should telephone marketing be treated in the same manner as face-to-face solicitation? Does the state interest in protecting privacy in the home as balanced against commercial free speech rights permit the state to prohibit door-to-door or telephone solicitation of funeral services? Review denied.[57]

Lower court: A Louisiana statute that prohibits unlicensed accountants from issuing financial analyses does not regulate speech so much as it does the manner in which an accountant expresses the practice of his profession. *Issue*: Does a law which prohibits a non-certified accountant from expressing an opinion about financial matters violate the First Amendment by impairing freedom of speech? Review denied.[58]

Lower court: A district court should refrain from interfering with state judicial disciplinary proceedings against a judge who brought civil rights action to protect his right to political speech. *Issue*: Does a district court err by refusing to protect the constitutional rights of free political speech by an appellate court justice? Review denied.[59]

Lower court: Oregon wage and hour regulations which prohibit employment of minors under certain age and time circumstances represent a substantial government interest in the working conditions for minors. These regulations do not infringe on the First Amendment rights of minors since they reach no further than necessary to accomplish a legitimate government interest. By exempting newspaper carriers and vendors from these regulations, there is a rational recognition that, while door-to-door sales by minors is sufficiently dangerous to warrant regulation, the activities of newspaper carriers and vendors are not so endangered. *Issue*: Does regulating a minor's employment as a door-to-door salesperson unduly restrict a minor's right of free commercial speech? Review denied.[60]

Lower court: Although the First Amendment protects Ku Klux Klan members' rights to express themselves, it does not permit a conspiracy designed to interfere with the rights of others to demonstrate in honor of Martin Luther King. *Issue*: Can racist speech incite imminent lawless action without espousing violent, illegal action and despite one-half hour elapsing between the speech and the time others threw rocks, bottles, and debris? Review denied.[61]

Notes

1. *United States v. Proctor & Gamble*, 356 U.S. 677 (1958).
2. *Id.* at 681–682.
3. *United States v. Socony-Vacuum*, 310 U.S. 150, 233–234 (1940).
4. 6(e)(2)(C)(i).
5. 384 U.S. 855, 872 (1966).
6. *Butterworth v. Smith*, 58 *LW* 4363. Official "U.S." case citations for the 1989–1990 Supreme Court term are not used because they are assigned subsequent to the preparation of this review.
7. *Smith v. Daily Mail Publishing Company*, 443 U.S. 97, 103 (1979).
8. 58 *LW* 4744.
9. 57 *LW* 4770.
10. 18 U.S.C.A., sec. 700.
11. 475 U.S. 767, 776.

12. "Under the First Amendment there is no such thing as a false idea. However pernicious an opinion may seem, we depend for its correction not on the conscience of judges and juries but on the competition of other ideas. But there is no constitutional value in false statements of fact." 418 U.S. 323, 339–340.

13. *58 LW* 4846, 4850.

14. "A lesson was learned (or relearned) yesterday by the student body of Maple Heights High School, and by anyone who attended the Maple-Mentor wrestling meet of last Feb. 8. . . . A lesson which sadly, in view of the events of the past year, is well they learned early . . . It is simply this: "If you get in a jam, lie your way out. . . . Anyone who attended the meet . . . knows in his heart that Milkovich . . . lied at the hearing after . . . his solemn oath to tell the truth." *Id.* at 4846–4847.

15. *58 LW* 4661.

16. 431 U.S. 209 (1977).

17. *58 LW* 4079.

18. 380 U.S. 51 (1965).

19. *58 LW* 4079.

20. *58 LW* 4145.

21. 458 U.S. 886 (1982).

22. *58 LW* 4689.

23. *58 LW* 4467.

24. 394 U.S. 557 (1969).

25. *58 LW* 4872.

26. 427 U.S. 347 (1976).

27. 445 U.S. 507 (1980).

28. *58 LW* 5013.

29. *New England Newspapers v. Healey. 58 LW* 3005, 555 A2d 321.

30. *Cape Publications, Inc. v. Hitchner. 58 LW* 3059.

31. *Dworkin v. Hustler Magazine, Inc. 58 LW* 3005.

32. *Eaton Publishing Co. v. Boettger. 58 LW* 3226, 555 A2d 1234.

33. *Ross v. Midwest Communications, Inc. 58 LW* 3275, 870 F2d 271.

34. *Yiamouyiannis v. Thompson. 58 LW* 3376, 764 SW2d 338.

35. *Eimann v. Soldier of Fortune Magazine. 58 LW* 3415, 880 F2d 830.

36. *Baltimore v. Prince George's County, Maryland. 58 LW* 3616, 886 F2d 1414.

37. *Porter v. City of Atlanta. 58 LW* 3493.

38. *Huber v. Leis. 58 LW* 3355.

39. *Kilgore, Texas v. Moore. 58 LW* 3355.

40. *Idaho Falls, Idaho v. Project. 58 LW* 3356, 857 F2d 592.

41. *Medvik v. Ollendorf. 58 LW* 3452, 772 SW2d 696.

42. *Barrett v. Burns. 58 LW* 3361.

43. *South Carolina Education Association v. Campbell. 58 LW* 3487, 883 F2d 1251.

44. *Rice v. Ohio Department of Transportation. 58 LW* 3403.

45. *Guardian Plans, Inc. v. Teague. 58 LW* 3142, 870 F2d 123.

46. *Mountain States Telephone and Telegraph Co. v. District Court, City and County of Denver. 58 LW* 3328.

47. *Ben-Shalom v. Marsh. 58 LW* 3451, 881 F2d 454.

48. *Woodward v. U.S. 58 LW* 3259, 871 F2d 1068.

49. *Harris v. Texas. 58 LW* 3116, 762 SW2d 440.

50. *Merrill v. August. 58 LW* 3119.

51. *Poling v. Murphy. 58 LW* 3378.

52. *Reece v. Washington. 58 LW* 3012, 757 P2d 947.

53. *Arizona v. Bauer. 58 LW* 3004, 768 P2d 175.

54. *Smith v. Cleburne County Hospital. 58 LW* 3140, 870 F2d 1375.

55. *Levine v. Heffernan. 58 LW* 3052.

56. *Frame v. U.S. 58 LW* 3412, 878 F2d 1172.

57. *National Funeral Services, Inc. v. Caperton. 58 LW* 3314, 870 F2d 136.

58. *Louisiana Society of Independent Accountants v. Louisiana. 58 LW* 3050, 538 So2d 593.

59. *Pincham v. Illinois Judicial Inquiry Board. 58 LW* 3226, 872 F2d 1314.

60. *Northwest Advancement, Inc. v. Oregon Bureau of Labor. 58 LW* 3684, 772 P2d 943.

61. *Stephens v. McKinney. 58 LW* 3697.

Social Research in Communication and Law

By Jeremy Cohen and Timothy Gleason
Newbury Park, CA: Sage Publications
1990 140 pp.

Communication is the most elemental social behavior and necessarily mediates all social processes including that of law. If we do not have an adequate understanding of communication processes, we cannot begin to understand the social ramifications of free speech law. Harry Kalven, in a passage cited by Cohen and Gleason, makes a similar argument concerning the centrality of freedom of expression in society: "If my puzzle as to the First Amendment is not a true puzzle, it can only be for the congenial reason that free speech is so close to the heart of democratic organization that if we do not have an appropriate theory for our law here, we feel we really do not understand the society in which we live" (54).

Freedom of expression confronts the social sciences—especially communication theory—as an imperative research concern. Courtroom communication processes (jury decisions, testimony functions, etc.) pose additional areas of research interest. These areas probably hold less theoretical significance than societal level control of communication. There is an intellectual need for a comprehensive and systematic presentation of communication and law concerns from a social sciences perspective.

How well does the Cohen and Gleason book meet the need? To begin, they describe their book as: "neither a text on how to conduct legal research nor a guide to communication research methodologies. It is presented instead as a conceptual map of the emerging area *communication and law*, which is, in turn, a means of raising basic questions about communication assumptions inherent in law" (12). The structure of the book is topical: six chapters are functionally independent essays on related topics. The first two chapters make rather agonistic distinctions between communication and law as disciplines. Chapters 3 and 4 respectively deal with "Theories of Freedom of Expression," and "A Social Research Approach to Libel." Chapter 5 deals with "Reconciling Communication with Law," and Chapter 6 is titled "A Research Agenda for Communication and Law."

Cohen and Gleason attempt to establish the groundwork for that interdisciplinary approach they dub "communication and law." In the final chapter, they attempt to disengage this approach from the values of the "dominant liberal paradigm" of free speech advocates, on the one hand, and the critical theorist on the other. The research agenda for "the researcher striving for value-free empirical research" is "to begin looking at freedom of expression, not as a question of law or as a question of communication effects, but as a question of communication and law" (134). The authors beg off from delivering a specific agenda in the final chapter, saying that such specificity is not available since there are "too few examples of existing research" (134). Rather than a pointing to a research agenda,

the final chapter is more like a wave of an arm in the direction of a horizon. What is beyond is anyone's guess.

I cannot say to what audience this book is addressed. As a conceptual map, the book does not take us very far. Ostensibly, the book is introductory. But it does not delve deeply enough into law (Chapters 2 and 3 provide a conceptual skim across the surface of legal theory and freedom of speech theory) to serve introductory functions for communication scholars, who presumably do not need introduction to social science. It does not delve deeply enough into communication theory as a social science to introduce that area to legal scholars. Probably the most useful chapter in the book for either group is Chapter 4, which actually presents social research on the issue of libel. One gets a far cleaner conception of the authors' subject from this chapter than any other.

The level of the writing suggests use as a text in a beginning course, but the content is too insubstantial for that purpose. The book might supplement more substantial texts in a freedom of speech course, but I cannot recommend the book for even that. Too little care in the book's production creates the impression of a gripe session begun over a cup of coffee turned into a book, thanks to rapid, cheaper publishing techniques.

One indication of the lack of care is relatively minor in its consequences. Chapter 2 is titled "An Introduction to Law and Legal Theory." In all other chapters, the top of the right-hand page carries the chapter title. In this chapter, the top of the right-hand page carries "Distinguishing Law and Legal Theory." Perhaps the authors had to reach a compromise on this chapter?

More significant are the consequences of inadequately considered and confusing arguments regarding relationships among communication, social science, and law. I will trace one of these offensive to my bias—which, I suppose, is the "dominant liberal paradigm" noted above. The authors argue that the concerns of communication theory are different from those of the law. Communication science, the authors remind us, informs us about phenomena, not jurisprudence. In illustration, they note sedition laws.

The authors argue it could be a mistake to assume that sedition law came into being as a result of the strong effects model of communication. Obviously, the strong effects model is wrong, the authors write, but a strong case can be made that "sedition laws were based not as much on a powerful effects paradigm as on a basic desire to punish the socialists and pacifists and to frighten others from joining them" (114).

Furthermore, although judges may talk about communication effects, they may not really be talking about that at all. The rationalizations given by the courts may not reflect the real reasons for law, which may be to have political trials of Bolsheviks and to punish them. We must be careful, the authors say, not to look at the first part of the century through the eyes of the Information Age (116–117).

Well, yes, all that might be true, although it presents a dismal view of law. It might be possible that the arguments in courts, law reviews, and other legal scholarship are all cynical pretexts to disguise the dark motives of a lynch mob. To reach that conclusion, we must also discount historical accounts and analyses by social psychologists of the period pertaining to the reasons for the sedition laws. If we do all this, it is still possible that the political trials of Bolsheviks reflect society's motive to punish them and society's fear of the powerful effects of their rhetoric upon the masses.

Certainly, the social climate of today is not what it was 70 years ago. Certainly, communication theory and research are not equipped to deal with the social climate of 70 years ago. Who in communication studies the informal social cause of a law's passage as their primary research objective? That level of social motivation might make good

ethnography or social history. It is irrelevant to both law and communication. The law is not sociology, and it is not history either. Whatever the informal social motives may have been for passing sedition laws, they are not valid as legal arguments. And legal arguments, regardless of their informal historical contexts, may be the precedents of today's cases.

Let us also be clear that communication science informs us about phenomena, yes, but about the *social effects* of communication phenomena. In excluding communication effects from their "communication and law" research agenda, Cohen and Gleason exclude classical science, which studies phenomena through effects. Because courts, past and present, presume to determine and punish certain social effects of communication, this is one of the least ambiguous intersections of communication theory and law.

The history of the sciences has been a continual confrontation with social motives spawned by folk knowledge. When communication science empirically demonstrates the fallacy of powerful, compelling speech, and courts continue to punish communicators on those grounds, then the courts—and, by extension, society—are as wrong as if they were punishing witchcraft. Whether the courts and society actually believe in powerful effects is irrelevant to the empirical demonstration of the fallacy of the legal argument.

Cohen and Gleason are right about the need for a book which maps the various points of intersection of law and communication theory and research. But the need is for a book more carefully planned and executed than Cohen and Gleason have produced.

<div align="right">

William Bailey
University of Arizona

</div>

The New Politics of Pornography

By *Donald Alexander Downs*
Chicago: University of Chicago Press
1989 290 pp.

It is now over five years since Federal Appeals Court Judge Frank Easterbrook ended the brief and troubled life of the Indianapolis anti-pornography ordinance (its older sibling in Minneapolis having previously suffered crib death by mayoral veto), thus bringing to a close one of the more troubling chapters in modern free expression jurisprudence. While the focus of public attention quickly shifted to the antics of the Meese Commission and eventually to the parallel attacks on elite and street art which culminated in the unsuccessful prosecutions of the Cincinnati Center for Contemporary Art and the members of 2 Live Crew, the events of 1983 and 1984 in Minneapolis and Indianapolis should neither be quickly forgotten nor simply dismissed as idiosyncratic aberrations of the democratic process.

I assume readers of the *Free Speech Yearbook* are familiar with the "Dworkin/MacKinnon" anti-pornography ordinances enacted in Minneapolis and Indianapolis. The struggles over these ordinances provide Professor Downs with the opportunity to continue the practice (begun in his earlier book on Skokie) of exploring the politics of free expression within the framework of a case study of a critical incident. Minneapolis and Indianapolis are pivotal moments in the current debates about the proper conceptualization of and response to pornography. What occurred in those cities has important lessons to teach about the dangers inherent in some superficially attractive solutions to sexism.

The book begins with an account of modern free speech theory and, in particular, the evolution of obscenity and pornography law from *Sedley* and *Hicklin* through *Miller* and *Ferber*. The emergence of a political attack on pornography in the 1970s and 1980s is seen here as a reaction to the growing permissiveness which characterized the "sexual revolution" of the 1960s, culminating in this view in the 1970 Presidential Commission which "exonerated" pornography on most counts of the standard moral/psychological/social bill of indictment. The sexual counter-revolutionaries who took porn as a prime target against which to organize (and fundraise) importantly include both the New Right and a significant grouping among feminists. As Downs perceptively notes, these feminists renounced the liberalism which has historically been associated with movements for women's rights and embraced a "progressive censorship" akin to that proposed (from the left) by Marcuse as necessary to avoid "repressive tolerance." Thus, they found themselves aligned with those who sought a more intolerant repression.

In telling the story of the Minneapolis ordinance, Professor Downs offers a brief but accurate account of the Dworkin and MacKinnon analyses of pornography (which, as he notes, are not identical, though their differences may not weigh heavily in the ideological balance) and shows how their approach led to the innovative legal strategy embodied in the ordinance. Pornography for Dworkin and MacKinnon is not a *representation* of harm

against women; it *is* harm against women (in MacKinnon's words, "pornography amounts to terrorism" against women). At the very least, it is the theory of which rape is the practice. Among the more striking and troublesome features of their analysis and their ordinance are the claims that women *cannot* consent to perform in porn (as Professor Downs notes, "the logic of presumptive non-consent makes adult women equivalent to minors") and that "the production, sale, exhibition, or distribution of pornography is discrimination against women by means of trafficking in pornography." In other words, as Professor Downs puts it, "the sheer existence of pornography [should be] actionable as a discriminatory act."

However, these very features of the Dworkin/MacKinnon position also contained the seed of their eventual constitutional undoing. By arguing that pornography must be seen as a vehicle of sexist ideology, they confer on it the status of political thought and thus render it worthy of constitutional protection. In the words of Joel Grossman, which Downs quotes, "By attributing meaning to pornography beyond its appeal to individual prurience the ordinance elevates pornography to the class of ideas which necessarily have some political and social—if not artistic or scientific—significance." In the end, this was a major rationale in the Federal courts' decisions striking down the Indianapolis ordinance.

Professor Downs' account of the political process in Minneapolis and Indianapolis combines absorbing story-telling with illuminating analysis of the players' motives and strategies. The tale of political manipulation and pressure "raises questions about the ability of democratic government to maintain constitutionalism, due process, political responsibility, and institutional integrity." The "unseemly haste with which the Minneapolis City Council passed the controversial measure" (after a one-sided and emotional public hearing) and the equally stacked and rushed process in Indianapolis do not bode well for the courage of "elected officials to be found on the wrong side of an emotionally charged issue which partisans have framed as a matter of good versus evil."

An important part of the picture which Professor Downs assembles with the help of numerous interviews with participants and observers in both cities is that the ordinances weren't pushed by massive public support. In Minneapolis, "no groundswell of support materialized in the city as a whole," and in Indianapolis, several Fundamentalist ministers and allied citizens groups packed the Council chambers with busloads of supporters. In other words, a vocal and organized minority was able to pressure City Council members to enact ordinances they did personally approve of. As one Indianapolis city lawyer put it, "You just could not vote against it. It was impossible. They all knew the thing was going to go down [constitutionally], and they knew they didn't like Catharine MacKinnon's approach, but they had to vote for it."

Professor Downs often seems as concerned with the tone of the debate as with its subject or outcome. His chapter on the Indianapolis ordinance is prefaced by a quotation from Reinhold Neibuhr which seems to express his own position: "The temper and integrity with which the political fight is waged is more important for the health of a society than any particular policy." Given the author's "even-handed" criticism of Minnesota Civil Liberties Union Executive Director Matthew Stark for an "absolutist liberal stance and indecorous hyperbole [which] make his opinions suspect," we can discern a concern for "civility and restraint" which should apply to citizens as well as to the state. In fact, Professor Downs' criticisms reveal a belief that even disputes as basic as these should be conducted in a civil and decorous fashion, and a willingness to "recognize the dangers inherent in some expression." In other words, as we will see shortly, Professor Downs is not an advocate of what he terms "an absolutist ideal of liberty."

It is possible that Professor Downs' ambivalence about the merits of the free speech position taken by the opponents of the ordinance or their rhetorical invocation of fascism and totalitarianism to characterize the manipulative politics of the proponents (although he does cite the confirmation of these observations by less "suspect" observers) leads him to pay little attention to the wider dimensions of the story he tells. As he notes, the anti-pornography wing of feminism didn't begin in Minneapolis but had been flourishing on the West and East Coasts since the late 1970s. What Professor Downs pays less attention to is the coherent and vocal opposition within feminism, represented by feminist writers and activists who propounded positions against censorship and, more importantly, in favor of open discussion and exploration of sexuality. For these feminists, the dangers of state censorship went beyond the important threats to freedom of expression to include the implicit (and sometimes explicit) coalition with the most antifeminist forces in the society and the re-invention of a Victorian view of sexuality as a male preoccupation forced upon vulnerable and unconsenting women. By narrowing his scope to the immediate surround of Minneapolis and Indianapolis, Professor Downs fails to illuminate adequately the larger battlefield on which these were important skirmishes but which also included numerous engagements such as the furor over the 1982 Barnard College conference as well as abortive attempts to enact similar anti-porn ordinances in Suffolk County, Los Angeles, and Cambridge, Mass. In addition, although Professor Downs does cite the important collection *Women Against Censorship*, published in Canada, he unaccountably fails to note or cite the article in that book by Lisa Duggan, Nan Hunter and Carole Vance, which focuses on the Dworkin/MacKinnon ordinances. This article comes out of the work of the Feminist Anti-Censorship Taskforce (FACT), a group which arose in response to the anti-porn feminists and which played an important and influential role in the anti-censorship struggles of the mid-80s. Professor Downs also fails to note that the Canadian volume he cites was motivated by the active struggle against censorship being waged in Canada, without benefit of First Amendment protections, and against the impassioned intervention of Andrea Dworkin and company.

The explanation for Professor Downs' exclusion of the wider debate within feminism might perhaps be seen in the position he reveals in the final chapter of the book. After recounting the tale of two cities, he turns to the broader question of whether censorship of pornography should be supported and, if so, what types of material should be suppressed. In examining these questions, he reviews the arguments for "progressive censorship" embodied in the failed ordinances and the grounds on which the courts appropriately rejected them. He then turns to the question of whether we should support what he sees as the heart of the ordinance, "shorn of its more extreme ideological elements": a "new unprotected classification for erotic violence." Here he uses a proposal by Professor Cass Sunstein of the University of Chicago as an exemplar of the "most moderate supporters of the logic of the ordinance." After a review and analysis of the arguments for and against such a proposal, he concludes that "a new classification is not merited *despite* the suggestive experimental evidence of harm [from violent pornography]" but that "present obscenity law should be retained but that it should focus on violence rather than sexual explicitness."

Professor Downs believes that "this approach synthesizes feminist and conservative concerns about maintaining norms of sexual expression; and unlike most critics of the new anti-pornography measures, it takes account of the findings of research." Indeed, it becomes apparent that Professor Downs is a convert to the Donnerstein school of experimental research, which currently holds to the view that it is violence, not explicit sexuality, that is the "most important variable" and that "obscenity law is in part misguided by its

exclusive focus on sex rather than violence." (Curiously, despite his acknowledged reliance on Donnerstein, he cites approvingly studies purporting to provide "supporting cross-cultural and sectional studies" which Donnerstein, et al., criticize for "[misusing] statistics and [drawing] conclusions that are either overstated or incorrect.")

In his review of the research of "harms" of pornography and his analysis of the nature of pornography, Professor Downs reveals a devotion to decorum which mirrors his earlier concern over civility in the political process. He fears censorship of pornography because it would catch art in the nets set for smut: "The line drawn between acceptable and unacceptable expression must take into account artistic quality and levels of degradation. Democratic society has a right to draw the line of tolerance at the worse [sic], most degrading depictions of sex that are unredeemed by art."

It turns out that violent depictions are those most likely to fall on the wrong side of that line; thus, Professor Downs recommends "that the concept of obscenity either be broadened to include certain forms of violence"—which ones are not specified—"or that violence be dealt with in established obscenity doctrine." In fact, what is being proposed here is the modifying *Miller* to "cover only violent obscenity. . . . This would actually narrow the test but would incorporate feminist concerns in so doing." However, I do not believe that such a victory for the Donnerstein school of research would in any way eliminate the constitutionally troubling problems of definition and value-bias inherent in any determinations of obscenity and redeeming social value, and I am not persuaded by Professor Downs that this proposal allows us to "err on the side of freedom without forsaking our responsibility to maintain a decent and just society."

As I noted in the beginning, the Minneapolis and Indianapolis struggles have been overshadowed by subsequent events as the counter-revolutionaries have moved on to other sites and strategies. The cultural front represented by the attacks on the NEA and rap (as well as the Washington wives' crusade against rock and roll lyrics) is currently an arena in which censorship hasn't fared well. On the other hand, there is a much more successful "secret war" on pornography being waged by the Department of Justice's National Obscenity Enforcement Unit (established in the wake of the Meese Commission). This group of ten full-time litigators has been pursuing Operation Post Porn since 1988, using the Federal RICO statute to seize the assets of accused pornographers before conviction, and in October, 1990, the U.S. Supreme Court refused to consider an appeal by a Virginia couple who were convicted under the RICO Act. Dennis and Barbara Pryba lost nine video rental shops and three bookstores, along with their other assets, after they were found guilty for selling $105 worth of erotic magazines and videos. Operation Post Porn has won convictions or plea bargains in 17 of the 23 cases filed and sent porn distributors to jail for as much as 18 months. In other words, we still have a way to go before we might be seen as erring on the side of freedom.

Lest it appear that I am urging Professor Downs to turn his attention to the latest stages in the ongoing struggle over the expression of sexuality, let me hasten to offer another candidate for his scrutiny. In discussing the Indianapolis debate, Professor Downs notes that "the First Amendment seems a burden to people bent on morally urgent reform." Nowhere today is this truth more apparent than in the controversies raging on campuses across the nation over the proper balance between freedom of speech and freedom from harassment on grounds of race, gender, or sexual orientation. The action of a Federal judge in striking down the anti-harassment policies of the University of Michigan is only one of the more visible moments in this ongoing story, and Professor Downs' own University of Wisconsin campus at Madison has been an active site of struggle. Following

his insightful case study of Skokie and the present account of the Minneapolis and Indianapolis ordinances, I can only hope that there will be a future volume in this series which will tell the story of what happens when the fight over freedom of expression comes home to roost in the academic backyard.

Larry Gross
University of Pennsylvania

Freedom of Expression in the American Military: A Communication Modeling Analysis

By Cathy Packer
New York: Praeger Publishers
1989 267 pp.

Modeling analyses should be inherently fascinating to communication scholars interested in freedom of speech. We have long taught the basic concepts of communication by using models, many of which are derived from communication theory and research. We have benefited from applying the "Two-Level Approach," modeled by Thomas Tedford to test judicial decision-making when free speech is abridged.[1] Does Cathy Packer model freedom of expression in the American military with similar insight?

Unfortunately, the answer is "No." This study fails to fulfill its promise for several reasons. The most obvious, however, is a lack of focus in the study itself. While Packer contends that she is modeling freedom of expression in the American military, she is actually modeling communication in the military. The resulting analysis, while useful for scholars of free speech, is nonetheless tangential to an understanding of the repressive behavior of military commanders and the failure of the courts to remedy these intrusions upon service members' right to freedom of communication. In fact, these are the very issues that Packer's modeling analysis overlooks. The author seems to recognize this weakness of her model and attempts to discuss these issues; in the end, however, she is destined to fail because her model cannot address the most influential controversies in military free speech law.

Chapter One introduces the reasons for conducting the study and identifies several questions for research. Packer specifies the intent of the work: "to identify models of communication implicit in the case law and legislation that restrict the First Amendment rights of military personnel and to explore whether alternative models might better serve the military." Here the author is at her clearest. Yet the reader is likely to wonder why Packer introduces numerous communication models in Chapter Two and then proceeds to ignore them until Chapter Eight, the last chapter in the book. If the models are indeed implicit in the case law and legislation, why not apply these models in those chapters (parts of Chapter Five, and Chapters Six and Seven) devoted to an explication of pertinent statutory and case law?

Chapter Two introduces the reader to 24 interpersonal and mass communication models developed by others and concludes with a "Summary Communication Model" (the author's) based on four "key assumptions" derived from the analysis of the previous models. This analysis is suspect, however. First, the "Summary Model" is undeveloped. Packer

devotes little more than a page to its explication. The "Summary Model" itself ignores many of the characteristics of the preceding 24 models, but no reason is given for these exclusions. Two purported features of the model—social context and noise—are omitted from Figure 2.25, the diagram of the model. Second, the models are not compared or contrasted, and no conclusion regarding the relative utility of the models is reached. As a consequence, the reader is overwhelmed with communication models that appear to have no discernible connection either to each other or to the topic of freedom of expression in the military. Interestingly, none of the 24 preceding models is ever mentioned again in Packer's study.

"How Communication Works in the Military" is the topic of Chapter Three. Packer identifies three types of military communication: top-to-bottom, bottom-to-top, and horizontal communication. She also analyzes interaction between service members and civilians, and explores in some detail the role of dissident rhetoric in the command structure. Packer's analysis is insightful and fruitful for those unacquainted with sociological perspectives on military communication.

Packer devotes Chapter Four to a study of "Military First Amendment Rights in the Literature," while reserving for Chapter Five her discussion of the legal system in the military. This structure puts the cart before the horse, because the reader is introduced to the relevant legal statutes after finding out why these were created and how they apply to service members. The resulting confusion is evident when Packer is compelled to explain some of the statutes prior to their introduction. A general exposition of military law from its origins to its contemporary form, followed by a focused analysis of restraints upon free expression in the military, would have provided more explanatory power for discussing the rationales behind these restraints. Nonetheless, the author's review of the military's motives for abridging First Amendment rights is accurate and thorough.

The same cannot be said of Packer's analysis of the relevant provisions of the Uniform Code of Military Justice (UCMJ) and cases arising from their application to service members in order to curtail their freedom of expression. The UCMJ specifies the structure and procedures of the military court system and specific offenses punishable under military law. Packer omits Article 92 of the UCMJ—willful disobedience of one's commanding officer—from the list of restraints upon service personnel. As a result, she improperly concludes in Chapter Six that she has provided a comprehensive survey of pre-Vietnam War military free speech cases. This conclusion is inaccurate in at least three respects.

First, Packer fails to mention *United States v. Wysong*,[2] a 1958 case that provides the only example of a military court ruling upholding free expression against a challenge of harm to national security. Second, the author gives short shrift to the importance of a second case, *United States v. Bayes*,[3] because "[t]he Court of Military Review did not explicitly mention the First Amendment." (140). However, the Court did explicitly adopt the "clear and present danger" test to assess the relation between Bayes' speech and its potentially deleterious consequences. Thus, *Bayes* is a *de facto* free speech case. Third, Packer asserts that all cases in which military courts "discussed neither the First Amendment nor communication" are irrelevant to the study (141). However, she fails to mention *United States v. Gustafson*,[4] an Article 92 case involving the right of enlisted personnel to gripe profanely at a commanding officer, though she recognizes the importance of griping as a form of dissident communication (65, 232). If griping is a relevant form, then the only post-UCMJ military case involving the right to gripe should be included in a comprehensive analysis of judicial decisions that explore military communication.

Packer's lack of comprehensiveness is again apparent in her discussion in Chapter Six

of the free expression cases arising during the Vietnam War. She omits three significant cases—*United States v. Toomey*,[5] *United States v. Bell*,[6] and *United States v. Locks*.[7] The *Bell* ruling is particularly important; a service member's right to speak in opposition to war, killing, conscription and Army service were all identified as "constitutionally protected expressions of free speech secured . . . by the First Amendment."[8]

The net effect of these omissions in Chapter Six is to paint an incomplete—and, to some degree, unbalanced—portrait of the right to free expression for military personnel. Certainly, failure to recognize the right to gripe (*Gustafson*), the right to be secure from blanket orders forbidding all communication (*Wysong*), and the right to express opinions unfavorable to the military (*Bell*) is likely to lead the reader to side more readily with the author's conviction that freedom of communication is severely restricted in the military. More importantly, downplaying the courts' continuing efforts to recognize a right to free speech (even as they deny that right to specific appellants) distracts the reader from finding an answer to the question: Where are freedom-of-expression rights in the military?

Chapter Seven analyzes four "Post-Vietnam First Amendment Conflicts": military unionization, personnel involvement with extremist groups, free speech for commanders, and service members' exercise of the right of petition. While these issues are discussed thoroughly, knowledgeable readers might wonder why Packer omits consideration of *Goldman v. Weinberger*,[9] since the right to wear religious apparel in the military is at least as relevant to freedom of communication as the right to join a union.

Packer concludes with a summary of the issues raised, nicely encapsulated in the comparison between a "Traditional Military Communication Model" and her own "Summary Communication Model." Her point is well taken: the military model inadequately represents the state of contemporary communication in the military, for numerous reasons primarily drawn from the effective analysis presented in Chapter Three. The author admits that the modeling analysis "does not propose a specific, new First Amendment standard for servicemembers." (239). More importantly, it fails to explain how acceptance of the "Summary Communication Model" as an articulation of the nature of communication in the military would be likely to change judicial standards for military personnel. The courts need not reject their current dichotomy between civilian and military communication on the ground of the model alone. The primary rationale for compromising service members' First Amendment rights—that the military is a "separate society" and therefore constitutional rights may be delimited—is questioned but not destabilized by Packer's model. In short, adoption of the model may make no difference in circumscribing service members' freedom of communication!

Is Packer's model at all useful in helping legal scholars and jurists to unpack the rationales that justify curtailment of free expression in the military? Perhaps the greatest value of this study is its threshing value—the model identified some influential misconceptions regarding communication in the military that need to be discarded if we are to reach bedrock in our investigation of justifications for abridging First Amendment rights. What is absent here—and is so sorely needed—is an intensive examination of the "separate society" argument as ground for the restriction of constitutional rights in general and of the right to communicate in particular. According to Packer, however, that is a task beyond the reach of modeling analysis.

Richard A. Parker
School of Communication
Northern Arizona University

Notes

1. Thomas L. Tedford, *Freedom of Speech in the United States* (New York: Random House, 1985) 454. Packer is apparently unaware of Tedford's book or his model.

2. 9 USCMA 249, 26 CMR 29 (1958).

3. CM 388545, 22 CMR 487 (1956).

4. CGCMS 19513, 5 CMR 360 (1952).

5. ACM 20248, 39 CMR 969 (1968).

6. CM 419988, 40 CMR 808 (1969).

7. ACM 20410, 40 CMR 1022 (1969).

8. 40 CMR 808, 817 (1969).

9. 106 S.Ct. 1310 (1986).

Liberty Denied: The Current Rise of Censorship in America

By Donna Demac
PEN American Center Publication
1988 177 pp.

Demac's book *Liberty Denied* is a book that surveys the different types of censorship and restrictions on speech that exist in American societies in the 1980s and 1990s. What the book lacks in innovative thought or theory it makes up for in concise explanations and readable prose. This book appears aimed, not at scholars or theorists in freedom of expression issues, but at a general public which is woefully uninformed on freedom of expression issues.

The book is divided into eleven chapters, the first of which is an introduction to the First Amendment. The next nine deal with separate aspects of freedom of expression, and the final chapter is a call to action for support of liberal free speech ideals. The second chapter focuses on book-banning in American schools and deals with issues such as religion in schools, accuracy in academia and school newspaper censorship. The third chapter deals with libel suits and their effect on the free marketplace of ideas. The fourth chapter deals with pornography and covers a wide range of topics from the Comstock laws to Tipper Gore's battle against rock lyrics and feminists' arguments against pornography.

The next six chapters focus on issues that are often not covered in traditional First Amendment survey books. These chapters deal with censorship within corporations, government surveillance and harassment, government secrecy, bureaucratic restrictions on information, government controls on press and travel, and restrictions on academic and scientific research. These chapters are both a strength and weakness of this book. The strengths are that the book expands our concept of what should be dealt with in First Amendment research. The free speech issues regarding employees and bureaucratic restrictions on information are too often ignored or given light treatment by many free speech scholars. However, these chapters also point up two weaknesses that exist with the book. The first of these weaknesses is that the book often stretches what can reasonably be considered First Amendment or censorship issues. The recruitment by the Central Intelligence Agency on college campuses may be good or it may be bad, but its relevance in a book on censorship is problematic (153–155). Several other claims by Ms. Demac are also questionable, such as her argument that government and corporate sponsorship of university-based research is a threat to academic freedom (156–157) and her claim that the National Endowment for Democracy might be linked to Oliver North (142). Demac makes no effort to explicitly link these situations with censorship and offers almost no evidence as to why a book on censorship should be concerned with them.

The second major weakness in this book is one of omission and not commission. This book leaves out important aspects of First Amendment controversies that have raged for

years. The two most prominent examples of what is missing are fighting words and commercial speech. Since two of the most wide-ranging controversies concerning the First Amendment now going on are racist and sexist speech on college campuses and the right of advertisers to speak, these omissions lessen the book's ultimate value. Whether or not the author has an ideological bias against these issues is not clear, but the fact that they are left out is disturbing.

Ms. Demac's book is ultimately difficult to review. It is highly readable and very concise. Its lack of jargon and clutter make it easily accessible to members of the general public. The book also opens new avenues for free speech scholars to examine. However, the book's digressions into corporate and governmental policy which have little relation to the book's stated purpose of dealing with censorship are troubling, and the book's ignoring of important elements such as fighting words and commercial speech is even more troubling. Finally, this is a book to be read and thought about, but also one to be seriously challenged and corrected.

<div align="right">

Charles C. Howard
University of Kansas

</div>

The First Amendment,
Democracy, and Romance

By Steven H. Shiffrin
Cambridge, MA: Harvard University Press
1990 285 pp.

In December of 1990, the National Council on the Arts, the presidentially-appointed advisory board of the National Endowment for the Arts, ordered the NEH to comply with Congress' new "decency standard." Here is one more example of the feebleness of First Amendment defense of dissent as presently interpreted, which is the concern of Shiffrin's book. Everyone who desires stronger and more consistent judicial support of free speech will welcome this book's powerful advocacy of civil liberties founded upon respect for dissenters.

Shiffrin's argument is both comprehensive and richly analytical of numerous specific judicial rulings. Chapters 1 and 2 indict current First Amendment doctrines based upon "defective social engineering" severed from free speech vision. Chapter 2 urges Emersonian and Whitmanesque dissent as a better foundation for democracy. Chapter 3 examines dissent as a positive cultural value fundamental to the First Amendment as an emotional symbol. And Chapters 4 and 5 relate democracy, the First Amendment, and dissent to "that aspect of the romantic tradition that prizes rebellion and dissent," to "forge a strong connection between the substance of the first amendment and its method" (7).

The nation needs an organizing symbol, a vision of what the country means and stands for worthy of its democratic pretensions. It needs a symbol able to weld self-government and freedom of speech. Majority rule is not only demonstrably false to political realities in the U.S. (judicial review, the Bill of Rights, the U.S. Senate, corporate power, representative government, 58–69), but utterly incapable of and often inimical to *self-*government and independence of thought and action. What the nation stands for, if anything else, is freedom of speech, in contrast to the repression of Fascism and Nazism (71–2), and the foremost foundation for that vision is the First Amendment, which to Shiffrin affirms above all "the protection of dissent and its nurturance" as "a major American value."

Instead of Fourth of July slogans ("Liberty," "Dignity," "Patriotism"), the symbol of the dissenter, the romantic, can provide the needed orienting vision for a nation truly founded upon the liberty of individuals. Ralph Waldo Emerson's Divinity School Address (1838) established this vision: "you should respect no authority, no custom, no convention, no habit, no institution unless it makes sense to you. If it does not make sense," Emerson counseled, demanded, insisted that you speak out (1). The purpose of the First Amendment from the Emersonian perspective is "to protect the romantics—those who would break out of classical forms: the dissenters, the unorthodox, the outcasts. The First Amendment's purpose and function in the American polity is not merely to protect negative liberty but also

138

affirmatively to sponsor the individualism, the rebelliousness, the antiauthoritarianism, the spirit of nonconformity within us all" (5). For Emerson and Whitman, democracy, defined as self-government and its instrument free speech, "stood against the whole idea of authoritative pronouncements" whether from government or custom. "They understood that democracy and orthodoxy are always potentially at war. They knew that democracy and dissent run together" (85).

Social engineering—maintaining contact with complex social reality—is also important (Chapter 1). First Amendment law should not proceed from "unchallengeable premises to conceptually entailed conclusions," but should regard society as humanly organized to satisfy a maximum of important wants without sacrificing other important wants; that is, a system of compromises (2). But the compromises must be bounded by a symbol and rhetoric of free speech. The past chaos of the Supreme Court is a persistent theme in the book. "Sometimes speech that presents a clear and present danger is protected; sometimes it is not; sometimes speech is not protected even though it presents no clear and present danger of any ordinarily recognizable evil. The Court periodically formulates exquisitely precise rules; it settles at other times for the most generally phrased standards; often it opts for hazy formulations and relies on the lower courts to fill in the details; sometimes the Court stays its hand and says nothing" (2–3).

Thus, we need social engineering with a vision, a romantic engineering, and we need the dissenter as the primary symbol because he and she provide an organizing vision that is no abstract theoretical fortress but one that reflects the complexity and fluidity of social reality. Further, we need this particular vision even more today since the Emersonian dissenting ideal of freedom of speech has "been subtly denigrated in recent first amendment theory and seriously abused in practice" (5–6).

Nor will the encouragement of dissent run "the risk of producing an excessively egoistic, individualistic, self-serving society" (7, 90–96), because dissent as speech is predominantly interpersonal and associational" and the "pressures to conform in every society are enormous" (especially against authoritarian power, in all its manifestations threatening when challenged). The First Amendment projects no negative liberty but is rather a cultural symbol (87) encouraging Americans to rebel against wrongdoing as "citizen-critics" (93). Self-serving egoism comes not from the tradition of dissent but from capitalistic and especially the televised marketplace of consumerist values, "hedonistic, acquisitive, materialistic, self-seeking, money-hungry" (93). The danger to democracy derives not from the remote potentiality of narcissism in individual opposition to the military-industrial complex, but from the many powerful ways dissent is discouraged in the U.S.

Shiffrin's quintessential example of Emersonian Romanticism is the Supreme Court ruling in *West Virginia Board of Education vs. Barnette*; it "manifested a strong appreciation for the Emersonian and Whitmanesque vision of America" when it "barred a school board from compelling a school child to salute the American flag." The First Amendment projected in this case "encourages us to picture Walt Whitman's citizenry—vibrant, diverse, vital, stubborn, and independent. It encourages us to believe with Emerson that 'America is the idea of emancipation' " (159).

This vision from Emerson and Whitman has never gained primacy, despite the efforts of Justice Brennan to expand Meiklejohn's political speech rhetoric to include all speech (47–53). Too often the First Amendment has been defined merely in terms of negative liberty—for example, the notion that a state regulation has to advance a substantial or even compelling interest in the least restrictive way (45). Other symbols of the First Amendment (the New England town hall, the marketplace of ideas, content neutrality)

have failed to defend what the nation most stands for "when the roar of the crowd gets too loud (4); they have failed to contain the wild vagaries of Justice Stevens in *Young v. American Mini-Theatres, Inc.* (540; in *United States v. O'Brien* (1968), they failed to protect draft card burning as speech (81); and in *FCC v. Pacifica Foundation* (1978), they failed to defend George Carlin's comic monologue, when Carlin "*is* the prototypical dissenter"—attacking orthodoxy, assaulting conventions (80). From the Supreme Court ruling of *Schenck v. United States* (1919, silencing a draft protester) to that of *Connick v. Myers* (1983, telling "public employees everywhere to shut up or get fired" (79), prevailing doctrines, symbols, and rhetoric have failed to protect dissent. Thus, a focus is needed which will consolidate the values contained in the other symbols and rhetoric.

We urge everyone who desires to strengthen free speech to read this book, but we would suggest five minor changes, if the book is ever revised. *West Virginia v. Barnette* seems a weak case to epitomize dissenting values. It offers only a negative perspective: a school cannot compel a child to salute the flag. But Shiffrin all along has argued that a dissenter focus for the First Amendment would provide a positive vision based upon Emerson's Divinity School Address of a citizenry that respects no authority, no custom, unless it made sense to the individual's judgment independently arrived at. Yet the *Barnette* case deals with a child who refuses to salute on religious reasons dogmatically arrived at.

Also, Shiffrin seems too optimistic regarding public support for dissent under the First Amendment as an important source of their national patriotism. More specifically, he claims in regard to *Connick v. Myers* that "most Americans" believe the First Amendment guarantees dissent against conventions. Apparently, none of these beliefs is as true as Shiffrin seems to think. Erskine, Hyman and Sheatsley, Wilson, Zalkind, and Zellman all call into question popular support for the First Amendment. Although "willingness to support the liberties of some dissenters" has increased, Zalkind's survey of research discerns "the absence of a solid consensus . . . to support specific applications of the Bill of Rights" (Zalkind), while Wilson finds "a minority of adults" prepared to "fully accept the principle of free speech and press." And although Mueller finds a broad increase of tolerance for leftists from 1940 to 1985, the public's grasp of and concern about civil liberties seem "so minimal that one might argue not that the public is substantially tolerant or intolerant, but that it has no really tangibly measurable 'attitude' on the subject one way or the other." But, regardless of whether Shiffrin is or is not overly optimistic about public pride in the First Amendment (in footnote 95, he refers to the public's ignorance of and hostility toward free speech), a more pessimistic outlook only reinforces his argument for the need for a rhetoric to undergird a stronger First Amendment for dissenters. Public indifference or dislike of the First Amendment and dissenters makes Shiffrin's message more urgently important.

We would thirdly recommend a more emphatic account of the history of repression in the U.S. Not only do we not embody as a nation a thoroughgoing Emersonian/Romantic commitment to dissent, but throughout the century, in fluctuating intensity and increasingly during the past decade, dissent has suffered repression. Shiffrin knows this, of course, as we have already quoted: "The Emersonian ideal of freedom of speech . . . has been subtly denigrated in recent first amendment theory and seriously abused in practice" (5–6). But this one sentence so understates the abuse that readers might not catch the urgency of his argument for the Emersonian dissenting ideal. The First Amendment has indeed been abused (Goldstein, Linfield), since World War II (Bennett *Control*: Andrews, Barth, Belfrage, Belknap, Bentley, Caute, Ceplair, etc.), and during the 1980s (Bennett, Curry,

Demac, Jansen). Walter Karp refers to the Reagan/Bush Administration as "a tyrant and a tyranny" (254). Bill Moyers in his *Frontline* documentary, "Crimes and Misdemeanors," calls the Iran-Contra machinations a White House "coup" against democracy. Shiffrin returns to these realities at the end of the book: "It would be just as easy to spin a story showing that the United States has not really valued dissent in its actual practice," but has "perennially ostracized" the eccentrics and iconoclasts and victimized minorities of all kinds (161). This awareness would have gained in utility had it been placed at the beginning accompanied by details and augmented references (in education, for example, Lewis, Meranto, Schrecker). Shiffrin mentions none of these sources.

Fourth, Shiffrin's application of dissent value to commercial advertising is less clear than it might be through a careful distinction between product advertising and image/advocacy advertising (Sethi). Although he denies First Amendment protection to commercial product advertising on city streets (82), elsewhere we think he concedes too much to corporate power, which by both censorship/secrecy and massive propaganda, overwhelms or silences opponents (Bennett *Control* III).

Fifth, the strategy of engaging in a wide-ranging discussion of romance/romanticism often seems confusing, a subject too complex and actually inessential for the purpose of the book. The initial confusion derives from the spelling of romanticism with lower-case "r," which has numerous denotations irrelevant to the specifically historical Romanticism (upper-case customary in this context) which Shiffrin discusses. We can see the reasonableness of trying to place dissent in its widest historical contexts, but while German and British Romanticism have general similarities, French Romanticism is very different (Abrams), and Emerson and Whitman express their own American Romanticism. Shiffrin understands these complexities well, but they overwhelm the central argument at times. On page 5, romantic is equated with dissenters; on page 48, it apparently means idealistic or even adventurous, and not until page 74 is the term limited historically and geographically to "American romantics." Particularly in the last two chapters, the issues of Romanticism often engulf the subject of the book. He does not need to discuss the world history of national Romanticism to make his essential case that "Ralph Waldo Emerson and Walt Whitman understood more about the relationship of freedom of speech to American democracy than did Oliver Wendell Holmes [clear and present danger doctrine] or Alexander Meiklejohn [political speech and majority rule doctrine] (74).

In protest against the new decency standard for the National Endowment for the Arts, members of the NEA panel on opera and musical theater declared their unanimous opposition, citing how "subjective, indefinable and irrelevant to the consideration of artistic excellence" are so-called standards of decency. Shiffrin's book makes instantly clear why their opposition lacks the power it might have possessed were it founded rhetorically and judicially upon a dissenter-affirming First Amendment.

A law professor and former communication instructor, Shiffrin understands the role and power of rhetoric. His case is that a First Amendment resonating with the symbol and rhetoric of dissent would protect democracy better than do prevailing symbols and rhetoric. Thus, "without obliterating the other pictures, I seek not only to associate images of the dissenters, the eccentrics, the rebels, and the iconoclasts with the first amendment and those who would speak out against prevailing conventions, norms, authorities, and institutions" (86–7). Implicitly, he appeals to all who share his vision to engage actively in placing the rhetoric of dissent and the symbol of the dissenter at the center of First Amendment theory and practice, and to extend this center outward, for example, to

dissenters' right of access to public and private workplaces, of access to shopping centers, and of access to the broadcast or print media (100).

James R. Bennett
University of Arkansas

Tim Simpson
University of Arkansas

Works Cited

Abrams, M. H. *Natural Supernaturalism*. New York: Norton, 1971.

Andrews, Bert. *Washington Witch Hunt*. New York: Random, 1948.

Barth, Alan. *Government by Investigation*. New York: Viking, 1955.

Belfrage, Cedric. *The American Inquisition, 1945–1960*. Indianapolis: Bobbs, 1973.

Belknap, Michal. *Cold War Political Justice*. Westport, CT: Greenwood, 1977.

Bennett, James R. "Censorship by the Reagan Administration." *Index on Censorship* 17.7 (August 1988): 28–32. Bennett, James R. *Control of Information in the United States: An Annotated Bibliography*. Westport, CT: Meckler, 1987.

Bentley, Eric, ed. *Thirty Years of Treason*. New York: Viking, 1971.

Caute, David. *The Great Fear*. New York: Touchstone, 1978.

Ceplair, Larry, and Steven Englund. *The Inquisition in Hollywood*. Garden City, NY: Doubleday, 1980.

Curry, Richard O., ed. *Freedom at Risk: Secrecy, Censorship, and Repression in the 1980s*. Philadelphia: Temple UP, 1988.

Demac, Donna. *Liberty Denied: The Current Rise of Censorship in America*. New York: PEN American Center, 1988.

Erskine, Hazel. "The Polls: Freedom of Speech." *Public Opinion Quarterly* 34 (1970): 483–96.

Goldstein, Robert. *Political Repression in Modern America from 1870 to the Present*. Cambridge, MA: Schenkman, 1978.

Hyman, Herbert and Paul Sheatsley. "Trends in Public Opinion on Civil Liberties." *Journal of Social Issues* 9 (1953): 6–16.

Jansen, Sue. *Censorship: The Knot That Binds Power and Knowledge*. New York: Oxford UP, 1988.

Karp, Walter. *Liberty Under Siege: American Politics, 1976–1988*. New York: Holt, 1988.

Lewis, Lionel. *Cold War on Campus*. New Brunswick, NJ: Transaction, 1988.

Linfield, Michael. *Freedom Under Fire: U.S. Civil LIberties in Times of War*. Boston: South End P, 1990.

Meranto, Philip, Oneida Meranto, and Matthew Lippman. *Guarding the Ivory Tower: Repression and Rebellion in Higher Education*. Denver, CO: Lucha, 1985.

Mueller, John. "Trends in Political Tolerance." *Public Opinion Quarterly* 52 (1988): 1–25.

Schrecker, Ellen. *No Ivory Tower: McCarthyism and the Universities*. New York: Oxford UP, 1986.

Sethi, S. P. *Advocacy Advertising and Large Corporations*. Lexington, MA: D. C. Heath, 1977. (See Bennett's review in *Rhetorical Society Quarterly* Winter 1979, 9.1: 37–42.

Wilson, W. Cody. "Belief in Freedom of Speech and Press." *Journal of Social Issues* 31.2 (1975): 69–76.

Zalkind, Sheldon. "Civil Liberties: An Overview of Some Contributions from the Behavioral Sciences." *Journal of Social Issues* 31.2 (1975): 1–12.

Zellman, Gail. "Antidemocratic Beliefs: A Survey and Some Explanations." *Journal of Social Issues* 31.2 (1975): 31–53.

Freedom of Expression and Partisan Politics

By Craig R. Smith
Columbia: University of South Carolina Press
1989 225 pp.

The aim of this book is stated in its introductory chapter as "a description of the major strategies employed to accomplish change in a free and open system." Its approach is an interesting if eclectic collection of five essays, drawn together in a final chapter entitled "Resolving the Tensions."

Chapter 2 explores two "Philosophical Confrontations." It considers the evolution of the Massachusetts Puritans from "intellection to emotionalism." and the 19th century political movement from Populism (mainly Bryan), through Social Darwinism (as espoused by Andrew Carnegie and Albert Beveridge) to the Progressive movement of Theodore Roosevelt and the "persuasion of progressive journalists."

The third chapter deals with the "radical segments of political parties" and their attacks on freedom of expression in three different periods of our history: the Alien and Sedition Acts, Reconstruction and the McCarthyism of the 1950s. In each of these cases, the author argues, the radicals failed because (83) they "had the conceptual and rhetorical disadvantage of having to establish some value as above freedom."

Chapter 4, on "The Contemporary Environment," brings the author to what appears to be the book's principal argument: that the now repealed "fairness doctrine" and the still-in-effect "equal access rule" are burdensome impositions on the electronic media which, moreover, seriously inhibit decision-making in a democratic society.

Chapter 5 seems, on first reading, to be curiously out of place. It is basically a sophisticated summary of the "system" of modern political campaigns: polling, targeting and "manipulating the media." It draws the somewhat debatable conclusion (154) that "it is clear that voters have a low degree of tolerance for negative advertising, phone banks, and direct mail solicitation." The author's real point, however, returns to his concern about the regulation of the electronic media. Having "surveyed what is going on in national political persuasion in the latter part of the twentieth century," he comes to three conclusions. The first is that political persuasion is a complex and sophisticated process; the second, that American politics and its tools of persuasion have become centrist. The third (161) is that: "Most attempts to elevate such values as 'equality' or 'opportunity,' 'financial equality,' 'truth,' and 'ethics' to positions above the traditional value of freedom of expression have in fact *restricted* political freedoms; on the other hand, where freedom of expression has been preserved it has usually brought with it its own self-corrective mechanisms" (161).

The sixth chapter, entitled "Inadvertent and Disguised Persuasion," provides some remarkable insights on the constraints and strategies of news reporting—particularly as it

is "jacketed" by the 30-minute format of the typical "evening news." Its detail and several anecdotal illustrations are well worth the reading. There is a good discussion of the "mythos" of presidential debates and an argument against any legislative effort to limit early projections of election results. The impact such projections might have on potential voters who see themselves as disenfranchised by an already foregone conclusion is dismissed because: "[If] a voter's commitment to those other candidates and propositions is so weak that he or she is no longer motivated to vote once a network has declared a presidential candidate the winner, then perhaps those voters should be discouraged from voting in the first place. Such a voter is likely to be the least informed on the other issues and candidates" (179).

The concluding chapter attempts to synthesize these somewhat disparate essays and from them reaches the author's final conclusion (22):

> The Congress has placed fairness, access, equity and other values above freedom of expression for licensed media. The result is that they have put in place or have advocated tools that can be used to suppress speech generally.
> In opposition to regulative lines of thinking, this book has been an attempt to show by historical illustration that free and open competition among values has been, in the long run, the better alternative. This is true in part because freedom compels competition among the media and those who invest in them. . . . [W]e must trust citizens to make proper decisions based on the information they have. And the best way to assure that the information they receive is unadulterated is to make sure it comes from an open, uncensored, unpatronizing marketplace of ideas.

The problem that I, and I suspect others, will have with this book is that it never comes to grip with the question of whether "the information they have" can be denied or distorted by those "who have invested" in the media. It is one thing to argue, as I think most of us would, that access to the media be open and uncensored, but it may not necessarily follow that the government is "patronizing" to insist that access also be open to people and points of view that cannot afford to pay for it.

There is a lot that is worthwhile in this very readable collection of essays. What is questionable is the author's attempt to string them together on the sometimes irrelevant premise that all government regulation of the media is bad and burdensome because, among other things (96), it "lead[s] to uniform, bland programming and to costs in terms of foregone business opportunities."

Frank Harrison
Trinity University

In Defense of American Liberties:
A History of the American Civil
Liberties Union

By Samuel Walker
New York and Oxford: Oxford University Press
1990 479 pp.

In January of 1990, the American Civil Liberties Union celebrated the 70th anniversary of its founding. Given the influential and controversial role the organization has played in American life, it is remarkable that not until that date did a scholarly, definitive, published account of its entire history make an appearance. There have been, it is true, three earlier efforts to capture something of the ACLU story in book form, but that hardly constitutes a library. The first, appearing in 1965 from St. Martin's press, was authored by Charles Lam Markmann. Despite its laudatory and ambitious titles, *The Noblest Cry: A History of the American Civil Liberties Union*, and its amassing of a wealth of accurate factual details, the writer's elitist biases so permeated the volume as to transform it into a seriously flawed rendering of the spirit and purposes of the organization. A second was a rather charming and enlightening, but hardly thorough, biography entitled *Roger Baldwin: Founder of the American Civil Liberties Union*, written by Peggy Lamson and published by Houghton Mifflin in 1976. The third was a 1985 publication of Transaction Books entitled *The Politics of the American Civil Liberties Union*, a right-wing polemic by William A. Donohue, which bears about as much resemblance to the truth as the Protocols of Zion.

Samuel Walker, a professor of criminal justice at the University of Nebraska at Omaha and a current member of the ACLU's national Board of Directors, makes no more pretense of being a detached observer of his subject than does this reviewer, who is a colleague of the author and has been a participant in nearly half of the 70-year history covered by the book. Yet Walker has done an amazing job of bringing objectivity and balance to his task, clearly giving his skills as a scholar priority over his sentiments as an activist. The ACLU and its key actors are treated with respect but not deference, sympathy but not adoration. The full record is there, warts and all. Still, the author does not hesitate to come to a conclusion that this probably biased reviewer happens to think is fully justified by the facts, namely that

The history of the American Civil Liberties Union is the story of America in this century. . . . When the ACLU was founded in 1920, the promises of the Bill of Rights had little practical meaning for ordinary people. Today, there is a substantial body of law in all the major areas of civil liberties: freedom of speech and press, separation of church and state, free exercise of religion, due process of law, equal protection, and privacy. . . . The ACLU can legitimately claim much of the credit— or be assigned the blame, if you prefer—for the growth of modern constitutional law.

The story Walker tells begins with the transformation under the leadership of Roger Baldwin of the Civil Liberties Bureau of the American Union Against Militarism, a small New York group defending the rights of conscientious objectors to the first World War, into the ACLU, whose charter members included, among others, Jane Addams, Felix Frankfurter, Arthur Garfield Hayes, Helen Keller, and Norman Thomas. He describes the recruitment of John Scopes as the plaintiff and Clarence Darrow as the attorney for the ACLU's first nationally famous test case in Dayton, Tennessee in 1925, challenging the constitutionality of the state's prohibition on the teaching of evolution in the public schools. The narrative from there on is too sweeping and complex to be encapsulated here—it ranges all the way from books banned in Boston to the Legion of Decency, from labor rallies in Jersey City to flag salute requirements in West Virginia, from the internment of Japanese-Americans in World War II to post-war McCarthyism, from the Civil Rights Movement to the Anti-Vietnam War Movement, from *Brown v. Board of Education* to *Roe v. Wade*, from Richard Nixon to Robert Bork, from Nazis in Skokie to the card-carrying membership of Michael Dukakis.

Not all of the book's attention is on the ACLU's external civil liberties battles; its major internal struggles and tensions are also faithfully reported—from the 1940 resolution expelling Communists from the organization's leadership, to the nationalization and democratization of its decision-making structure in the 1950s, to the moves from *amicus* briefs to direct representation, and from litigation to legislative lobbying in the 1960s, to the foundation funding of special projects on prisoners' rights, women's rights, children's rights, and reproductive freedom and the dramatic changes in personnel of the 1970s and 1980s.

The author spent five years in research for this book—interviewing key actors across the country, exploring the ACLU archives at Princeton's Mudd Library as well as the records at national and state offices. The task of organizing this material and selecting that which should be reported was, of course, enormous, and it has been done with a fine sense of what is more and less important. Being as close to the situation as I have been for so long, I was naturally frustrated by what he chose to leave out, and I might have made a few decisions on that score differently from his, but Walker certainly cannot be faulted for that.

In addition to the information being beautifully organized and judiciously selected, the book is extremely well written. It will hold the attention of anyone with even a modicum of interest in the subject. Its appeal, I believe, is not limited to those, like myself, with a passion for the ACLU but to anyone who seeks new understandings of the history of 20th century America.

Franklyn S. Haiman
Northwestern University

Contributors

Richard S. Arnold is United States Circuit Judge for the Eight Circuit. Judge Arnold is a 1953 graduate of Phillips Exeter Academy, cum laude. He took his B.A. at Yale, where he graduated magna cum laude in 1957 and was awarded membership in Phi Beta Kappa. He finished his law degree at Harvard in 1960, again magna cum laude. Following law school, Judge Arnold clerked for U.S. Supreme Court Justice William Brennan in 1960–61 and then went into private law practice. He was named to the U.S. District Court for the Eastern and Western Districts of Arkansas and to the U.S. Court of Appeals for the Eighth Circuit in 1980. He is a member of the Council of the American Law Institute and a Fellow of the American Bar Foundation.

W. W. Finlator is Pastor Emeritus of Pullen Memorial Baptist Church of Raleigh, North Carolina. He is a graduate of Southeastern Theological Seminary and is a former member of the U.S. Commission on Civil Rights, appointed by President Lyndon B. Johnson. He was a founder of the North Carolina affiliate of the American Civil Liberties Union and is a recipient of that organization's highest honor, the Frank Porter Graham Award. He has also served as a member of the National Board of Directors of the ACLU.

Franklyn S. Haiman is John Evans Professor of Communication Studies at Northwestern University. He received his B.A. from Case Western Reserve, where he was a Phi Beta Kappa graduate in 1942, and his M.A. and Ph.D. degrees from Northwestern. Among his many works in freedom of expression, most notable is his *Speech and Law in a Free Society* (University of Chicago, 1981), which received numerous national awards. He has served on the National Board of Directors of the American Civil Liberties Union since 1965: as its Secretary from 1976 to 1982, and as its Vice President from 1987 to the present.

Anthony Lewis is a two-time winner of the Pulitzer Prize and is a syndicated columnist for the *New York Times*. He is a 1948 graduate of Harvard University. He served as a lecturer in law at Harvard in 1974 and as James Madison Visiting Professor at Columbia University in 1983. He is the author of several books, including *Gideon's Trumpet* in 1964. He has a new book on the *New York Times v. Sullivan* case coming out soon.

William A. Linsley is professor of communication at the University of Houston. Professor Linsley received his Ph.D. at the University of Oklahoma and has long served the discipline of comunication through his scholarship in freedom of expression. He has served in leadership roles in the Free Speech Division of the Southern States Communication Association and the Commission on Freedom of Expression of the Speech Communication Association. He was the 1976 recipient of the H.A. Wichelns Award for Scholarship in Freedom of Speech.

Harry C. Martin, A.B., University of North Carolina at Chapel Hill, L.L.B., Harvard Law School, L.L.M., University of Virginia, is an Associate Justice of the Supreme Court of North Carolina and a visiting lecturer of law at the University of North Carolina School of Law. He has also taught at Duke University.

Robert M. O'Neil is a university professor and director of the Thomas Jefferson Center for the Protection of Freedom of Expression at the University of Virginia. Professor O'Neil received his undergraduate, master's, and law degrees from Harvard and also holds honorary doctor of the law degrees from Indiana Uinversity and Benoit College. His is immediate past president of the University of Virginia and previously served as provost of the University of Cincinnati, vice president of Indiana University and president of the University of Wisconsin. In 1962–1963, he served as law clerk to Supreme Court Justice William Brennan. Professor O'Neil began his career as professor of law at the University of California at Berkeley. In 1970–72, he served as General Counsel to the American Association of University Professors. He was the founding Editor of the *Free Speech Yearbook* and is the author of numerous articles and books on First Amendment law, including *Classrooms in the Crossfire, Free Speech: Responsibile Communication Under Law,* and *Civil Liberties: Case Studies and the Law.*

Raymond S. Rodgers is professor and associate head in the Department of Communication at North Carolina State University. He received his B.A. degree from Northwestern State College of Louisiana, his M.A. from the University of Arkansas, and his Ph.D. from the University of Oklahoma. He has served as both vice chair and chair of the SSCA Division on Freedom and Responsibilities of Speech and as vice chair of the SCA Commission on Freedom of Expression. His research in communication law has been honored by both the H.A. Wichelns Award and the Karl R. Wallace Memorial Award. He was named to Who's Who in American Law in 1983, and he has served on the Editorial Boards of the *Southern States Communication Journal, Free Speech Yearbook, Communication Education, Communication Quarterly,* and as Editor of *Communication Law Review.* He currently serves as National Executive Director of Lambda Pi Eta, the undergraduate honor society for communication majors.

Donna B. Slawson, B.A., Oberlin College, M.A., Duke University, J.D., University of North Carolina School of Law, has been a law clerk at the Supreme Court of North Carolina and has practiced law in North Carolina. She is presently a visiting lecturer of law at the University of North Carolina School of Law. She has previously taught in Duke University's Institute of Policy Sciences and Public Affairs as well as the Department of Philosophy at the University of North Carolina at Chapel Hill.

Stephen A. Smith is professor of communication at the University of Arkansas, where he also received his B.A. and M.A. degrees. He received his Ph.D. from Northwestern University. He is the only person to have received both the Wichelns and Haiman Awards for Scholarship in Freedom of Expression from the Speech Communication Association. He has been a Visiting Fellow at Princeton University, the University of Wisconsin, and Mellon Fellow at the Center for Early American Studies at the University of Pennsylvania.

Rodney A. Smolla is Arthur B. Hanson Professor of Law, and director of the Institute of Bill of Rights Law, College of William and Mary, Marshall-Wythe School of Law. He